STILL LIFE

04
5. 3
10

This book is due for return or, or before the last date shown below.

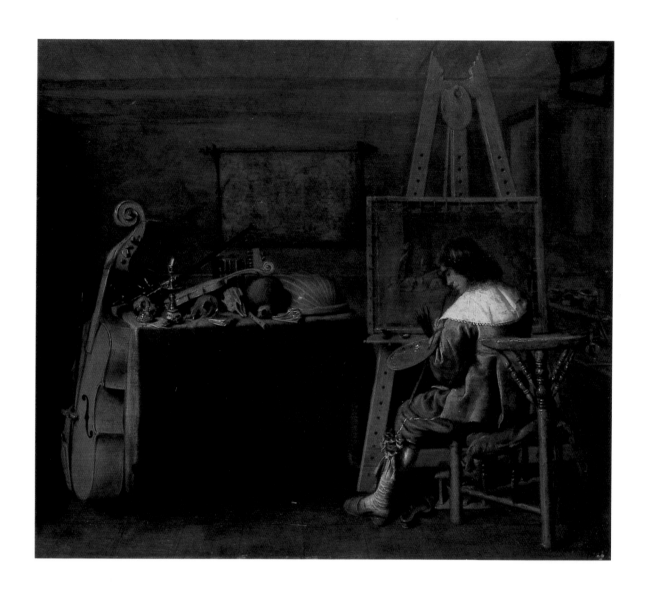

Norbert Schneider

STILL LIFE

Still Life Painting in the
Early Modern Period

TASCHEN

KÖLN LONDON LOS ANGELES MADRID PARIS TOKYO

COVER:
Adriaen van Utrecht
Large Still Life with Dog and Cat (Detail), 1657
Canvas, 184 x 227 cm
Dresden, Staatliche Kunstsammlungen Dresden
Gemäldegalerie Alte Meister
Photograph: Estel/SKD

ILLUSTRATION PAGE 2:
Hendrik Pot
The Painter in His Studio, c. 1650 (?)
Oil on wood, 42 x 48 cm
Bredius Collection, Haags Gemeentemuseum,
The Hague

© 2003 TASCHEN GmbH
Hohenzollernring 53, D–50672 Köln
www.taschen.com

Original edition: © 1990 Benedikt Taschen Verlag GmbH
English translation: Hugh Beyer, Leverkusen
Cover design: Angelika Taschen, Claudia Frey, Cologne

Printed in Italy
ISBN 3–8228–2081–4

Contents

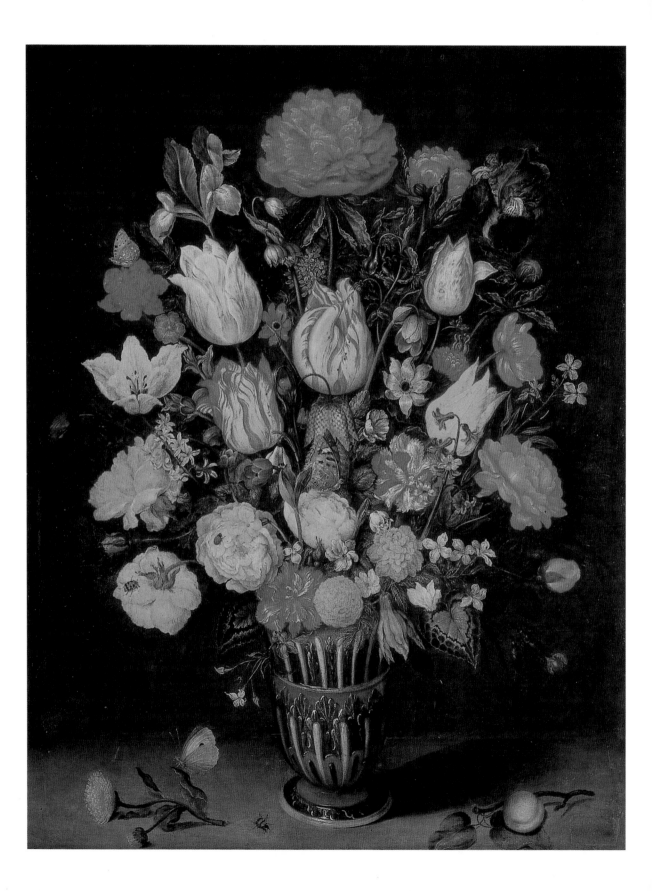

1 Introduction

"Still Life" – Some Theoretical Background

It often happens in art history that certain facts and circumstances have existed in aesthetic practice for quite some time before any classifying concepts and theories are evolved. Following its own norms and rules, academic reflection tends to lag behind developments in the art world, which is far closer to everyday life and therefore ahead of the academic world. This is also what happened to still lifes. Both in form and content, they had already existed as a special form of painting and were not given a generic name until the first crest of their development had already passed.

The word *still life* was not used until the mid-17th century, and we first come across it in Dutch inventories. At that time, however, it was still competing with other terms which had first been used exclusively for special variants of still lifes, such as *fruytagie* ('fruit piece'), *bancket* ('banquet') and *ontbijt* ('breakfast'). The Dutch word *stilleven* originally meant no more than 'inanimate object' or 'immobile nature' (*leven* or 'model'). In 1675 the German artist and art historian Joachim von Sandrart (1606-1688) spoke of 'immobile objects' in his *German Academy of the Noble Arts of Building, Painting and Drawing*.[1] A century later, in France, the term *nature morte* was coined. When Du Pont de Nemours wrote to Margravine Caroline-Louise von Baden in 1779, this word was obviously still new, as he felt the need to define it as a painting of 'inanimate things' (*les choses inanimées*). Writing in 1780, Jean-Baptiste Descamps also referred to a *nature morte* as a depiction of 'immobile objects' (*objets immobiles*).[2]

In the 17th century the Parisian Academy of Art, set up by Charles Lebrun, inspired the foundation of the first schools of art under the auspices of the various courts of the most important places in Europe.[3] At the same time, statutes and doctrines were laid down which resulted in a fixed hierarchical canon of the genres of painting that were to be taught. Still lifes were given the lowest rank, as they were regarded as mere recordings of inanimate objects, such as a vase of flowers, the leftovers of a meal on a table, books, documents and painters' palettes – things that appeared to have been scattered around without thought. Such paintings did not accord with current notions of a dignified order – an order that should follow the etiquette of absolute monarchies and proclaim the sublime as a standard for all artistic endeavour. The highest rank was given to history paintings – depictions of Biblical or mythical scenes and of the 'principal acts of state' of impressive potentates, and these were followed by portraits. Animals, landscapes and still lifes were assigned to the lowest places in this scale of genres, as

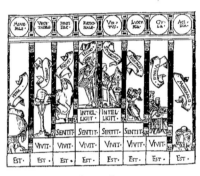

Bovillus (Charles de Bouelles)
Liber de intellectu, Paris 1509, fol. 119 v
(The Realms of Nature and of Man)

Ambrosius Bosschaert (1573-1621)
Still Life of Flowers, undated
Oil on wood, 66 x 51 cm
Alte Pinakothek, Munich

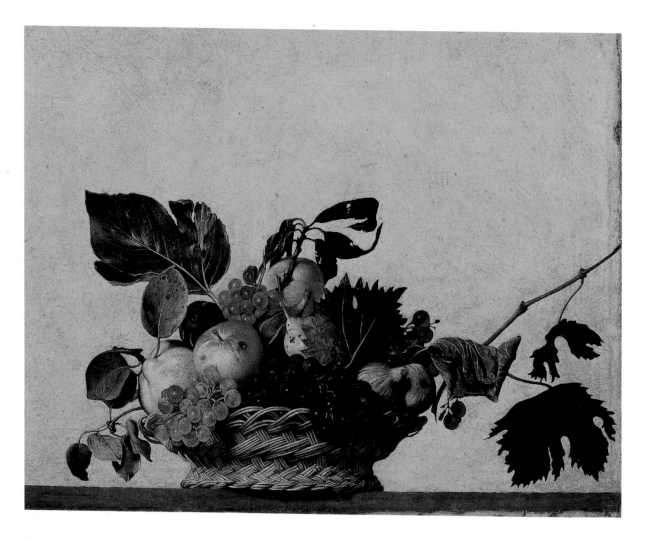

they were concerned with the lower forms of life or, indeed, merely with inanimate nature.

In the final analysis, this hierarchy was largely a matter of extra-aesthetic norms and followed the philosophical system of the *Porphyrian Tree*[4] (p. 7), where the world is ordered in such a way that inanimate or non-corporeal objects are the lowest form of existence, followed by corporeal, then animate and sensitive beings and finally Man, with his immortal soul, as the crown of creation. It was no coincidence that this normative academic canon was fixed at a time when feudal society was gradually being dissolved and replaced by the early modern corporative system. A new social dynamism was beginning to disrupt traditional systems of privilege, and this was the attempt by the social elite to halt this development by assigning to each social group and class a place within the social hierarchy.[5]

The fixing of such hierarchical systems was by no means, as might be assumed, a feudal or medieval model of organization and categorization. Rather, it was typical of the transition from feudal production methods to a form of society characterized by bourgeois trade capitalism. Politically, this went hand in hand with absolutism, which rationalized the traditional form of rulership. Although a large-format history painting generally required a great-

Michelangelo da Caravaggio
Fruit Basket, c. 1596
Oil on canvas, 46 x 64 cm
Pinacoteca Ambrosiana, Milan

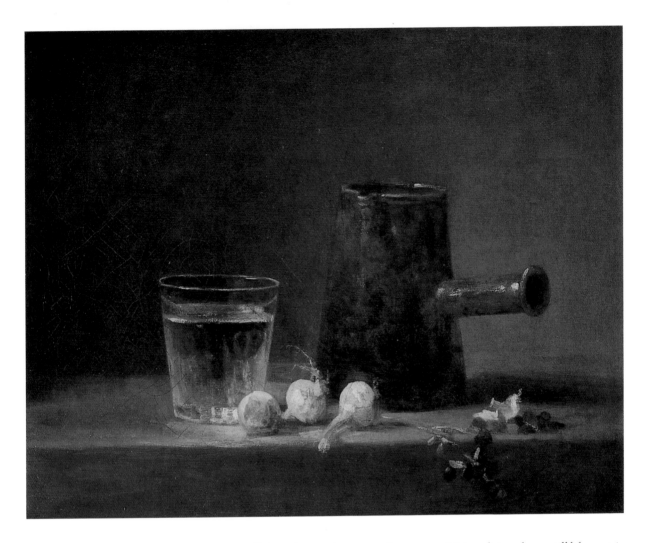

Jean-Baptiste Siméon Chardin
Water Glass and Jug, c. 1760
Oil on canvas, 32.5 x 41 cm
Carnegie Institute, Museum of Art,
Pittsburgh, PA

er effort with regard to conception, composition and time than a still life, we can gather from the words of contemporary painters that this academic hierarchy of genres bore very little resemblance to anyone's perception, or to the production of art itself. Vincenzo Guistiniani Caravaggio, whose *Fruit Basket* (around 1596) was much admired in later years (p. 8, see also chapter 9), was reported to have said that it is just as difficult to paint a good picture of fruit as it is to paint human figures.[6] Such words show that the artist's interest, perception and self-image only partly corresponded to the ideas of art historians who represented the claims of the public. It took them a long time to accept willingly – this time as advocates of the public – what many artists had said again and again when commenting on their own work: that in principle it is aesthetically and technically irrelevant whether the depicted subject is sublime or trivial. The artistic achievement is the same in both cases. Denis Diderot, in his salon discussions, for example, at first accepted the hierarchical system of genres without question, but limited himself almost entirely to aesthetic qualities in his later critiques of Jean-Baptiste Chardin's still lifes (p. 9). Chardin, he said, whose paintings were always 'nature and truth," was so perfect and "extremely truthful"[7] that he could easily prevail against history painters.

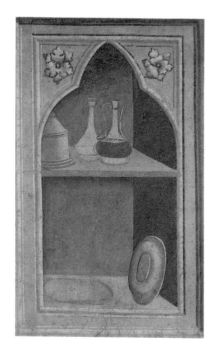

Taddeo Gaddi
Niche with Paten, Pyx and Ampullas
Fresco, 1337-1338
Santa Croce, Florence

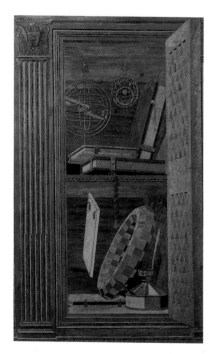

Francesco di Giorgio Martini and *Baccio Pontelli*
Intarsias at the Studiolo of the Duke of Urbino
Palazzo Ducale, Urbino

Despite academic doctrine and the criteria that dominated the early modern art market, connoisseurs and art enthusiasts nevertheless knew how to remunerate the artistic achievements of still-life painters. Tradition has it that Ambrosius Bosschaert was given 1,000 guilders for one of his flower still lifes – an extraordinary price at the time. Jacques de Gheyn, too, was able to demand a large amount for a flower still life: 600 guilders.[8] By contrast, a good portrait generally cost only 60 guilders on the Dutch art market.[9] Quite a few artists, as well as 'amateurs', probably felt that still lifes and still-life elements were a particularly appropriate aesthetic medium. After all, the objects that served as motifs in this genre consistently permitted a realistic rendering with a maximum degree of refinement in artistic methods, such as the discovery of chromatic and tonal values. To the extent that still-life painters examined their object – 'nature,' as it was called by art historians of the time – very closely and with almost scientific rigour, they also developed a sensitivity for the aesthetic means of its reproduction.

The Grapes of Zeuxis – Illusionism as an Artistic Principle of Early Still Lifes

From the very beginning, still lifes have been known as a genre radically conspicuous for its *illusionist* methods. Pliny the Elder's 'History of Nature' was often quoted, where the ancient painter Zeuxis is praised for painting such realistic grapes that birds would come along and pick at them, mistaking them for genuine fruit. And Zeuxis himself was in fact taken in by a curtain painted by his rival Parrhasius, which he tried to pull aside.[10] Such optical illusions (*trompe l'œil*) were popular as early as the 14th century. In 1305 Giotto painted the corner of a chapel, a so-called *coretto* (p. 11), onto the wall of the triumphal arch in the Cappella degli Scrovegni in Padua. The visitor looks into a rib-vaulted illusionist space which appears to dissolve the wall. A candelabrum shaped like a bird-cage is suspended from the vault, which also looks as though it had a Gothic lancet window and frescoed walls. Other famous examples are Taddeo Gaddi's niches (p. 10), with intermediate shelves behind frames with rosette-filled spandrels.[11] One niche appears to contain an upright paten (a plate for the communion host) below a pyx (a vessel for the host), as well as two big-bellied ampullas which taper off towards their necks. The other niche seems to contain a candelabrum and a book (probably a lectionary for mass). So they are largely liturgical objects. But as they are mere optical illusions, they are unexpectedly deprived of the sacred value and the magical qualities normally ascribed to them when they are used for the purpose of Holy Communion.

From the 1560s onwards there was growing appreciation not only of these illusionist murals but also trompe l'œil effects in intarsias,[12] and examples of such inlay work can be found both in the ecclesiastical sphere – again, with the illusion of little cupboards or niches for storing liturgical objects – and at court. Francesco di Giorgio Martini and Baccio Pontelli decorated the studios of the Duke of Urbino, Federigo de Montefeltre, at his palaces in Gubbio and Urbino (p. 10).[13] The general creative principle is always that of utilizing the laws of central perspective (or *perspectiva artificialis*), where doors broken up with rhomboid grids open at different angles, thus giving the impression of chance and a lack of permanence. These so-called marquetries (intarsias or inlays) display a high degree of abstraction, as colour has been discarded in favour of a monochrome structure,

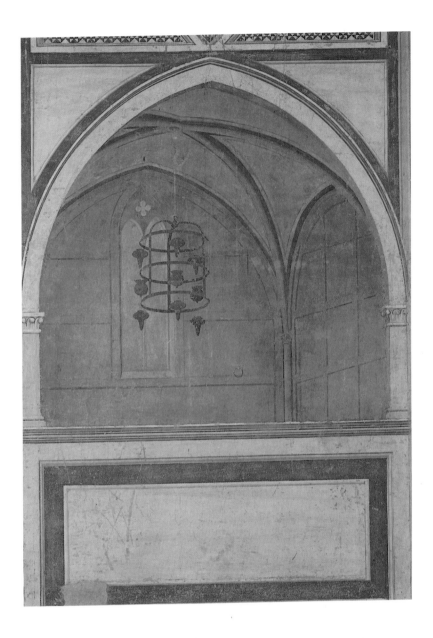

Giotto di Bondone
Coretto, 1305
Fresco
Cappella degli Scrovegni, Padua

while at the same time being limited to very few types of wood. The wood has been coloured very sparingly, either with sulfuric oil or naturally, or with water containing arsenic. As this is merely a matter of isolating the relationship between light and shade, it is no longer any genuine form of deception, that is, a deception that would actually irritate the viewer.

Painters, on the other hand, continued to seek such optical illusions again and again. The famous early *Still Life with Partridge, Iron Gloves and Bolt of a Crossbow* (1504, p. 12) by the Venetian painter Jacopo de'Barbari – court painter of the elector Frederick III ('the Wise') of Saxony – is one of those paintings that mislead the unprepared viewer by displaying the wall on which these objects have been hung. It is likely that the painting was cleverly integrated into the room of a hunting lodge where it was intended to provide

amusement for the hunting party. Nowadays we would hardly be deceived by such a painting technique. At the time, however, it was radically new and people's habits of perception had been formed by less illusionist paintings. Barbari's still life is akin to extremely precise studies of nature by contemporary German artists such as Dürer and Lucas Cranach the Elder. It has therefore been suggested that the Italian artist was influenced by Dürer. Cranach, who often depicted the partridge motif, was praised by a contemporary, the German humanist Dr. Scheurl, as a second Zeuxis ("At Coburg hast thou painted a stag at whom strange dogs bark whenever they behold him").[14]

Similar effects were intended by a number of 17th-century Dutch still-life painters with their 'paintings of paintings,'[15] where a curtain, draped aside, seems to be hanging in front of a painting (for example, Gerrit Houckgeest and Adriaen van der Spelt; p. 16). This genre of still life was known as a *bedriegertje* ('little trickster'). At the same time, Dutch painters also cultivated the so-called *quodlibet* ('hotchpotch'). The trompe l'œil by Hoogstraaten (pp. 14/15) shows a leather belt stretched across a wooden frame and fastened to it with nails. The belt serves as a

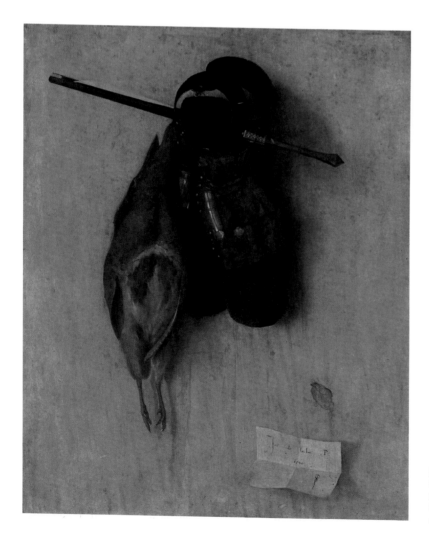

Jacopo de'Barbari
Still Life with Partridge, Iron Gloves
and Bolt of a Crossbow, 1504
Oil on wood, 49 x 42 cm
Alte Pinakothek, Munich

Master of the Annunciation of Aix
Still Life (Lunette of the Prophet Isaiah),
2nd quarter of 15th century
Oil on wood, 101.5 x 68 cm
Rijksmuseum, Amsterdam

clamp to hold a motley collection of everyday articles – stationery items such as rolled-up sheets of paper, a writing quill, a letter opener and some sealing wax, and toilet articles such as soap, a shaving brush, a razor and a comb, to name but a few.

This illusionism arose in the Middle Ages and became an important creative principle in the history of the still life. Relying on the misinterpretation of one's sensory perception, and the confusion of reality and its two-dimensional artistic imitation, it required an intensive study on the part of the artist of the laws of optics. Illusionism was a radical variant of the emerging 15th-century empiricism in art which no longer sought inspiration in pattern books but increasingly in immediate experience and observation. 'Imitation of nature' was the motto which recurred again and again in all Renaissance treatises on art. "If painting aims at depicting visible things, we must first of all notice *how* one sees things," writes Leon Battista Alberti in the second book of his treatise *On Painting* (1437).[16] And Leonardo da Vinci demands in his *Book about Painting*: "The spirit of the painter must be like a mirror which always changes to the colour of the object that faces it." Elsewhere, he says, "I tell a painter that he should never imitate the manner of another, because with regard to art he will be called a grandchild rather than a son of nature. Since natural things exist in such great abundance, one will and should take refuge in these things themselves rather than in the masters who have learnt from them."[17]

The precise rendering of objects together with attention to one's own perception – these were the features of 15th-century Dutch and French painting. This approach, therefore, included the first elements of still life, although still only in a minor role, as decorative additions to the Biblically motivated context into which they were integrated. In Jan van Eyck, Robert Campin and the Master of the Annunciation of Aix such still life arrangements can be isolated by selecting certain details. The latter, for example, painted arched niches above the prophets Isaiah and Jeremiah (p. 13),[18] consciously introducing an element of chance, with unarranged layers of open books, chip boxes, little chests and clay pots. This could be regarded as a 'pure' still life if the objects were not recognizably related to the biblical figures on a pedestal below them. Still lifes

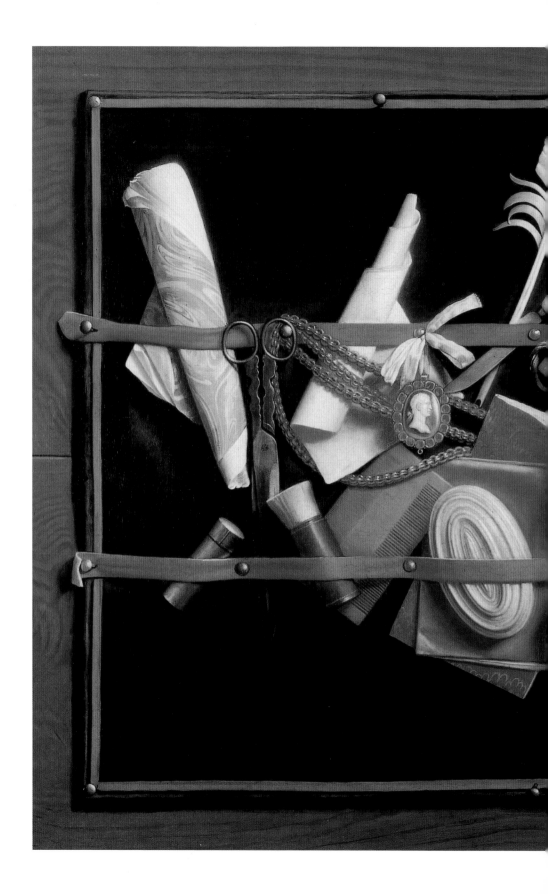

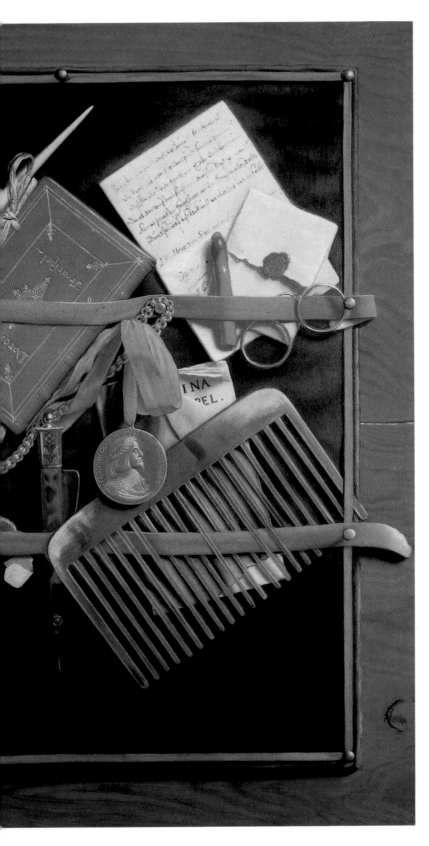

Samuel van Hoogstraten
Trompe l'œil (Pinboard), 1666-78 (?)
Oil on canvas, 63 x 79 cm
Staatliche Kunsthalle, Karlsruhe

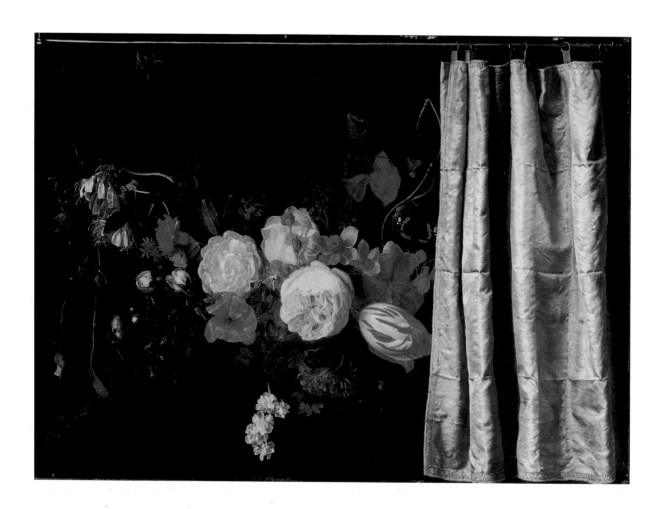

had not yet become autonomous as an independent genre. This is also true for the vases of flowers (Hans Memling) and skulls (Barthel Bruyn, p. 22, and Jan Gossaert, p. 77) on the reverse sides of donor portraits.[19] These must be regarded as symbolically and philosophically related to the depiction on the front from which they cannot be separated.

It is a noticeable feature of these early paintings that objects and their physical properties have been studied with almost obsessive precision, and that these properties are sometimes rendered with an excessive degree of exactitude. The artists were particularly interested in the effects of light and colour on the objects, which changed considerably according to the time of day. Temporality, variability and chance were a matter of real day-to-day experiences which influenced these paintings and, subsequently, also the entire genre of still lifes. Therefore, they continually emphasize the aspect of vanity and the transitoriness of all things (cf. chapter 6).[20]

This 'naturalism' as a method of depiction, together with illusionism, is parallelled in the late medieval philosophy of nominalism,[21] whereby the world was seen as consisting merely of individual objects. According to this view, an object can hardly ever be discerned in its essence, and only its sensorily perceptible outer skin – its 'appearance' – points to its actual existence.

Disguised Symbolism

It may seem surprising, at first sight, that this radical empiricism was regarded as perfectly compatible with a theological interpretation of objects symbolizing the facts of salvation history. The essence of things was declared inaccessible to philosophy, art or aesthetics, because it was only appearances that could be grasped by the human mind and its senses. This created a vacuum in the theory of knowledge which 15th and 16th-century theologians were able to fill with symbolical speculation that was often excessive and, indeed, went beyond that of the early and high Middle Ages.

Medieval Bible scholars taught that, in addition to their 'literal' meanings (*sensus litteralis*), all things also had three levels of religious meaning, related to certain Bible passages (a *sensus mysticus* or *sensus spiritualis*).[22] These were (1) an *allegorical* meaning related to faith, (2) a *tropological* or figurative meaning that concerned questions of Christian morality and (3) an *anagogical* or mystical meaning which pointed to the 'last things.' While the literal meaning was regarded as unambiguous, with virtually no differences of opinion, the spiritual meaning allowed a variety of different interpretations, depending on the ideological view of each particular theologian. As a result, it is not always easy to reconstruct which particular system of theological symbolism had inspired a given artist of the late Middle Ages or the Renaissance in his endeavour to edify Christians with his motifs.

Erwin Panofsky spoke of a 'disguised symbolism' in this context,[23] a hidden religious structure beneath the 'cloak' of appearances. To give a few random examples, wooden boxes in still lifes (p. 20) often retained the significance they had in 15th and 16th-century Madonna pieces, and denoted the shrine in which the saint was thought to lie concealed. Given a positive interpretation, fruit still lifes of grapes, pears and apples were often allusions to the blood of Christ, the sweetness of His incarnation and Christ's love of the Church. In an open walnut, gnawed at by a mouse (as a symbol of evil), the shell denotes the wood of the cross and the sweet kernel the life-giving nature of Christ (p. 91).[24]

Around the year 1700 religious speculation was replaced by humanist scholarship, whose protagonists tried to find symbols of subtle spiritual content – usually of a moral kind – in so-called emblems.[25] These emblems usually consisted of three parts: a brief motto, a picture (*pictura*) and, below it, an explanatory text in verse form (*subscriptio*). Research has provided sufficient evidence to show that such emblems influenced at least partly the disguised symbolism of still lifes. This was also true of so-called genre paintings, of which still lifes formed part in the form of details and then often gained independence. So, although these paintings could be viewed and enjoyed on a purely aesthetic level, those with a humanistic education could also discover elements of moral reflection, political allusions or theological theories. And it was these educated people that artists, fighting for greater prestige, sought to emulate with their encoded messages. This dual structure corresponded to Horatio's principle of instruction and entertainment,[26] which the work of art had to fulfil.

These emblematic constructions were often influenced by tangible political, economic or socio-cultural events. An emblem like Roemer Visscher's (1614, p. 135), *Een dwaes en zijn gelt / zijn haest gheschejden* ('A fool and his money are soon parted'), is an unambiguous allusion to the *tulip fever* which

raged in the Netherlands at the time, that is, the frantic stock exchange speculation of Dutch citizens in tulip fields (cf. chapter 10).

Still Lifes as Documents of the History of Civilizations and Mentalities

For an understanding of the still lifes discussed in this book it will occasionally be necessary to point out symbolical contexts or emblematic allusions. However, paintings must not just be understood in their religious dimension. Equally important – if not more so – is the immediate and straightforward significance of these paintings with regard to the cultural and economic interests, needs, values and preferences of the public for whom the artist painted, either directly or through the mediation of the art market. The very subjects of Dutch 17th-century still lifes occasionally tell us something about the target group as well as the place where they were painted.

Fish still lifes show that a picture was painted at The Hague with its abundant market, whereas the affluent citizens of Haarlem were particularly open to the refined taste displayed in breakfast still lifes by artists like Willem Claesz Heda and Pieter Claesz (p. 21). Utrecht, on the other hand, offered asylum to refugees from the southern Netherlands and therefore gave preference to the Flemish tradition of flower still lifes.[27]

The question that should be asked is what ideas and ideals were artistically formulated alongside the kinds of everyday objects which were considered worth painting. After all, the function of the depicted objects in a still life is not merely a matter of cultural history, but they also bear witness to changes in people's awareness and mentality. They teach us, sometimes very directly and sometimes rather more inconspicuously and implicitly, about historical changes in attitudes towards the capabilities of human perception (chapter 5), transformations in man's awareness of death (chapter 6) or the gradual penetration of new scientific insights into the traditional medieval model of viewing the world (chapters 12 and 16).

Using a limited number of representative examples, the following fifteen chapters are intended to give a history of motifs, highlighting the special features of still lifes as an artistic genre, a genre which accompanied these changes in culture and society at the beginning of Naturalism and whose paintings provide us with a commentary on these changes.

Jan Brueghel the Elder
Bouquet in a Clay Vase (Bouquet of Viennese Irises), c. 1599 or c. 1607
Oil on wood, 51 x 40 cm
Kunsthistorisches Museum, Vienna

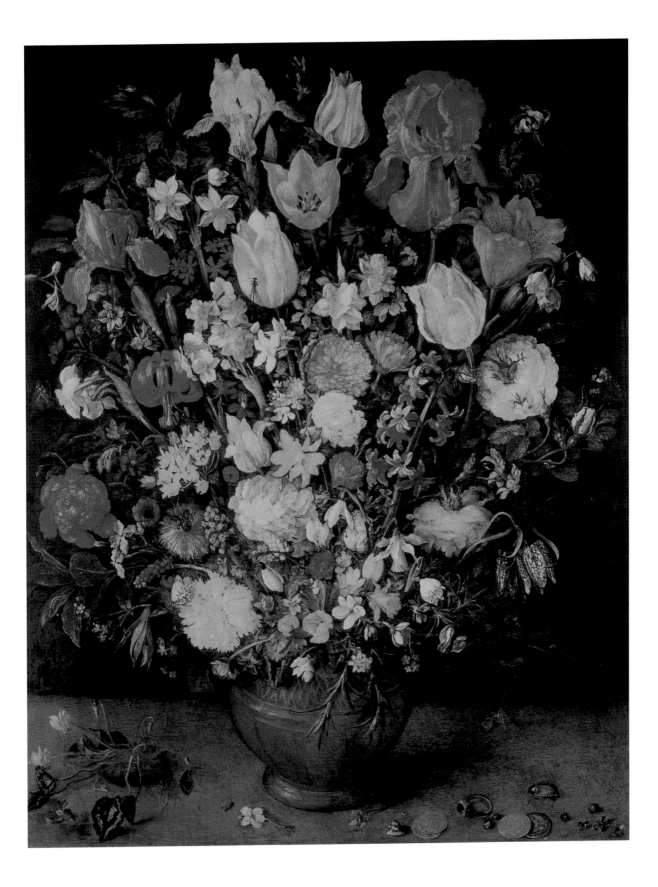

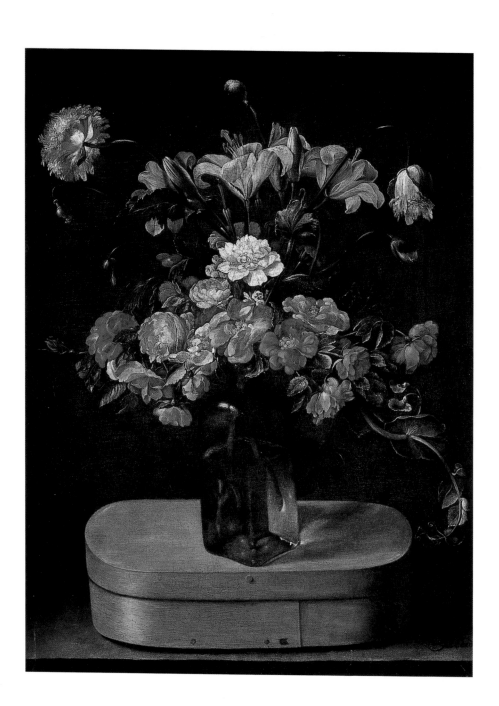

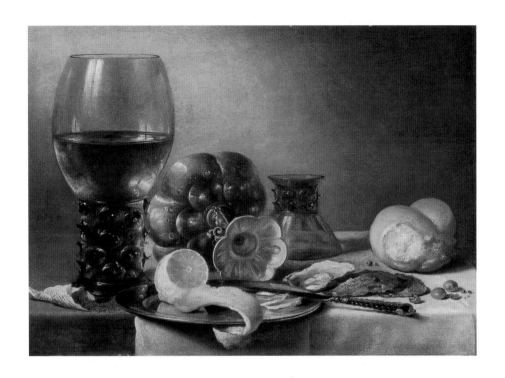

Pieter Claesz
Still Life, 1633
Oil on oakwood, 38 x 53 cm
Schloß Wilhelmshöhe, Staatliche
Kunstsammlungen, Kassel

OPPOSITE PAGE:
Jacques Linard
Bouquet on Wooden Box, c. 1640
Oil on canvas, 57 x 42 cm
Staatliche Kunsthalle, Karlsruhe

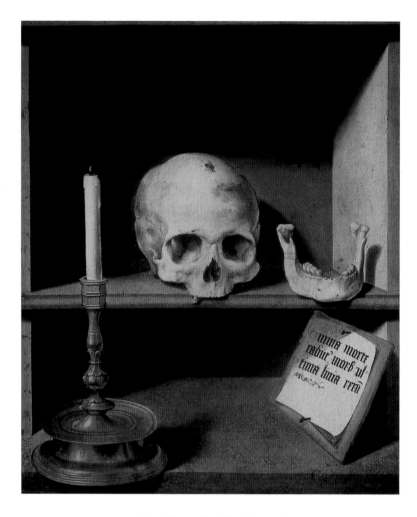

Barthel Bruyn the Elder (1493-1555)
Vanitas still life on the back of the portrait of
Jane-Loyse Tissier
Oil on wood, 61 x 51 cm
Rijksmuseum Kröller-Müller, Otterloo

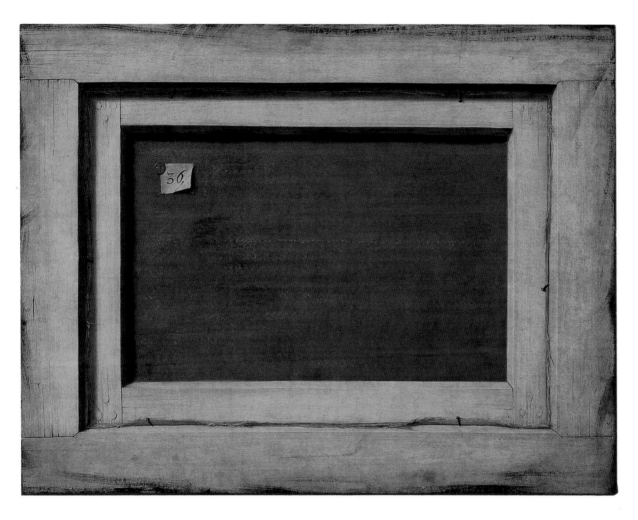

Cornelius Norbertus Gijsbrechts
Reverse side of a painting, 1670
Oil on canvas, 66.6 x 86.5 cm
Statens Museum for Kunst, Copenhagen

Gijsbrechts' *betriegertje* is meant to lead the viewer astray by thinking that he ought to turn the picture the right way round. The scrap of paper with the number 36 on it gives the impression that this deceptive illusionist painting is actually meant for sale. It is therefore likely that the painting was originally put up at a sales exhibition as a practical joke. The saleability which is associated with the picture probably also explains why it appears so abstract. At first sight, the painting certainly seems modern to today's viewer. However, it is not an abstract painting like Malevich's two-dimensional Suprematist colour configurations. The accurate rendering of the stretching frame and its borders, as well as the canvas, show that the basic intention is totally different: it is meant to emphasize plasticity, thus functioning as a substitute for a real object.

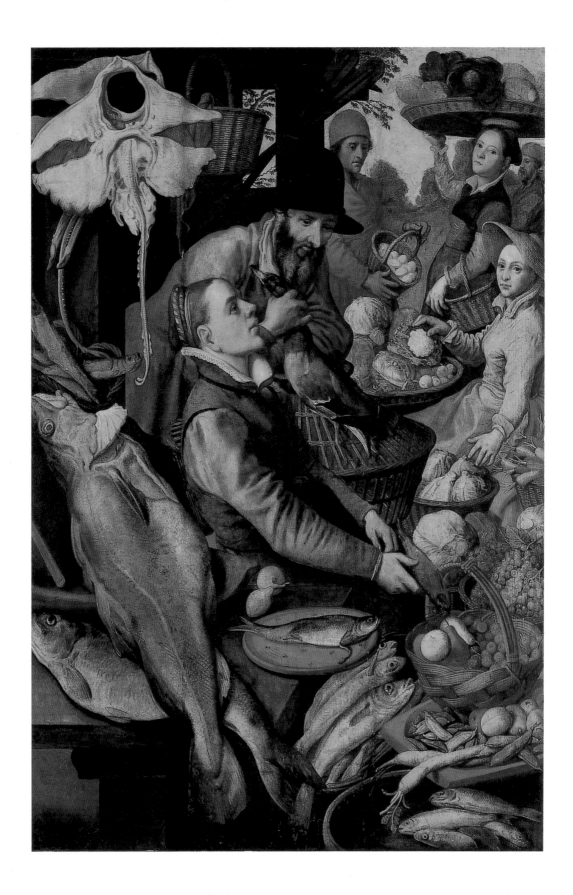

2 Origins and Early Stages of the Still Life

Economic Conditions

The earliest forms of post-medieval still life were shaped during an era that was marked by economic revolutions, as well as by the beginnings of the dissolution of feudal structure, a process which was already partly in evidence. The motifs of these paintings – mainly market and kitchen situations – can therefore be regarded as indications of the changes in economic and social conditions. Thus they also show changes in people's values and an interest in the commodities manufactured with the new production techniques. Within Europe this disintegration of the barter economy, which was due to a produce tax levied by the feudal landlords as well as the introduction of a monetary system, took place most noticeably in the Netherlands. Formally it belonged to the huge Hapsburg empire of Charles V (1515-1555) but, because of its high standard of economic development, it had a special autonomous position within the realm. The provinces of Flanders and Brabant, with the towns of Ghent, Bruges, Ypres, Louvain and Brussels, had already been centres of the guild trade in the 13th century. This is where the first factories were built in the 14th century. These highly efficient and competitive producers gradually ruined the guild trade, as they were able to supply the market with a continually growing quantity of products. In the 16th century Antwerp, Brabant's largest port, rose to the position of the most significant trade and banking centre in Europe, where all important business houses – such as Fugger, Welser and Grimaldi – were based. Every day enormous overseas cargoes were unloaded at Antwerp harbour, which offered enough space for up to 2,000 vessels at anchor. Furthermore, in the area around this town there was an extensive cottage industry for the processing of English cloth and the production of glassware, soap, sugar and other goods.[28]

But not only in the world of commerce did far-reaching changes take place; the changing conditions in agriculture were almost equally revolutionary. The influx of large amounts of gold and silver from overseas had brought about a price revolution – i.e., inflation – so that many noblemen, who had hitherto been unproductive and lived only from the land tax which they levied, found that their money became increasingly worthless until eventually they were so impoverished that they had to sell their property. This was bought up by rich town-dwellers who saw to it that new production methods were implemented by day labourers. The population increase at the beginning of the 16th century meant a greater demand for food, which had to be satisfied by an agricultural system that was now no longer catering merely to itself but also to

Detail from Jacob Jordaens' *Allegory of Fertily*, pp. 30/31

Pieter Aertsen (c. 1533 – c. 1573)
Market Scene, undated
Oil on oakwood, 127 x 85 cm
Wallraf-Richartz-Museum, Cologne

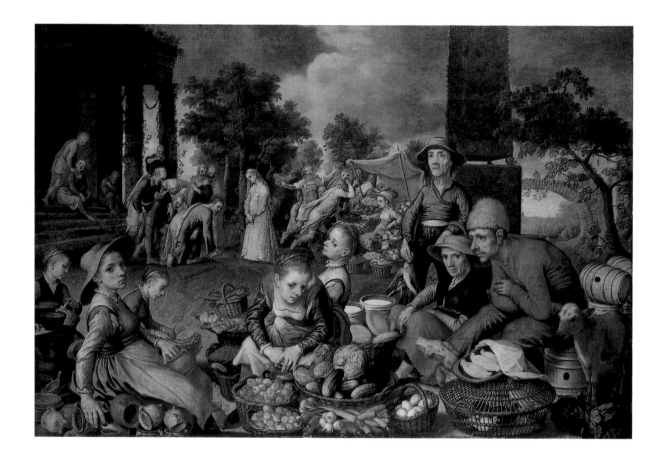

the market. Rich patricians realized that this would give them an opportunity to enhance their profit considerably. The medieval system of three-field rotation was now replaced by crop rotation, where the ground was used more systematically and intensively, as shown by agricultural surpluses. This production increase was academically supported by a good deal of learned literature, the so-called *paterfamilias literature*, which was partly inspired by the authors of antiquity and medieval writings such as the *Ruralium Commodorum Libri XII* of the rich Bologna patrician Petrus de Crescentis (1230-1310). This first agricultural handbook was printed in 1493. Alongside these progressive and innovative approaches in agriculture, there were also some town-dwellers who had bought property but chose to follow the old feudal and semi-feudal production methods.[29]

Pieter Aertsen
Christ and the Adulteress, 1559
Oil on wood, 122 x 177 cm
Städelsches Kunstinstitut, Frankfurt

Market Scenes

After years of inadequate supplies this increase in food production, brought about by changes in agricultural methods, was experienced by the general public as a great improvement – so much so, in fact, that it virtually demanded some form of artistic expression. Celebrating this new wealth in an almost solemn manner, the Amsterdam-born painter Pieter Aertsen, who lived in Antwerp in 1555-56, depicted market scenes as part of biblical illustrations. However, instead of following traditional conventions and playing only a minor part in these illustrations, these market scenes dominate the biblical

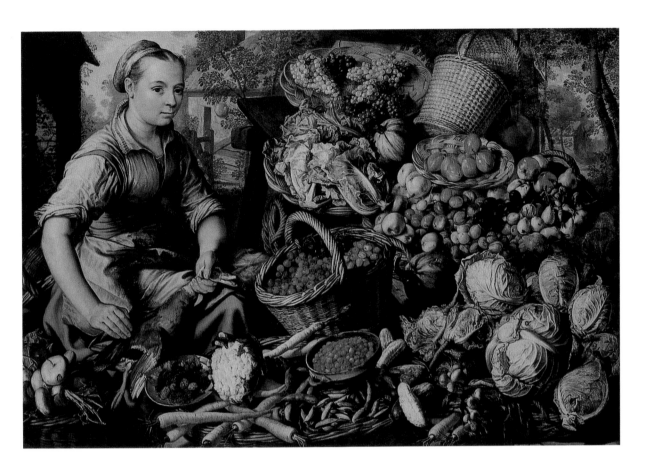

Joachim Beuckelaer
Market Woman with Fruit, Vegetables
and Poultry, 1564
Oil on oakwood, 118 x 170.5 cm
Schloß Wilhelmshöhe, Staatliche
Kunstsammlungen, Kassel

motifs so much that the latter are literally pushed into the background (p. 26). In his painting *Christ and the Adulteress* (1559),[30] now in Frankfurt, the biblical event takes place at the back, on the left, while the foreground is dominated by a market scene with peasants offering clay pots, baskets laden with fruit, vegetables such as onions, carrots, cucumbers and cabbages, as well as eggs, loaves of bread and large jugs of milk. It is this foreground which attracts our attention. There is also a peculiar mixture of time levels: the biblical scenario (with people wearing the clothes of antiquity) and the contemporary market scene (with sixteenth-century peasants) are intricately interwoven, as is shown in the Roman soldiers storming past the market stall. The same principle can be found in Aertsen's Ecco Homo fragment in Munich[31] (p. 29): somewhere in the background, the picture – cut off at the top – affords a small glimpse of the platform where the masses are shouting 'Barabbas' (cf. John 19:4-6). Again, this is optically overlaid by the bow-shaped arrangement of carts and market stalls – a reversal of emphasis which is typical of Aertsen.[32] The same feature can be found in numerous other paintings of his. There was a time when it was believed that this reversal could be adequately explained by attaching the stylistic label of Mannerism, though this label is in need of clarification itself. For the dominance of mere objects over the sublime, highly meaningful motifs can only be understood in the context of the social and economic revolution that had taken place. Arnold Hauser, in his book of Mannerism, therefore correctly emphasizes the element of alienation in this particular style. However, we can go one step further and – together with Georg Lukács – speak of a

form of 'materialization' (Lukács) in which the 'relationship between people and objects' becomes 'tangible' and the objects – that is, commercial products – determine in a fetishist way the 'metabolism' of society with all its manifestations of vitality and its forms of consciousness.[33] To the extent that, for the first time in Western society, religion was beginning to 'lose its magic' (Max Weber),[34] commercial products developed a special fascination and turned into fetishes. These fetishes almost (and sometimes literally) turned into objects with a libidinous significance, seeming to have a magical effect.

Aertsen's nephew Joachim Beuckelaer painted in a more simple style, although he generally overloaded the market scenes so excessively that they acquired an independent quality. At the same time he frequently discarded the biblical scenarios altogether. His *Market Woman with Fruit, Vegetables and Poultry* (p. 27) is a typical example. Here the market woman – probably a farmer's wife – almost becomes an accessory to the over-abundant baskets and bowls containing a rich variety of fruit and vegetables that reach right up to the upper edge of the painting. In this way Beuckelaer tries to show the impressive quantitative results of the new agricultural methods. The greenish-purple iridescence of the cabbages, with their bizarre curls and wrinkly whirls, bears witness to improvements in fertilization, and the abundance of different kinds is meant to show the large number of refinements and crosses between the different fruits. Similarly, Beuckelaer's *Market Scene* (p. 24) – a painting in vertical format – shows a column of sea food on the left, building up and culminating in a ray and – directly opposite, on the right – a large number of fruits of the field and the garden. Wedged between this enormous abundance of produce, the farmer and his wife appear to be mere appendages whose job is only that of proudly pointing with silent gestures to the victuals that are on offer.[35] This ostentatious wealth of fruit and vegetables may lead to the false conclusion that the population had plenty to eat. But although more was being offered on the markets, this did not meet the demands of the urban population, who had to pay exorbitant prices for agricultural produce in comparison to what

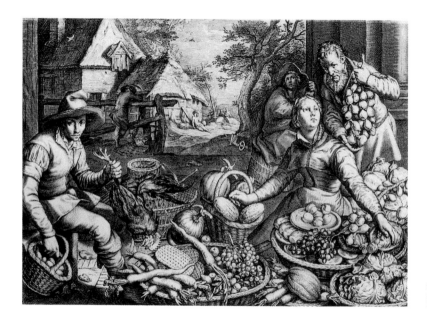

Jacob Matham, after Pieter Aertsen
Market Scene, 1603
Engraving, 24 x 32 cm

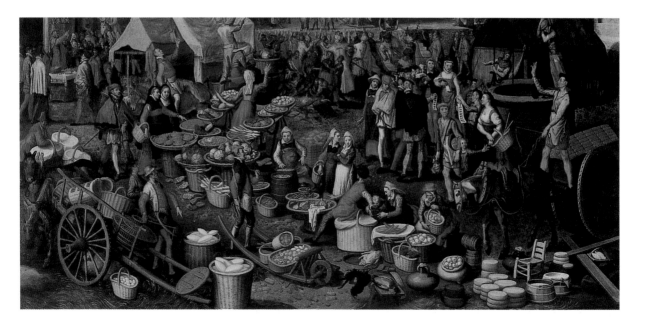

they actually earned.[36] And so, the horn-of-plenty motif of these market pictures reflects far more the perception of those who benefited, that is, the newly-rich farmers. In this way the artist emphasized the commercial aesthetics of agricultural products from the farmers' fields and gardens, products that were meant to arouse in the viewer the desire to buy, though not in the sense of present-day advertising. However, this does not exclude the possibility of ambivalent reasoning behind such paintings. While stimulating people's cravings and appealing to their needs, they often contained a subtle element of criticism, particularly in Aertsen's biblically motivated pictures. This criticism concerned the contradiction between people's consumer habits and the demand of temperance ('fasting'). While this critical element was still obvious in Aertsen's paintings, it seems to have disappeared almost completely in Beuckelaer's.

Pieter Aertsen
Market Scene (Ecce Homo fragment), c. 1550
Oil on oakwood, 59.5 x 122.5 cm
Alte Pinakothek, Munich

Allegories of Fertility

In fine art the new prosperity that came from up-to-date agricultural production methods was aesthetically reflected in the mythological exaltation of the soil and its achievements. Anticipating the economic theories of the Physiocrats, 16th-century Flemish paintings already reflected the view that the earth itself could naturally provide welfare and happiness, and that human labour was not actually necessary to attain these. In his *Allegory of Fertility* (pp. 30/31) Jacob Jordaens probably paid 'homage to the goddess Pomona': satyrs and other Bacchanalian divinities of the woods and fields are gathered together, carrying huge arrangements of agricultural produce on their shoulders or offering grapes to the nude goddess at the centre of the painting. Among the satyrs – who are half animals but not (as they still were in Titian) orgiastic creatures – there is also a genteel lady. She was probably the person who commissioned this painting and wanted to see the production increase on her estate celebrated with the solemn formulas of ancient mythology.[37]

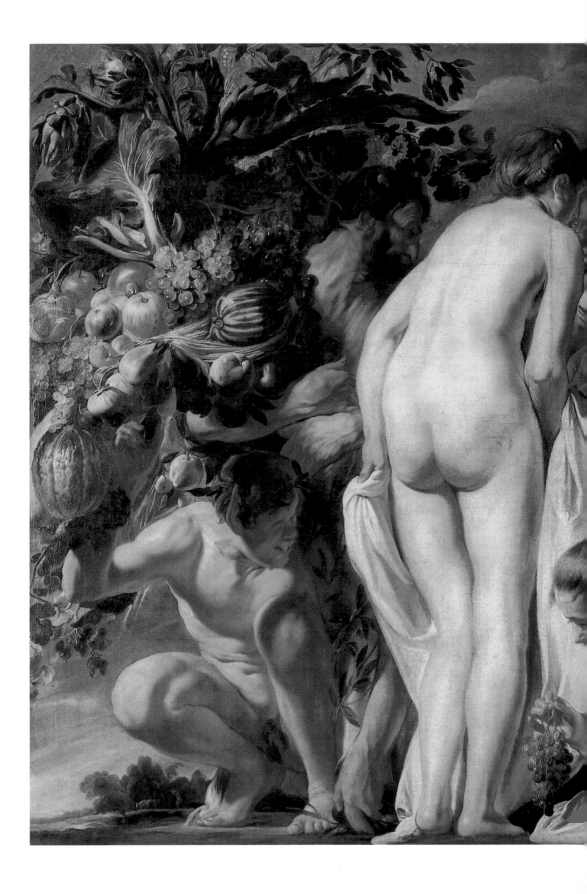

Jacob Jordaens
Allegory of Fertility (Homage to Pomona), c.
1622
Oil on canvas, 180 x 241 cm
Musées Royaux des Beaux-Arts de Belgique,
Brussels

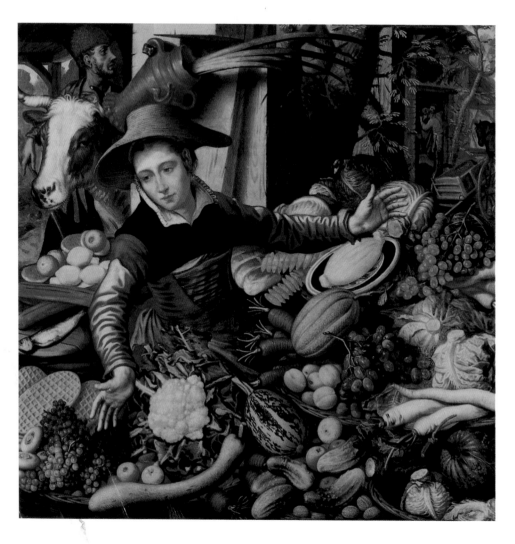

Pieter Aertsen
Market Woman with Vegetable Stall, 1567
Oil on wood, 111 x 110 cm
Stiftung preußischer Kulturbesitz, Staatliche
Museen, Berlin

The painting demonstrates a wide range of agricultural products, made possible by improvements in production methods. Offering her fruit and vegetables, the woman is almost an appendage to her produce. Despite all exaggeration, the picture quite adequately shows the new economic prosperity of the time. At the same time, however, it still contains a background scene in genre style of embracing lovers in a stable, thus relating the painting to late medieval peasant satires. Peasants were regarded as lustful, sensuous and carnal by the middle classes.

(Ascribed to) *Frans Snyders*
Vegetable Still Life, c. 1600
Oil on canvas, 144 x 157 cm
Staatliche Kunsthalle, Karlsruhe

This still life from the collection of Margrave Hermann von Baden-Baden (1628-1691), which has – probably correctly – been ascribed to Frans Snyders, may have belonged to P.P. Rubens at one time. It is one of the few examples of early 17th-century Flemish paintings which do not show market or kitchen scenes, but the agricultural sphere of production itself. However, it is worth noting that the farmer's labour, as a source of the new wealth, has been completely delegated to the background (small section in the top right corner).

Paintings of Butcher's Shops

Using the language of the Bible, theologians have referred to the dangers of the consumer habits which emanate from such an abundant supply of products as 'temptations of the flesh,' and these are quite often the theme of rather graphic paintings of butchers' shops. Like Aertsen and Beuckelaer's art, they are not yet pure still lifes, although they do display the tendency towards materialization inherent in this genre. In Bartolommeo Passarotti's *Macelleria (Butcher's Shop)*, two butcher's assistants have spread out pieces of meat on the table parallel to the frame as if the viewer were meant to examine them. One of them is about to cut off the snout of a wild boar with a sharp knife.[38] In Annibale Carracci's painting with a similar motif (p. 34), the characters are also facing the viewer as if they were on stage.[39] On the right, a butcher's servant is dragging along a freshly cut ox or cow, the spine and innards visible as in an anatomical longitudinal section, which he is about to hang on a hook. Another servant is kneeling beside a sheep that is lying on the ground, its legs tied, which he is about to slaughter. A third servant is holding a pair of scales, adjusting its weights. In the background, a butcher is taking a hook off the ceiling. Goods are exhibited in front of him, and an old woman is seen stealing a piece of meat without being noticed by the butcher. On the left a rather foolish-looking man, dressed in a dandy-like manner with a feathered hat, tattered, baggy yellow trousers and a huge codpiece, can be seen rummaging awkwardly in his purse. The actions of the characters show that the painting is a thematic representation of a literary motif from a picaresque tale. Both Passarotti and Carracci intended to emphasize the rough crudeness of the butcher's assistants and their apparent lack of sensitivity. In the 16th and 17th centuries it was still quite common for theologians to see a slaughtered animal as symbolizing the death of a believer and to combine with it the warning:

"You who with much pleasure
Slay a swine or calf,

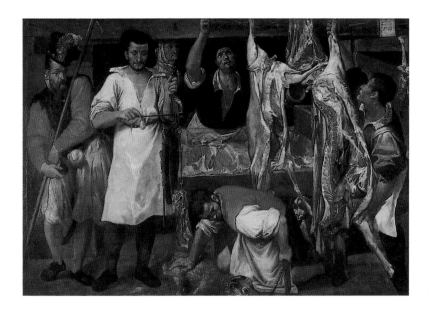

Annibale Carracci
Butcher's Shop, 1680s
Oil on canvas, 185 x 266 cm
Christ Church Picture Gallery, Oxford

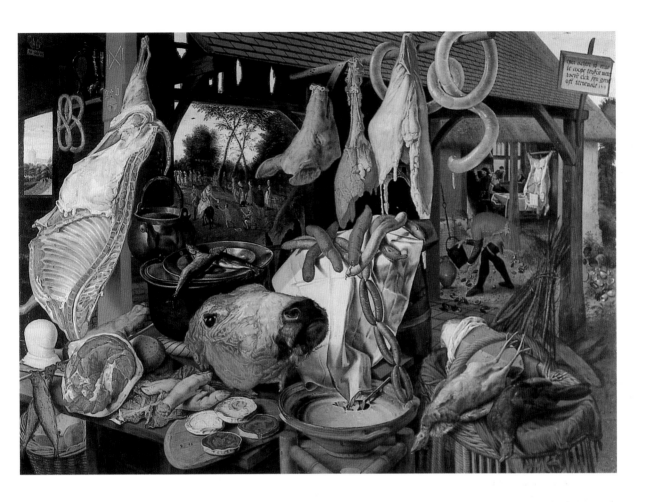

Think how on the Lord's Day
You will stand before God's Judgment."
(Groote comptoir almanach, Amsterdam 1667)[40]

Pierter Aertsen
Butcher's Stall, 1551
Oil on wood, 124 x 169
University Art Collection, Uppsala

Such allusions to the 'weak flesh' (cf. Matthew 16:41) and the way of all flesh may well have been associated with Aertsen's *Butcher's Stall* (p. 35) where – like on his fruit and vegetable stalls – a seemingly infinite abundance of meat has been spread out. In the foreground tables, pots, plates, a barrel, some wickerwork chairs and baskets serve as supports and containers for huge hunks of meat, pig's trotters, soups, chains of sausages hanging down and freshly slaughtered poultry. In the background there is an open, shingle-roofed studded stable with a pole from which further pieces of meat are suspended, including a pig's head, a twisted sausage and some lard. Through the stable we can see a garden scene.[41] On the right, in the middle ground, a farmer is filling a large jug, and behind him we can see a slaughtered and gutted pig – a motif which Beuckelaer also used as an independent motif (p. 36), as did Rembrandt later (where the animal is a slaughtered ox, p. 37)[42] and also Chaim Soutine, who went beyond the trivial context of a farm by introducing expressive associations between a sacrificial animal and the Passion.

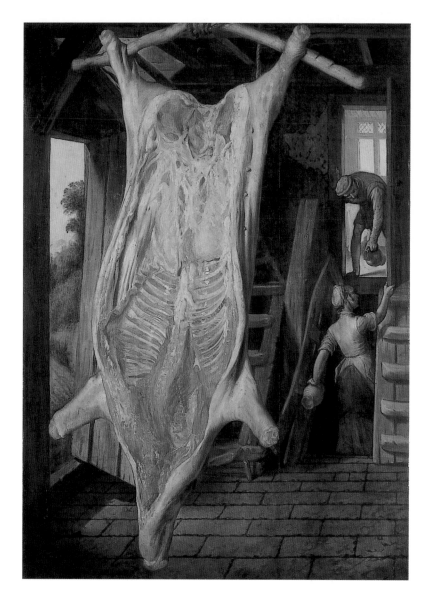

Joachim Beuckelaer
Slaughtered Pig, 1563
Oil on oakwood, 114 x 83 cm
Wallraf-Richartz-Museum, Cologne

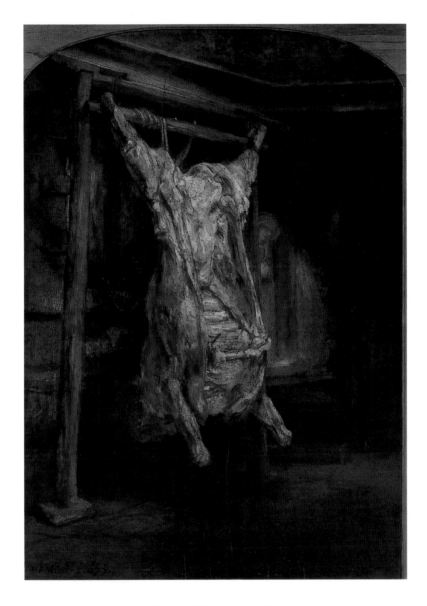

Rembrandt Harmensz van Rijn
Slaughtered Ox, 1655
Oil on wood, 94 x 67 cm
Louvre, Paris

3 Kitchen Scenes

Occasionally it is hard to distinguish market scenes from the genre of early kitchen scenes which also tended to display still life features. Similar to the market stall, they often show tables and sideboards with clusters of baskets and bowls full of fruit and vegetables. Frans Snyders' *Pantry* (Brussels), for example, resembles his *Fruit and Vegetable Stall* (p. 40): in both paintings a woman is seated next to a table loaded with victuals. In the one case this is a kitchen maid, and in the other a market woman who is offering a fig to a young man – apparently an obscene gesture.[43] Many kitchen scenes are only distinguishable from market scenes by the setting. While the former have their location in a dark basement room, the latter often appear to be situated alongside the wall of a house, with a view of an open square or a street to the side.

Yet despite structural similarities there are still differences with regard to the subject. While market stalls illustrate the commercialization of agriculture and the principle of agro-economic production, kitchen and pantry paintings are dominated by the aspect of satisfying the needs of domestic economy, usually in a feudal or re-feudalized upper middle class household (of which the piece of venison in Snyders' *Pantry* is evidence). Leaving aside the fact that these paintings grossly exaggerate the wealth of the day, the ostentatious display of the fruit of the earth proves that the principles of the paterfamilias literature were observed even in the non-market-oriented system of domestic self-supply. These principles demanded an improved utilization of the soil by extending the agricultural acreage and intensifying agriculture, as well as by improving crop sequences and fertilization and, in part, by transforming ploughed fields into gardens.

The subject of food and supply was of particular interest to those who commissioned and bought these paintings. In the early modern period the 'entire house' (Otto Brunner),[44] as the households of the landed gentry and the merchant classes of this time were often called, formed a self-contained, self-sufficient economic system which produced everything required for the needs of its members. The production and preparation of food were the most important economic problems of society, which explains their central position in contemporary iconography.

An early example of such kitchen pieces can be seen in a painting by Ludger tom Ring the Younger:[45] In front of the fireplace the housewife, accompanied by her little daughter, is giving instructions to a maid as to how the food for the party in the background (*The Wedding at Cana*, John 1:1-12) is to be prepared and served. The kitchen is on ground level, as is the pantry directly to the left, where a servant is busying himself with a barrel fastened to a chain. It is worth

Detail from illustration pp. 42/43

Frans Snyders (1579-1657)
Fruit and Vegetable Stall
(detail), undated
Oil on canvas, 201 x 333 cm
Alte Pinakothek, Munich

noting that the food is not just kept in baskets and other containers, but is also spread out on the tiled floor – like the fish, for example, which are being guarded by a dog. As regards its conveniences, the kitchen can hardly be distinguished from other rooms, as illustrated by the fine china and vases on the sideboard and the painting above them, with fish, fruit and vegetables scattered around the floor. The same features can be found in Joachim Antonisz Uytewael's *Kitchen Scene* from 1605 (p. 41), where the real subject is supposed to be the Rich Man and Lazarus (Luke 16:19-31).[46] This shows that in the 16th and early 17th centuries the biblical motifs of feasts were used by painters as pretexts for reflection on consumer habits and attitudes towards the new wealth which resulted from improvements in agricultural production.

Fish and meat (for example, the goose being put on a spit by the cook) figure as theological symbols standing for Lenten fare and lust of the flesh (*voluptas carnis*) respectively, as seen by the Roman Catholic Church in their doctrine of good works. It is true, however, that the contrast between the two symbols is not emphasized very strongly in Uytewael's paintings. Instead, it is still overshadowed by erotic notions. As J.A. Emmens has shown, poultry was associated at the time with the Dutch word *vogelen* ('to catch birds') – a colloquial expression meaning 'to have sexual intercourse.' When fish, carrots, etc. were shown in paintings, these were partly understood as obscene allusions to phallic symbols.[47] The erotic component is confirmed by the flirtatious behaviour of the couple seated on the ground. They are probably part of the domestic staff, who were generally looked down upon by their masters as lazy, lecherous and depraved.[48]

The connection between kitchen scenes and the biblically motivated subject of the feast is also present in Pieter Cornelisz van Ryck's large-format *Kitchen Scene* (pp. 42/43) from 1604.[49] The painting has a moral message. The luxurious spread with extravagant quantities of fresh beef, mutton, poultry, crayfish and venison is to provide a contrast with the invitation to the poor who can be seen in the background, behind a double arcade. The wasteful economy at the households of the landed gentry and the merchant classes is thus being criticized as incompatible with Christian ethics. Also, there is the associative connection be-

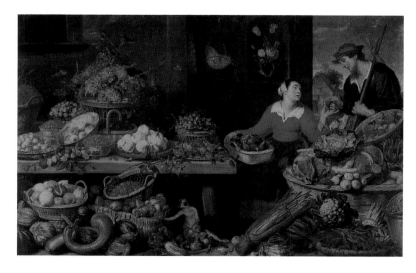

Frans Snyders (1579-1657)
Fruit and Vegetable Stall,
undated
Oil on canvas, 201 x 333 cm
Alte Pinakothek, Munich

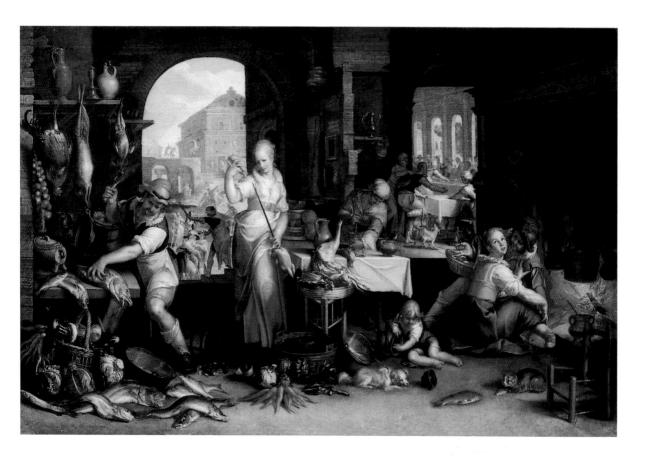

tween fresh meat and eroticism (*voluptas carnis* or, as Luther put it, the 'wilful wickedness of the flesh'). Ancient notions of magic probably played a part, too, whereby a person's libido could be influenced by the consumption of meat. Not surprisingly, therefore, a toothless old woman can be seen in the left-hand corner of the painting, touching the leg of mutton which is being held by the young servant girl. The girl's bodice is half open, and the ugly old woman is a realistic depiction of a contemporary *meretrix* or matchmaker.

It is difficult to say with any certainty which scene is depicted in the background of Adriaen van Nieulandt's *Kitchen Scene* (p. 45).[50] It may well be the story of an epileptic 'with an evil spirit,' recorded several times in the Bible. The action in the foreground may then be related to it by the fact that the exorcized 'demons' often took possession of animals. But whichever interpretation we may prefer, there can be no doubt that – as in Ryck's painting – the freshly killed animals, and particularly the chicken being plucked by the young woman with the low neckline, are symbolic indications of the temptations of the flesh.

Compared with Nieulandt and Ryck, there is a considerable reduction in the amount of action in the painting nowadays ascribed to Frans Snyders (1630-40, p. 48). It shows a cook preparing a meal and is set in a basement room. The woman is grinding spices with a pestle and mortar – there is a rolled-up bag full of cloves[51] on the table in front of her – to improve the flavour of the vegetables (artichokes, asparagus and red turnips) and the different roasts. The artist's macabre sense of humour prompted him to depict the rabbit (on the left), both paws

Joachim Antonisz Uytewael
Kitchen Scene, 1605
Oil on canvas, 65 x 98 cm
Gemäldegalerie, Staatliche Museen, East Berlin

PAGE 42/43:
Pieter Cornelisz van Ryck
Kitchen Scene, 1604
Oil on canvas, 189 x 288 cm
Herzog-Anton-Ulrich-Museum, Brunswick

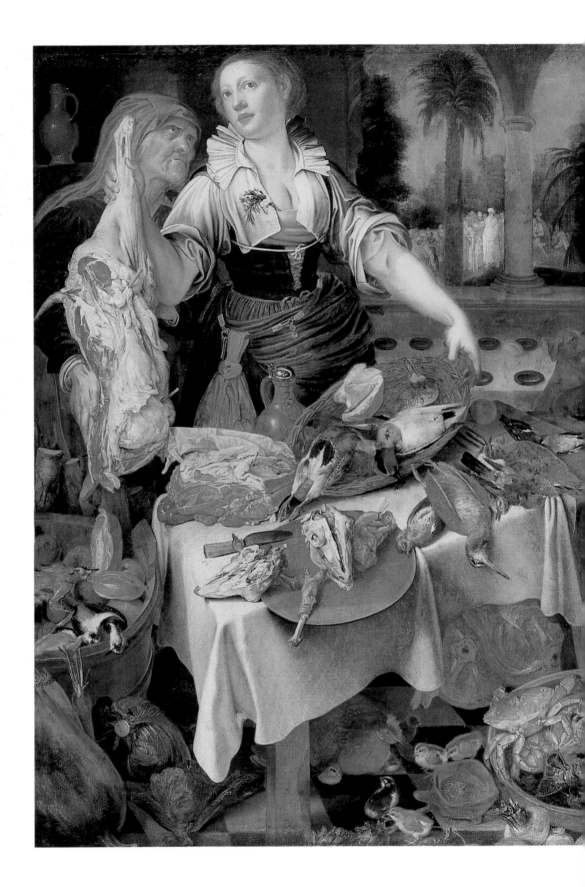

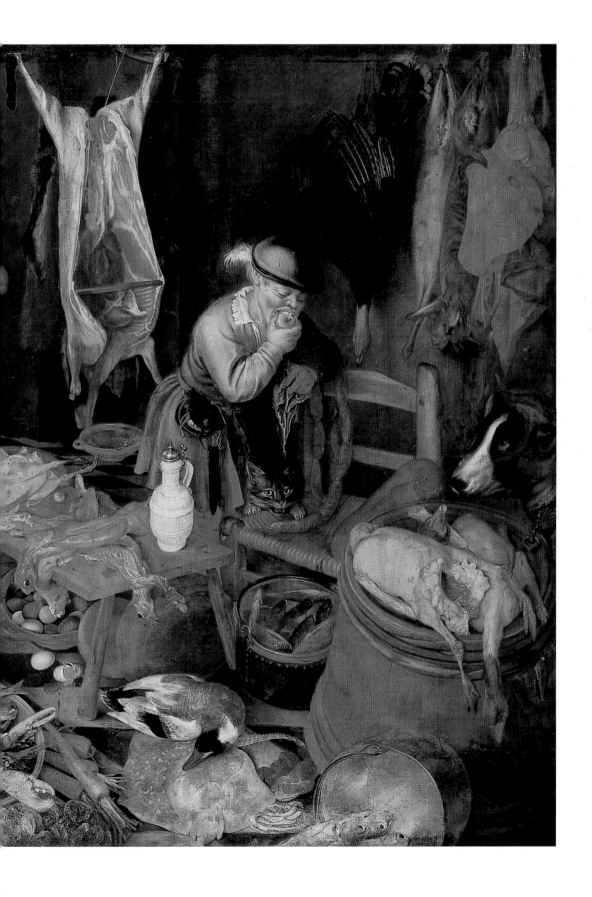

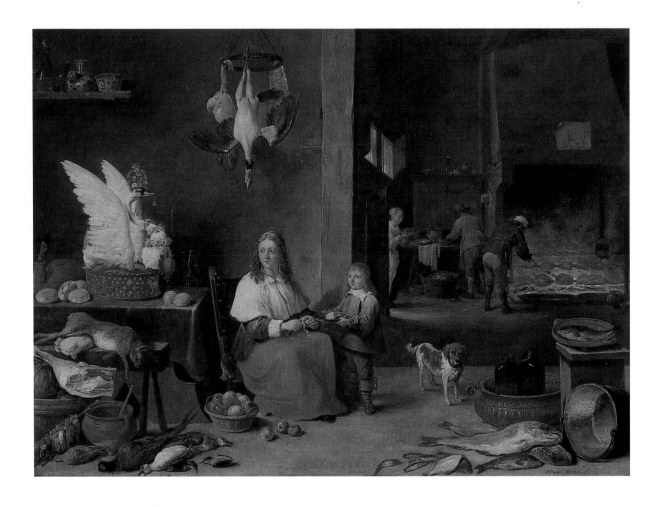

stretched out and flexed, as if with rigor mortis. Desserts have been placed on the shelf at the back, including a pie, lemons (one of them halved), a china bowl with strawberries and a bulging greenish jug which matches the two glasses with knob handles, hardly noticeable against the dark background.

It was part of the ceremony of a 17th-century aristocratic feast to include artistically moulded creations made from luxury food or shaped as pies. These formed part of *display meals* which – as the name suggests – were indeed intended rather to delight the eye than the palate. On the other hand, it was also possible to combine both. Adriaen van Utrecht's *Kitchen Scene* from 1629[52] or David Teniers the Younger's painting, now in The Hague, from 1644 (p. 44)[53] each contain a swan pie – a festive decoration which has apparently only just been finished in the kitchen. Underneath the swan there was a real, edible pie (though probably not made from the flesh of a swan, which would have tasted rather too oily). The swan itself consisted of the stuffed bird, decorated with a crown. Teniers' painting contained allusions to the political situation at the time. The crust of the pie is decorated with the double eagle of the House of Hapsburg, and suspended from the swan's neck there is an emblem showing folded hands and a burning heart as symbols of the Christian faith. Teniers had in fact painted the picture before he began to serve as court painter under the Archduke Leopold William in 1651, so

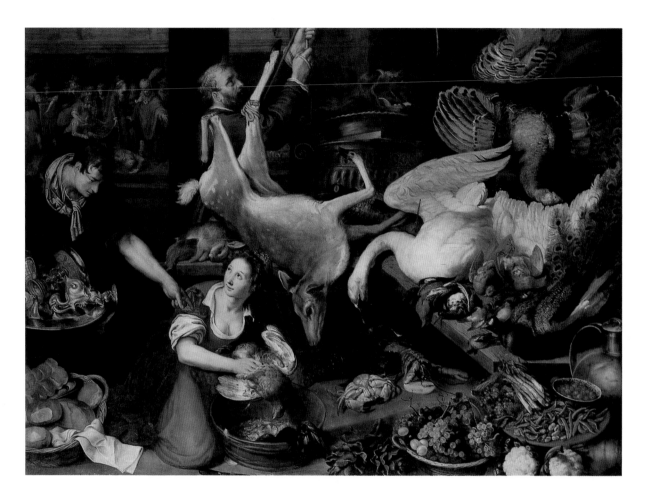

that the earlier title *The Kitchen of the Archduke Leopold William* is probably inappropriate. Nevertheless, the artist does indeed pay homage to the Hapsburgs in this painting and in fact at a historic time when peace negotiations were beginning in the Holy Roman Empire. The emblem of the folded hands seems to refer to the intention of concluding a peace treaty, though with the assumption that the other side would accept the intention of the Hapsburgs to reintroduce Catholicism, represented by the burning heart. Interestingly, however, this emblematic swan, which is intended as a conversation piece for courtiers during a show meal, has not been placed by Teniers in its intended environment, the dining room of a palace, but is shown in the kitchen as a product of the lower classes, the kitchen staff.

Bodegones

With the southern Netherlands remaining under the rule of the Spanish House of Hapsburg, it was inevitable that the influence of Flemish and Dutch art continued to have a lasting effect on Spanish painters. Kitchen scenes, for example, which had been introduced as a genre by Aertsen and Beuckelaer, were soon being painted by artists like Diego Velázquez. Francisco Pacheco and

45

Antonio Palomino described Velázquez's early Seville paintings (1617-23) as *bodegones*, and both art historians emphasize the innovative character of these paintings. Palomino has established a scholarly link between Velázquez and the ancient Greek painter Piraikos, whom Pliny had given the nickname *rhyparographos*, that is, a painter of common or ordinary subjects. Apparently, the problem of the normative differentiation of genres had not yet presented itself at the time. With his bodegones, says Pacheco, Velázquez found a way of "faithfully imitating nature."[54] According to tradition – though this may not be authentic – Velázquez himself stated that he preferred "to be the first with ordinary themes to being the second with sublime ones."

In Velázquez's early paintings the influence of Caravaggism is distinctly noticeable. He, too, used a dark backdrop with light coming in from the side, so that people and objects are brightly illuminated in places and cast hard shadows. The nuances of light can be seen very clearly in his painting of an *Old Woman Poaching Eggs* (1618, p. 46): the intensive brightness of the light shows the face of a woman, with a white linen scarf which makes her appear pale and weak, while the skin of her hands is almost leathery and seems to be shaded differently, depending on the distance of her hands from the light source. On the table in the bottom right corner a number of still life elements form a coherent group: a white enamelled bowl with a knife laid across it, throwing a harsh shadow, a brass pestle and mortar, a red onion, an earthenware jug with black glaze running down its side and a milk jug with white glaze. The woman is cooking poached eggs in a clay vessel filled with hot water on a hotplate. On the left, a boy with a serious expression on his face is looking out of the painting. In his left hand he is holding a carafe of rosé which reflects the light, and he is clutching a honey melon with his right. With a thin cord tied round it, the

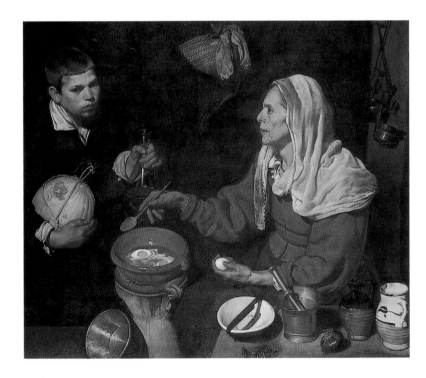

Diego Velázquez
Old Woman Poaching Eggs, 1610
Oil on canvas, 99 x 117 cm
National Gallery of Scotland, Edinburgh

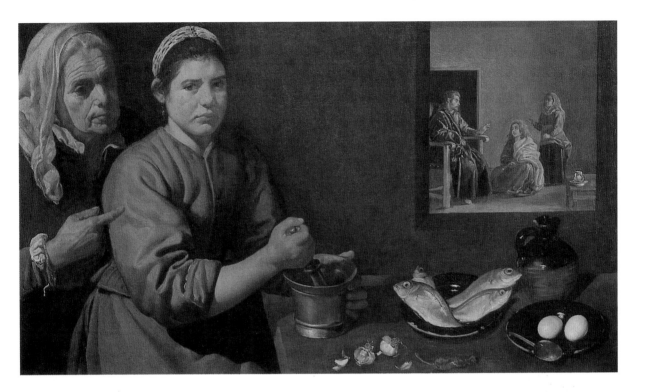

melon resembles an Imperial orb. Beside the hotplate, on the left, is a shiny copper pot lying on its side. This is an element which later became an independent motif in still lifes, as in paintings by Cornelis Jacobsz Delff. In Delff's Munich still life,[55] the glowing reddish coppery shade of the metal vessels spreads a gleam of light which also shines on the depicted food. Chardin, too, likes using the motif of the copper pot on its side.

Velázquez's bodegones also include his *Christ at the House of Martha and Mary* (p. 47) from 1618, named after the scene in the background (cf. Luke 10:38-42) – an oddly ambiguous scene which could be a picture within a picture or a mirror motif, or a view through a window-sized aperture into a room at the back. This principle of reversing a sublime main motif and a trivial secondary one may well have come to Velázquez from Aertsen, via an etching by Jacob Matham.[56] A young servant is crushing a clove of garlic with a pestle and mortar, in order to season the four fish arranged in pairs on a plate. It is obviously a Lenten meal, emphasized further by the two eggs on the second plate. The older woman's gesture, with her index finger stretched out, is probably meant as a warning that being busy and diligent and leading an active life (*vita activa*) are not in themselves sufficient. What is also needed is the *vita contemplativa*, that is, sincere devotion and strong faith – the 'better part' as chosen by Mary.

Diego Velázquez
Christ at the House of Martha and Mary, 1618
Oil on canvas, 60 x 103.5 cm
National Gallery, London

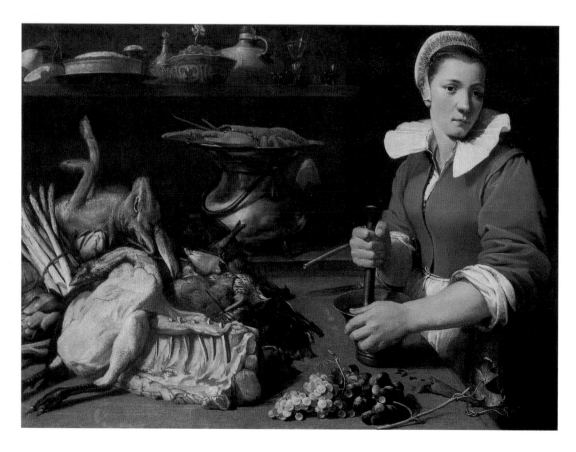

Frans Snyders
Cook with Food, c. 1630/40
Oil on canvas, 88.5 x 120 cm
Wallraf-Richartz-Museum, Cologne

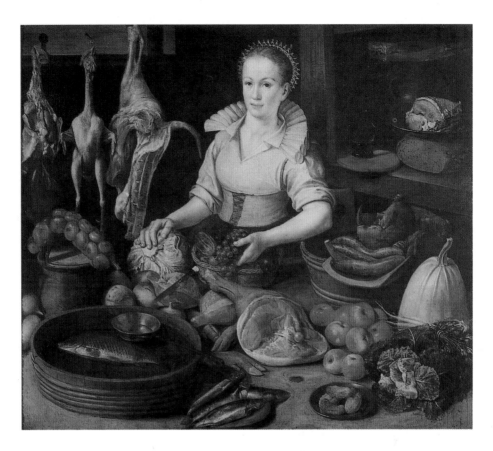

Pieter Cornelisz van Ryck
Kitchen Scene, c. 1628
Oil on wood, 116 x 134.5 cm
Museum voor Schone Kunsten, Ghent

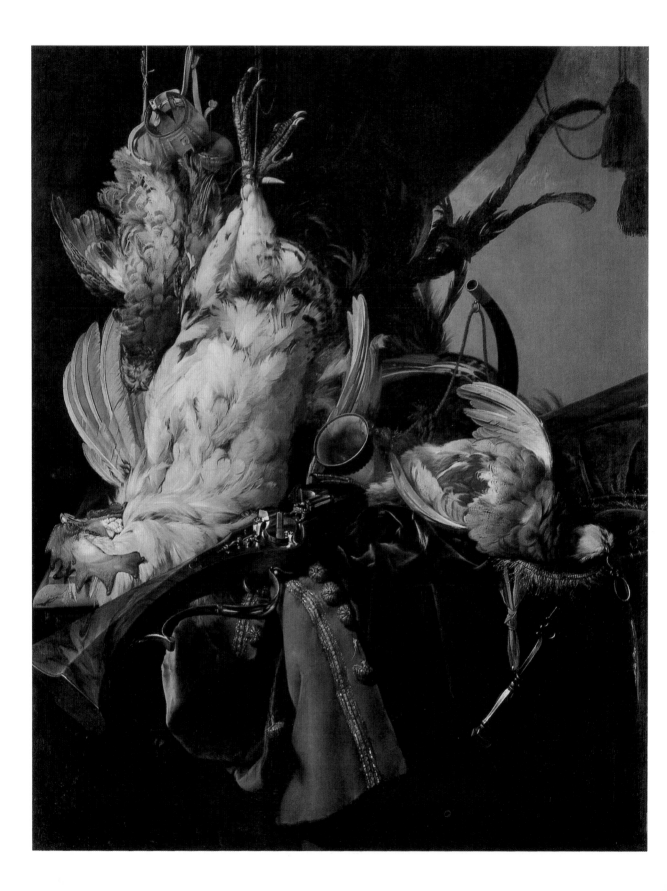

4 Game Still Lifes

Game still lifes were closely connected with kitchen scenes and pantry motifs, of which they were in many ways a special form. While the social context of a kitchen is not always obvious and may be either the household of the landed gentry or the merchant Patrician classes (peasant households were very rarely depicted), the majority of early, large-format game still lifes reflected the interests and spheres of royalty and nobility. The hunt as an aristocratic privilege had only just begun to emerge at the beginning of early modern times. Medieval German law had still given every free-man the right to hunt for game wherever he pleased, but when the sovereignty over territorial states passed into the hands of the princes, they were increasingly given authority over the forests with the right to hunt. These princes also had the right of ownership to all unclaimed property and passed their hunting rights to the aristocracy in the form of royal prerogatives. The legal basis of this process was the adoption of Roman Law in Germany, and it was completed by around 1500. This caused far-reaching social conflict, because under 15th-century law the 'common man' or peasant had still been permitted to hunt for wild boar and now he was deprived of any hunting rights whatever. The princes reserved themselves the rights for the so-called big game, while the aristocracy and the higher clergy were allowed to hunt for small game. The enormous meat requirements of the courts – meat being the most important food at that time – meant that several times a year chase hunts took place in which the peasants' fields were devastated and their seed destroyed. This damage to their land considerably aggravated the desperate situation of the country population who were already on the verge of starvation and unable to defend themselves. Moreover, the country folk were legally obliged to provide unpaid accommodation and food to members of the hunt, as well as to their hounds. The royal passion for hunting was in fact one of the central charges made by the rebellious peasants on the eve of the Great German Peasants' War, and one of their Twelve Articles proclaimed that "all game, animals, birds and fish are free".[57] Driven by hunger and want, many a poor peasant claimed the 'old law' and went hunting. This, however, made him a 'poacher' according to the new game law and he risked harsh punishment, for example, being sent to the galleys.

To provide, as it were, a visual seal for the new legal conditions, hunts in the 16th century were captured in the form of large-scale panoramic paintings which were mainly documentary in character, such as the *Stag Hunt of the Elector John Frederick* (1544) by Lucas Cranach the Younger (p. 53). Also, there were numerous glorified transpositions of real hunting scenes into mythological ones: Jan Brueghel the Elder's *Forest Landscape with Nymphs*

Detail from illustration page 58

Willem van Aelst
Still Life of Dead Birds and Hunting Weapons, 1660
Oil on canvas, 86.5 x 68 cm
Stiftung preußischer Kulturbesitz, Staatliche Museen, Berlin

and Kill (p. 56) shows a clearing – the 'battlefield' – with the dead animals, known as the 'kill.' There are also donkeys carrying dying stags on their backs. Unlike this painting, which affords a comprehensive, panoramic survey of the entire hunting scene, game still lifes are limited to relatively narrow subjects. The works of the Flemish painter Frans Snyders, who specialized in this motif, are particularly typical.

From 1608, when Snyders had become master of the Guild of St. Luke in Antwerp, he cooperated very closely with Jan Brueghel the Elder and Peter Paul Rubens, contributing animal motifs to many of their paintings. Conversely, his fellow artists were responsible for the addition of some of the characters in Snyders' paintings. Characteristically, his still lifes are in fact not *nature morte* pictures. Rather, the dead animals are there to provide an intentional contrast to animate creatures (p. 59). Often a cat can be seen creeping up from the side, or a dog is sniffing the venison which seems to have been casually and accidentally cast aside. In fact, its position on the shelf shows that the artist put a great deal of thought into the arrangement of the table, which is seen at close quarters and parallel to the horizontal edges of the painting. As well as making a visual impression, Snyders' paintings also appeal aesthetically to other senses, such as smell and touch. The animals are usually shown by Snyders at a stage before being prepared for consumption; only occasionally do we come across flesh which has already been skinned and roughly cut up. His paintings therefore look like collections of hunting trophies which are often not even meant for consumption, but rather for stuffing. After all, it is a well-known fact that the oily meat of a fully-grown swan, as painted repeatedly by Snyders, is not even fit to eat. (Nevertheless, we do find a passage in François Rabelais, quoted by Fernand Braudel,[58] where feathered game such as herons, great white herons, wild swans, bitterns, cranes, young partridges, bustards, quails, wild and domestic doves, pheasants, thrushes, fat larks, flamingoes and coots are considered ideal for consumption. However, rather than taking this as a realistic description, we should make allowances for the hyperbolical manner of Rabelais's satirical style!)

In Snyders' *Still Life with Poultry and Venison* (p. 59) the white swan, with its neck hanging down listlessly, is in contrast to the intensive vermilion of the carpet on the table with its ornamental edge. Beside the swan there is an eagle, deprived of all the strength that characterized it in life. Its beak half open, the eagle's head nestles against the chest of the swan, which is stretched out on its back with its wings open. Here two animals are united in death, of which Pliny the Elder said in his *Natural History* (X:203, as did Aelianus and Albertus Magnus[59]) that they were bitter enemies: the swan (a symbol of fearlessness) was not afraid of fighting off an attack by the eagle and often emerged victorious. On the left, placed on top of one another and difficult for us to disentangle, are the bodies of other birds, including a heron, a stork and a peacock, with its tail forming a diagonal line. On the little bench, which is next to the basket full of grapes and protrudes at a slight angle, are the smaller game birds, such as pheasants and songbirds. None of the birds show any traces of the shooting on their bodies; it all seems to have been absorbed by the colour of the carpet. The only hunting motif is the head of the wild boar on the board that half covers a box full of artichokes, and the animal's blood oozing from its head is the only reminder of the crudely brutal side of hunting. Although this 'victory' over nature is not free from the barbarism of unrestrained sensual delight, we can already find the first

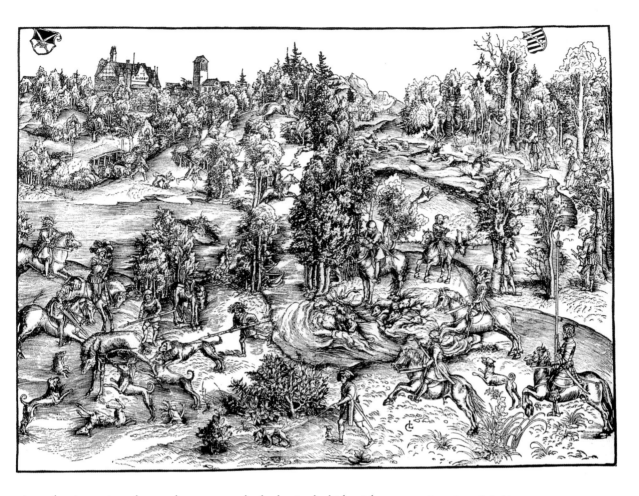

signs of an increasing taboo on those aspects of a dead animal which might cause horror or revulsion. And it was probably not without a certain macabre sense of humour that Snyders placed a couple of guinea fowl in the bottom right-hand corner. As the only survivors, who do not themselves live in the wild, they seem engaged in conversation, reflecting upon the fate of the tall, proud birds who have been snatched away by death. A peculiarly strong contrast is provided by the scene on the staircase, separated from the foreground by an inner courtyard, where a messenger is handing a letter to the lady of the house. This architectural context identifies the setting as that of the landed gentry, and indeed the killed animals are, – according to Veit Ludwig von Seckendorff's classification,[60] part of the 'big game' which only princes are allowed to hunt (Seckendorff lists stags, wild boars, bears, black grouse, roe deer, bustards, black grouse, hazel hens, swans and pheasants).

That the ostentatious display of killed animals had a representational and symbolic function for the landed gentry can also be seen in later game still lifes, such as the gigantic three-part painting by Jan Weenix of 1703-16 at Schloss Bensberg, where it hangs in the audience chamber as well as two ante-rooms (pp. 54/55). When Goethe visited the stately home in 1774, he noted with admiration in *Dichtung und Wahrheit* ('Poetry and Truth,' volume 14), "What delighted me there beyond all measure were the mural decorations by Weenix ... All around and neatly arranged as on the plinth of a large columned hall, there was every animal the hunt could yield; above them, in the distance, one

Lucas Cranach the Younger
Stag Hunt of the Elector John Frederick, 1544
116 x 176.5 cm
Kunsthistorisches Museum, Vienna

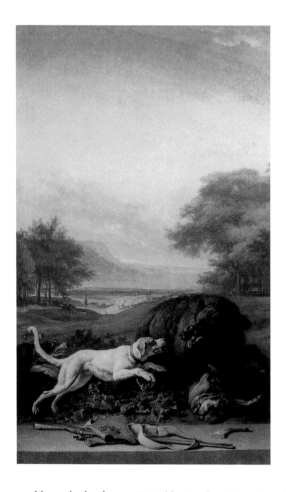

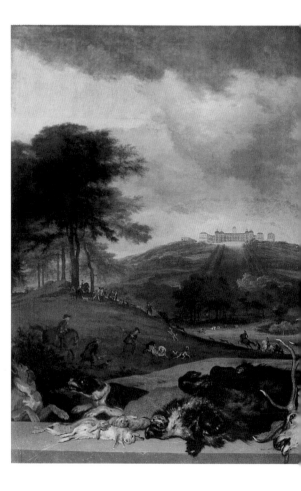

could see the landscape."[61] Unlike Snyders, Weenix no longer creates an impression of excessive abundance. The wastefulness of 16th and 17th-century economy, which was still marked by the excessive consumption of meat, has already made way for qualitative refinement. This can be seen particularly clearly in the decorative presence of the animals suspended from a slender little tree behind the parapet – the parabolically shaped stag, hanging head down, and the hares. This tendency towards elegance and genteel, aristocratic culture is further emphasized by the hunting pavilion on the right, built in the style of classical antiquity and – in the shade – the mythological statue (probably Hercules with a cudgel) by the entrance. In Snyders' art, principles of aesthetic composition had already begun to acquire a measure of independence in relation to the depicted situation, and they became increasingly dominant during this early phase of the 18th century: shifted slightly to the right of the centre, the stag and the hare form a *figura piramidale* – an arrangement which enhances the impression of depth, thus serving as a repoussoir, with the hill with the hunting lodge in the background.

The motif of a dead animal hanging upside down – an actual hunting custom – had been taken over by Weenix from his father Jan Baptiste Weenix. His father, in turn, had been inspired by an even older tradition, particularly in his *Dead Partridge* which was intended as a trompe l'œil (p. 60), and this older tradition can be traced back as far as Jacopo de'Barbari and Lucas Cranach the Elder. Such dead animals can also be found in paintings by another Amsterdam

Jan Weenix
Game Still Life Before a Landscape with Bensberg Palace, 1703/16
Oil on canvas, 345 x 561,5 cm
Alte Pinakothek, Munich

LEFT:
Jan Weenix
Boar Hunt, 1703/16
Oil on canvas, 345 x 206 cm
Alte Pinakothek, Munich

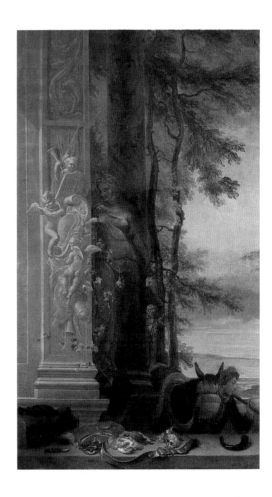

painter, Willem van Aelst,[62] who was born in Delft in 1627. In addition to fruit and flower still lifes with cool colour harmonies, he also enjoyed painting elegant hunting weapons and dead animals placed in a dark corner by a wall for rich clients. One example is the still life bought by Margravine Karoline Luise von Baden at The Hague (p. 58). A dead partridge is hanging by its leg from a piece of string. Its wings and feathers, which are grey with brownish patches, open up towards us at the bottom like a fan. The fly on the light-coloured feathers has an illusionist effect: disproportionately large in size, it belongs to the realistic level of the picture rather than its fictitious one, so that the viewer is given the impression that a real fly is crawling across the painting. The bird's head has been pressed slightly towards the middle by the blue hunting bag with the golden fringe and the adjustable shoulder strap which is lying on the stone shelf. Beside the partridge a hunting horn, also adorned with tassels, and a powder bottle have been hung up. The shiny, metallic grey of the hunting horn has been painted by the artist with a highly sensitive eye for the different hues of the bird's fluffy, grey feathers on its breast and as a contrast to the grey of the wings which merges into white towards the middle. But, although the bird has been rendered with almost unsurpassable precision, it has an odd abstract quality. It seems as if, in its material consistency, it had undergone a synthesis with the implement of civilization by which it was pursued – as if it was no longer merely part of nature and a victim, but an aesthetically refined and ennobled form of existence.

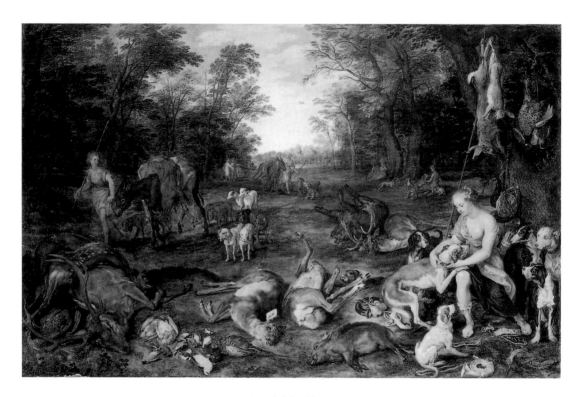

Jan Brueghel the Elder
Forest Landscape with Nymphs and Kill, 1620
Oil on oakwood, 63 x 98 cm
Alte Pinakothek, Munich

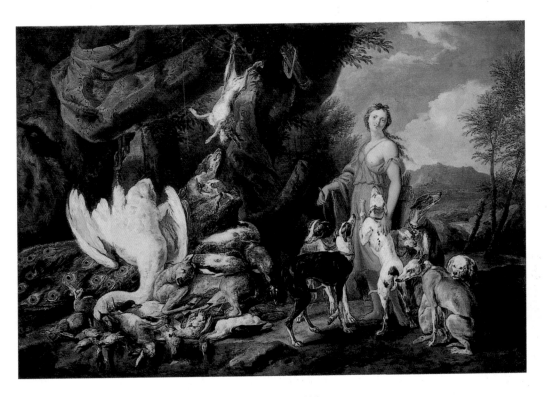

Jan Fyt (1611-1661)
Diana with Her Hunting Dogs Beside Kill,
undated
Oil on canvas, 79 x 116 cm
Stiftung preußischer Kulturbesitz, Staatliche
Museen, Berlin

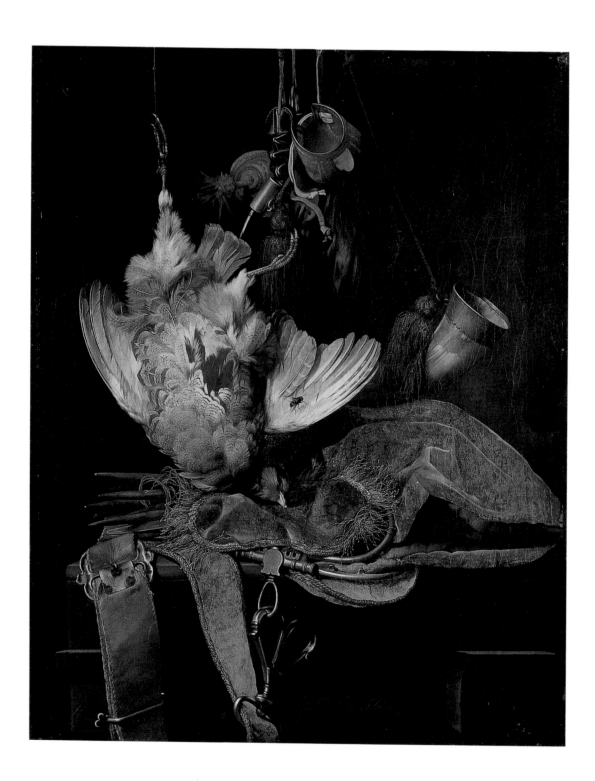

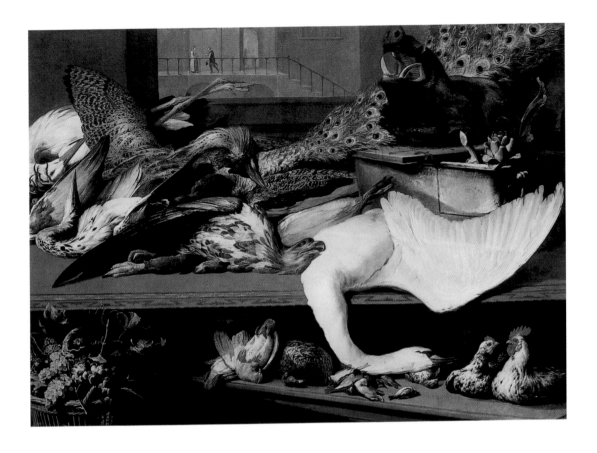

Frans Snyders
Still Life with Poultry and Venison, 1614
Oil on canvas, 156 x 218 cm
Wallraf-Richartz-Museum, Cologne

OPPOSITE:
Willem van Aelst
Still Life with Hunting Equipment and Dead Birds, 1668
Oil on canvas, 68 x 54 cm
Staatliche Kunsthalle, Karlsruhe

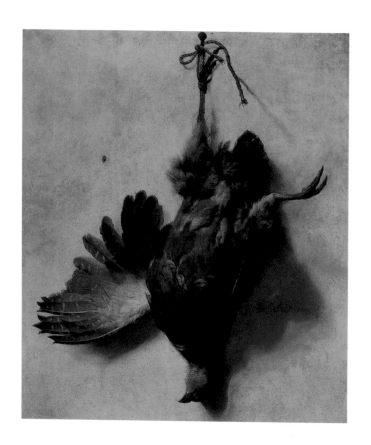

Jan Baptiste Weenix (1621 – c. 1660/62)
Dead Partridge, undated
Oil on canvas, 50.6 x 43.5 cm
Mauritshuis, The Hague

OPPOSITE:
This still life was painted by the artist during his later years. In 1728 he was accepted as a painter of animals and fruit at the Paris Academy of Art without having to fulfil the usual requirements. The structure of this painting is simpler than in his earlier still lifes, and Chardin has reduced the number of objects to a minimum. By singling out and thus monumentalizing the motif of the bird, Chardin gives it considerably more emphasis. According to the categories of feudal game law, the pheasant was seen as reserved for nobility, but the hunting trophy which has been attached to the pheasant has, from a bourgeois point of view, lost its value of triumphantly demonstrating man's lordship over nature. – However, the way in which the pheasant is rendered does not indicate in any way that colour is gradually becoming detached from the object. Rather, the careful, delicate application of the paint – even in the more roughened structures – heightens the element of sensitive empathy. Unlike the game still lifes of his contemporaries Jacque Bachelier and Jean Baptiste Oudry – which have a smooth, cold objectiveness about them – the artist has created an atmosphere of intimacy between the viewer and the object.

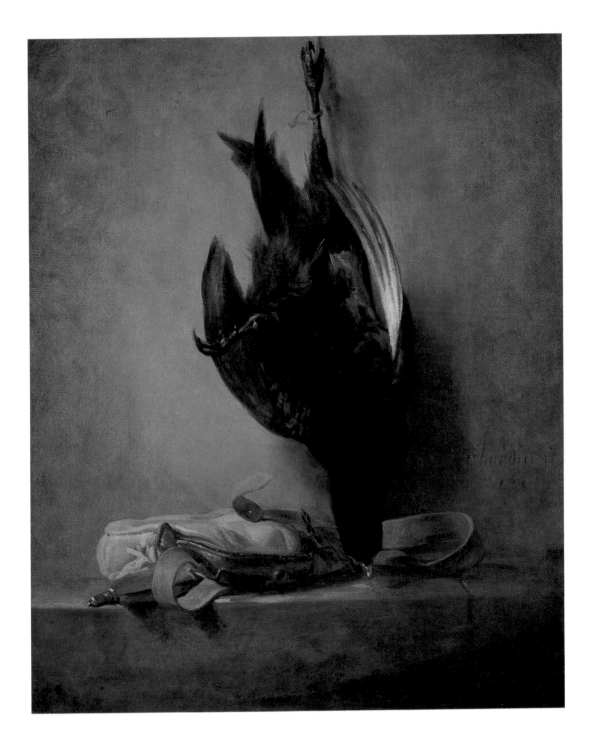

Jean-Baptiste Siméon Chardin
Still Life with Dead Pheasant and Hunting Bag, 1760
Oil on canvas, 72 x 58 cm
Stiftung preußischer Kulturbesitz, Staatliche Museen,
Berlin

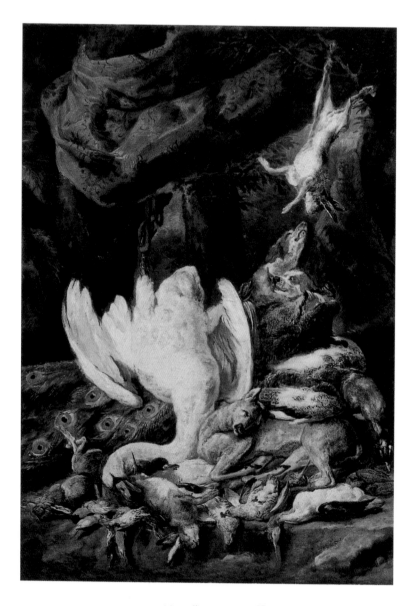

Detail from illustration page 57

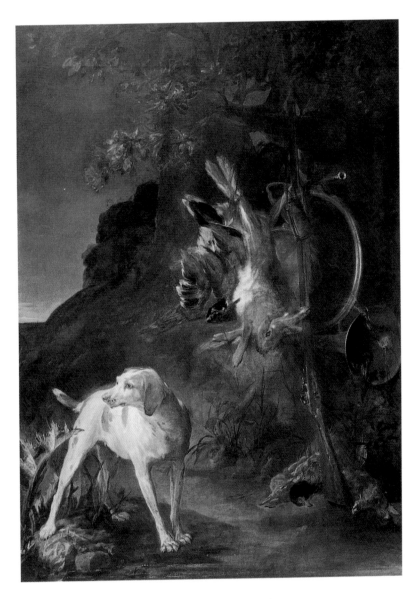

Jean-Baptiste Siméon Chardin
Game Still Life with Hunting Dog, c. 1730
Oil on canvas, 172 x 139 cm
Formerly Ramon J. Santa Marina Collection,
Buenos Aires

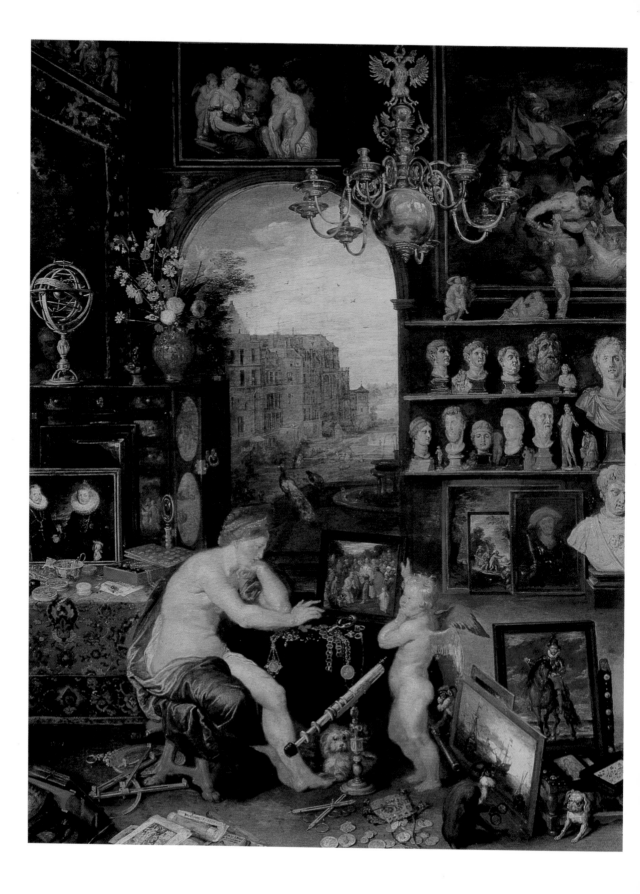

5 Depictions of the Five Senses

The still life elements in early market and kitchen scenes give evidence of the new needs and desires brought about by changes in the manufacturing process. Spread out in lavish abundance, the products which are on display vie for the viewer's attention and arouse new cravings in him, albeit within a purely fictitious sphere and with illusionist methods. It is worth noting that Pieter Aertsen and Joachim Beuckelaer enjoyed adding tactile qualities to their paintings – local colours that make us want to touch the objects in the paintings (cf. pp. 26 and 27). To the contemporary viewer who had never encountered such artistic standards before, the objects must have seemed extremely tangible and therefore reminiscent of the Grapes of the Zeuxis,[63] an oft-related tale at the time.

This amazing increase in the commercial and agricultural product range caused a complete restructuring of people's perception – a change which can be seen very clearly in numerous paintings and series of paintings on the subject of the Five Senses. They are documentary evidence that the stimuli provided by the new range of luxury goods triggered off a compulsive urge in the viewer to enhance his own sensual pleasure and to keep increasing his long-term needs. Jan Brueghel the Elder's famous variations on this motif – now at the Prado (pp. 64-69) – show a number of settings, each of which is associated with the five senses. The dramatic 'unity of character' has been divided into the components of the senses, thus reflecting an increasing compartmentalization of the world into functional spheres – a world which is defined in terms of luxury goods. The philosopher and theologian Nikolaus von Kues still emphasized the sensory unity of character: he saw it as that of a perfect sensual creature and compared it to a cosmographer who owns a city with five gates. These are entered by 'messengers from all over the world with accounts of how the world is constructed.' Students of Nikolaus von Kues would regard the aspect of sensory perception as important, but not yet that of consumption.[64]

In Jan Brueghel the Elder's paintings, the part of purely passive reception or physical consumption is played by an allegorical female figure. Interestingly, by depicting her naked or semi-naked breasts and sometimes her entire body, the painter emphasizes an element of eroticism. In this way the consumption of luxury goods and an emotional state of ecstasy are recognized as a syndrome. Furthermore, the paintings are meant to show that luxury is entirely due to the desires and needs of privileged women – a view which was later formulated as a theory by Werner Sombart,[65] though with such exclusiveness that it can hardly be regarded as tenable. Of course, the allegories of the senses need not necessarily have been represented by women, as the grammatical gender

Detail from illustration page 66

Jan Brueghel the Elder
Sense of Vision (detail), 1618
Oil on wood, 65 x 109 cm
Prado, Madrid

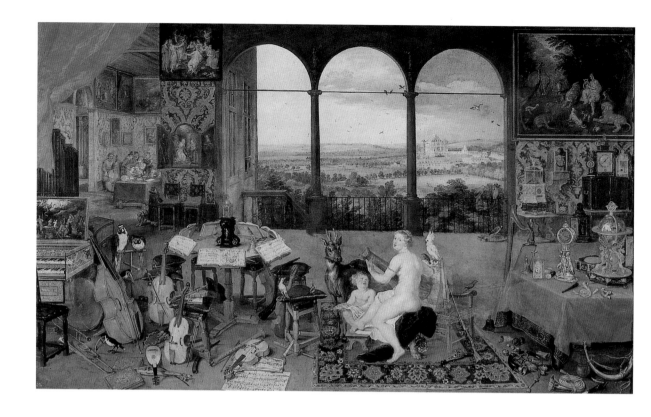

of the senses (*visus, odor*) is masculine – at least in Latin. Jan Brueghel the Elder[66] depicted model situations of consumer habits within the household of a feudal residence. Many of his paintings include a view in the background, through colonnades, of gardens and stately homes, creating the impression of extensive manorial landed property, as in the painting devoted to *gustus* (*Taste*, p. 67). Fish, fruit and hunting trophies are piled up in the foreground and behind them, parallel with the top and bottom edges of paintings, we can see a lavishly set table with swan and peacock pies, a bowl of oysters, crayfish and fruit. In front of the table, at an angle, there is a dessert bowl full of sweets. The personification of Taste is being served wine poured from a jug by a Satyr. In two other paintings, Jan Brueghel the Elder depicted 'visus' and 'odor' (*Vision* and *Smell*, pp. 64 and 68/69): Vision is shown in the form of an art and wonder chamber, as a kind of walk through a long gallery flooded by sunlight through its covered skylight windows, so that light is shown as the physical equivalent of visual perception. The sun-like quality of the eye had already been commented on by Plotinus (*Enneads* 1, 6 and 9), who said that this was the reason why man could perceive light – a thought which was later put into verse by Goethe in his *Tame Xenia*: 'If the eye were not sun-like, it could never behold the sun.'[67] Hanging on the walls or leaning against them are paintings from a collection with ancient sculptures in front of them. Rows of Roman busts have been placed on long shelves. In the foreground a woman, as an allegory of *visus*, is sitting at a round table, somnolently looking at a painting. Vision, as one of the five senses, also includes astronomical implements such as the telescope and the astrolabe, as developed by Martin Behaim and Johann Regiomontanus. These were used on voyages of discovery, where they were of great importance for the

Jan Brueghel the Elder
Sense of Hearing, 1618
Oil on wood, 64 x 108 cm
Prado, Madrid

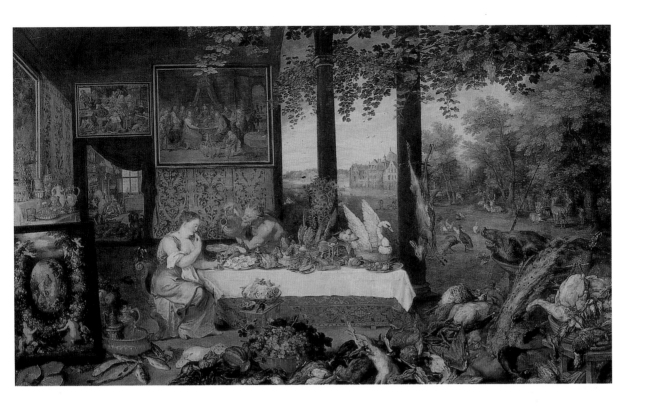

gathering of exact geographical, nautical and astronomical data. In the other painting, the sense of smell is embodied by a nude woman, seated, with her head slightly inclined and smelling a flower from a large bunch behind her. The flower is being handed to her by a cherub.

Depictions of the Five Senses had their parallels in early modern theories of human emotions, as taught by Juan Luis Vives, Geronimo Cardano, Bernardino Telesio, Juan Huarte, Thomas Hobbes, Baruch Spinoza and René Descartes.[68] It is worth noting that these psychological or anthropological theories put the emotion called *appetitus*, that is, desire or covetousness, at the very top. Hobbes defined emotions entirely in terms of the tension between desire and disgust ('appetitu et fuga constant', *De Corpore*, c. 25, 12). Spinoza saw emotions as psycho-physical states of an organism whose strength they either increased or reduced.

However, emotions brought about by the sensual stimuli of luxury goods are not necessarily pleasurable, and refinement does not automatically lead to unsullied delight. This, according to Hendrik Goltzius (1558-1617), is the warning contained in the series of engravings by Jan Saenredam (1565-1607, p. 70).[69] Their critical tenor must be understood against the background of middle-class morality and its disdain of the unfettered self-indulgence of the landed gentry. The mixture of consumerism and eroticism is particularly dominant in the paintings of lovers: the message of these paintings was that love at court and among the aristocracy seemed to be virtually impossible without the alluringly attractive mediation of precious objects (mirrors, musical instruments and expensive flowers and fruits). These objects, however – it is claimed in the titles –

 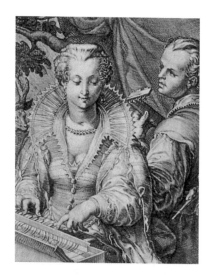

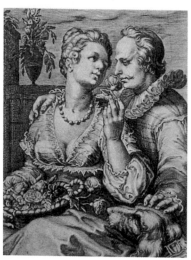 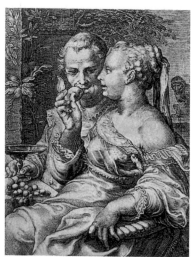

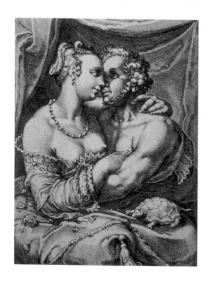

Jan Saenredam (1565-1607)
The Five Senses
Series of copper engravings after Hendrick
Goltzius, 17.6 x 12.2 cm each
(F.W.H. Hollstein, Dutch and Flemish
Etchings, Engravings and Woodcuts ca. 1450-
1700, Amsterdam, undated, volume VIII, p.
136)

promote vice and, instead of causing pleasure, they actually cause feelings of aversion.

Saenredam's *Vision*, for example (top left) warns against the wantonness of those 'little eyes' (*ocelli*) and the danger of vice to which youngsters, in particular, can easily fall prey. The sense of *Hearing* (top right), symbolized by two lovers playing a virginal and a lute, is associated with the sounds of the 'flattering Sirens' in the Latin title. *Smell* (middle, left) is illustrated by a garden full of flowers, with two lovers sitting by a wall. The girl is allowing her lover to smell the bud of her rose, though their delight is marred by the 'galling' reference to the 'gall' (*fel*), concealed beneath the sweet smell. *Taste* (middle, right) has been allegorized by Saenredam in the form of fruit and wine. The title reminds us of the vice of *gula* (greed), which was still regarded as a deadly sin until the late Middle Ages. The monkey on the wall emphasized this aspect of greed. However, the picture is less about unrestrained gluttony than refined pleasures which trigger off 'lustful desires.' Finally, unlike the other senses, *Touch* (bottom) – allegorically represented by embracing lovers – does not contain any symbolism. Only the tortoise on the girl's knee symbolizes the attribute of *acedia* (sloth, laziness), which is believed to be the result of such love relationships.

Later, many 'pure' still lifes, in which the Five Senses are once more represented in the form of objects, display a similarly critical tendency. All property and wealth is seen as vain (i.e., signs of *vanitas*) and therefore detrimental to the salvation of a person's spiritual well-being. Occasionally, however, despite all the negative symbolic meanings of these objects, there are also some positive emphases. In Jacque Linard's still life (p. 72), for example – according to Christian Klemm[70] – hearing is clearly given a greater value than all the other senses. The open hymn-book with the words of thanksgiving 'Laudate dominum' forms a clear contrast to the reprehensible game of cards and the empty purse beside it – two objects representing the sense of touch.

Ambiguities of this kind can also be observed in a depiction of the Five Senses by Lubin Baugin (c. 1610-1665), painted in 1630 (p. 73) – a picture in which the archaic arrangement of objects seems rather meagre compared with Dutch still lifes at that time. This artist later became a member of the Académie de St.-Luc, an association of all Parisian artists who were also organized in the Artists' Guild. Baugin's paintings are dominated by aesthetic elements that reflect a strict Calvinist morality. The symbolic props have been placed very economically: a dark mirror represents vision, a bunch of carnations in a vase – smell, bread and wine – taste, a chessboard in a closed box – touch, and finally the vermilion mandolin – hearing. These are not far from a game of cards (with a Jack of Spades on top) and a tied-up purse. Similar to the *Merry Society* paintings but unlike Linard's aforementioned still life, music is regarded as morally corrupt and in opposition to the eucharistic symbols of bread and wine.

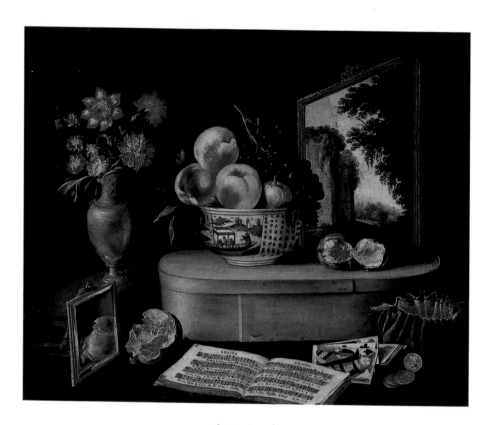

Jacques Linard
The Five Senses, 1638
Oil on canvas, 55 x 68 cm
Musée des Beaux Arts, Strasbourg

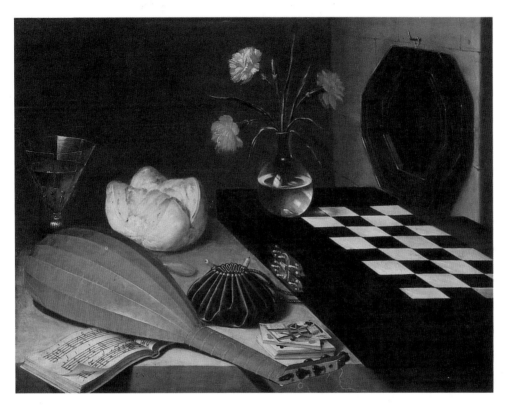

Lubin Baugin
The Five Senses, 1630
Oil on wood, 55 x 73 cm
Louvre, Paris

Ludovicus Finson
The Five Senses, 1737
Oil on canvas, 141 x 189 cm
Herzog-Anton-Ulrich-Museum, Brunswick

.Ipſe morietur. Quia nõ habuit diſci=
plinam,& in multitudine ſtultitiæ
ſuæ decipietur.

PROVER. V

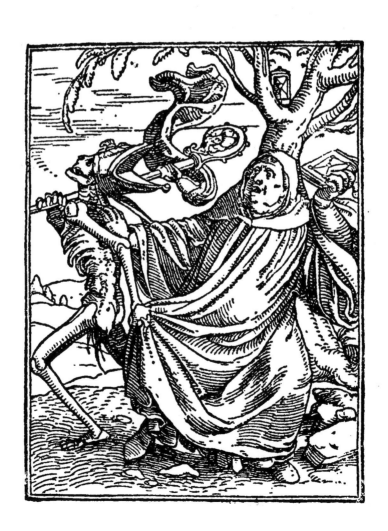

6 Vanitas Still Lifes

Just as the first flower still lifes were painted on the reverse side of portraits (such as Hans Memling's still life of 1490),[71] the same was originally true for skull motifs, which subsequently became a recurring iconographic component in a large number of variants of the still life genre. They were intended to symbolize man's mortal nature (or *mors absconditus*) and anticipate the future state of the person in the portrait.

One early example is the *Skull Still Life* (p. 77) by Jan Gossaert, also known as Mabuse. It was painted on the reverse of the left side panel of the Carondelet Diptych (1517) and shows a skull, seen slightly from below, its jaw disconnected and put to one side (as a symbol of the person's decomposition). The skull occupies a niche with a round arch, and above it there is a piece of paper which bears the inscription 'Facile contemnit omnia qui se semper cogitat moriturum. Hieronymus 1517' ('He who thinks always of Death can easily scorn all things').[72] Underneath, in the lower portion of the niche, the word MATVRA has been chiselled into the stone. The aphorism is a quotation from *Epistolae* (53, 11, 3) by Hieronymus – a church father who was portrayed particularly frequently at the time, as he was considered to be the patron of Christian humanism.[73] One thinks of the 1514 copper engraving by Dürer or paintings by Quentin Massys and his pupils. The Düsseldorf painting of 1520, by one of Massy's pupils, shows Hieronymus in a pensive posture, his right hand on his head, with the index finger of his left hand on the skull – the object of his meditation; on the wall behind him there is the inscription 'Cogita mori' (p. 81).[74]

This early church father's reflections on the subject of death are, in fact, not far removed from the materialist Epicurean ideas of the Roman philosopher Lucretius (c. 96-55 BC). This was quoted by Bartel Bruyns the Elder in his *Vanitas Still Life* (p. 22, on the reverse of Jane-Loyse Tissier's portrait of 1524) on a piece of paper in the bottom right-hand corner: 'Omnia morte cadunt / mors ultima linia rerum' ('Everything decays with death / death is the final boundary of all things'). Again, there is a niche, though this time shaped like a box. Inside the niche there is a shelf with a skull whose jaw has been placed separately beside it. In front of the arrangement is an extinguished candle to symbolize that time has run out in the person's life.[75]

This adoption of the Lucretian motto showed an extreme radicalization of Christian *ars moriendi* notions. These ideas were widespread in the late Middle Ages in the form of a moralizing anecdote called *The Three Living and the Three Dead*, as well as in dance-of-death rituals, written as dialogues, in series of woodcuts (p. 76), devotional tracts and religious writings such as Thomas à Kempis' of the *Imitation of Christ*.[76] During the Middle Ages there had still been

Jan Gossaert
Carondelet Diptych (outside), 1517
Oil on wood, 43 x 27 cm
Louvre, Paris

Hans Holbein the Younger
Death and the Abbott, woodcut from:
Les simulacres & historiees faces de la mort,
Lyon 1538

so much mutual support within the community that death was hardly a matter of fear and horror. Furthermore, medieval theologians still proclaimed a direct transition from a person's earthly life to life after death. However, from the mid-14th century onwards clergymen increasingly concentrated on the macabre side of death. To this end they made use of the devastating plague epidemics of the Black Death. The plague, however, was not the primary cause of these notions. Such large-scale epidemics had always existed, without necessarily leading to a change in the idea of death. The real background was the interest of the Church, which was undergoing one of its worst crises in history and which showed itself, for example, in the break-up of the Church into two papal churches – the Great Occidental Schism;[77] its influence on the laity was dwindling and had to be regained. For this purpose it introduced the 'drama of agony' into its theology.[78] The believer, who was branded as thoroughly sinful, could gain salvation if he spent the final years of his life in a state of continuous self-lacerating penitence and contrition. However, to achieve this he had to entrust himself to the clergy as the only instrument of absolution ('Ego te absolvo'). Not surprisingly, it was in the 14th and 15th centuries that auricular confession (*confessio oris*) before a confessor was introduced as a method of controlling all spheres of life of the laity.

But these new notions of death which enabled the Church to adopt intimidation strategies had another cause, possibly even more important than the first: during the late Middle Ages a growing individualism gradually began to spread among the intelligentsia and the merchant classes. The spread of early capitalism and its methods of trading, increasingly demanded that its concomitant functions should be fulfilled by individuals. Being 'cast back,' as it were, to one's own ego, the individual person now tended to become detached from the social structures of the community and the protection which it offered. Fur-

Theodor Galle
Opportunity Seized, Opportunity Missed, from: Joannes David: Occasio arrepta, neglecta, Antwerp 1605

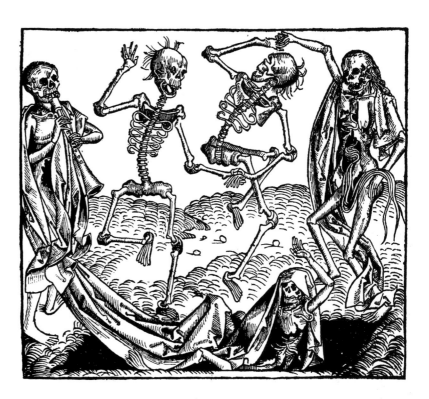

Michael Wolgemut
Dance of Death, illustration for Hartman
Schedel's *Weltchronik* (Chronicle of the
World), Nuremburg 1493

thermore, the credit system cultivated by the merchant classes was now being
applied to life itself, so that the Church could regard it as a forward exchange
transaction: life, too, was a matter of recognizing the right opportunity (*oc-
casio*),[79] and to gain eternal life one had to be converted at the right moment; at
death (p. 78).

One critical aspect which the Church would put forward as an argument
against growing capitalist structures was that the accumulation of wealth
through profit was totally meaningless – mere vanity – *sub specie aeternitatis*
(in the face of death). This notion of *vanitas* was shared in particular by the
humanist intelligentsia, a culturally conservative social class who had no share
in this wealth. It therefore became an integral iconographic part of many still
lifes depicting the luxury goods which reflected the new consumer standards.
However, they always contained an element of ambivalence so that, although
the seductively enticing lure of an object was further enhanced by a highly
refined and sophisticated composition, its attractiveness was marred again by
the ominous presence of a skull to remind the viewer of the transience of all
things. A cultural pattern had been officially introduced whereby the motif of
death was seen as creating neurotic suffering so that the unsullied enjoyment of
life was no longer possible. This pattern was to have a long-lasting effect.

The vanitas theme occurred particularly frequently during the 1650s and
1660s, the phase immediately following the Thirty Years' War (1618-1648). It
was a time when most countries were completely ruined by the enormous
expenses of the war, so that the worthlessness of their national budgets and the
small fortunes accumulated by individuals had become all too obvious. The
authorities, too, had suffered: never before had the population been so pain-

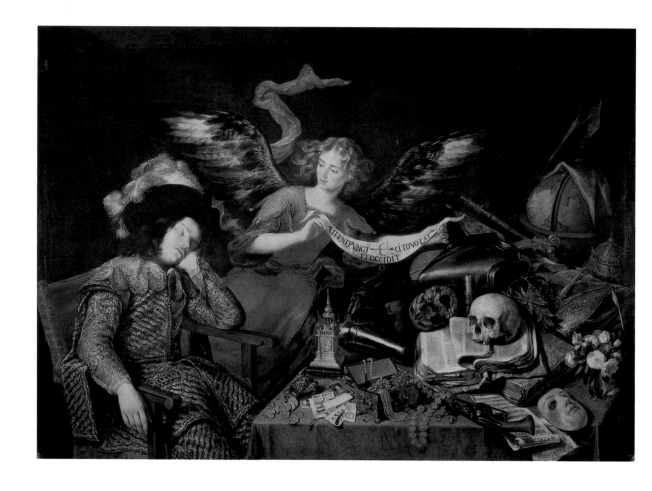

fully aware of the discrepancy between ideology (the religious motivation of the war) and reality (the ambition to conquer and make forays).

In most cases, the verdict of vanity in still lifes concerns not so much the goods that represent the acquisitiveness of the merchant classes as it does the wealth and power insignia of the rulers. It is significant that the first time the power monopoly of a king (Charles I, 1649) was broken – and he was in fact deposed and executed – it was done by Parliament. These new political constellations added a new dimension to the vanitas theme. Despite the new situation the repertoire of objects continued to be confined to external power symbols: crowns – including the papal tiara and mitres, as well as kingly crowns – and a knight's armour were always part of such still lifes, as was the globe as a symbol of worldwide expansion and a craving for conquests. Indicating the rulers' loss of legitimacy, these 'elements of vanity' are of central importance in *The Knight's Dream* (p. 80) by Antonio de Pereda (1608-1678). A young nobleman has fallen asleep in an armchair on the left, his head, pale with sleep, supported by one hand.[80] The content of his dream – the world and its vanity – is displayed on the table on the right, against a pitch-black background. Other objects of vanity, apart from the power insignia mentioned above, are books, music, coins, jewellery, weapons and a mask (as a symbol of *Thalia*; the theatre). These are all considered futile. Transience is symbolized by two skulls – one of them rolled over so that we

Antonio de Pereda (c. 1608-1678)
The Knight's Dream
Oil on wood, 152 x 217 cm
Real Academia de San Fernando, Madrid

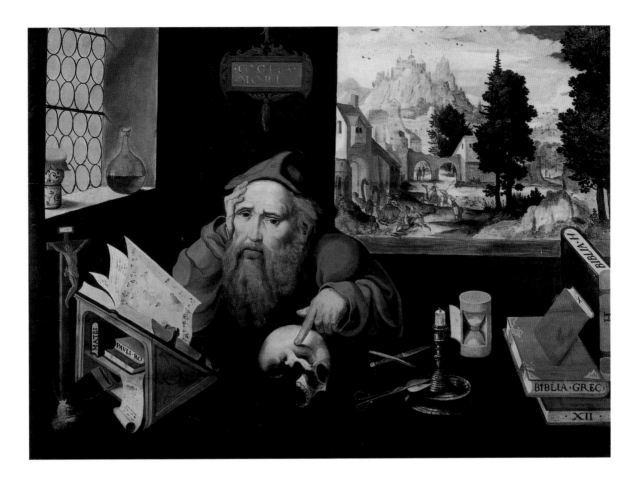

One of Massys' pupils
Hieronymus, c. 1520
Oil on wood, 77 x 105 cm
Kunstmuseum, Düsseldorf, on permanent loan
from Ms. Bettina Bachmann

can see inside (a motif which could also be found earlier, in Andreas Vesal's *De Humani Corporis Fabrica*, 3rd edition, Venice 1568, p. 164) – as well as by a burnt candle and a clock. The flowers in the vase, too, are symbols of vanity (according to Psalm 103:15-16, where man is compared to the flowers of the field, which will soon wither). A winged angelic creature has come flying to the scene, opening up a banner which reads 'Aeterne pungit, cito volat et occidit.'[81] The message of Pereda's painting is best captured in Gryphius' poem *Alles ist eitel* ('Everything is vain'): "The fame of lofty deeds must perish like a dream" – words which can be seen as a motto of this painting. The iconography of Pereda's dream, however, has an even closer literary parallel in Calderón de la Barca's play *La vida es sueño* ('Life is a Dream'), in which a ruler is told that his authority as king is no more than a confused dream. He meditates:

"For in the chambers
Of this wondrous world
All of life is but a dream;
And man (as I can see)
Merely dreams his entire existence and actions
Until his dreams float away.
The king dreams that he is a king;

And, submerged in this delusion,
He reigns, rules and directs.
Everything is subject to him,
Yet little of it remains,
For death quickly turns his happiness
Into dust (O bitter fate!);
Who can revel in his power
If he knows that he is threatened
by an awakening in the dream of death? . . ."[82]

 The problems of imperial power are also alluded to in Antonio de Pereda's *Allegory of Transience* (p. 85). This can already be gathered from the cameo held by an angel towards the viewer in her left hand. The cameo shows the portrait of the Spanish King and German Emperor Charles V, and is above a globe, which is meant to symbolize the extent of the Hapsburg empire. Nearly a century had already passed (c. 1640/50) since the Emperor's death. At the front edge of the table some symbolic remnants of human existence, as totally subject to decay, serve as reminders that his empire, too, was transitory.

 Pieter Boel's (1622-1674) large-format painting from 1663 (p. 83) has been described as the 'chef d'œuvre du genre' (the masterpiece of the genre).[83] The artist was born in Antwerp, where he also studied under Jan Fyt. Later in his life he moved to Paris (in 1668) to work for the Royal tapestry makers, together with Charles Lebrun. The painting shows a sarcophagus in a half-ruined church, with its vanishing point on the left. Objects of vanity are assembled in the foreground, piled up in the shape of a pyramid and culminating in an ermine coat, a turban (at the very top, on the banister, next to the skull), a royal crown, a mitre and a globe. These symbols of secular and ecclesiastical power at the zenith of the composition are further explained by a richly decorated bowl, worked by a goldsmith. It shows mythological scenes of unhappy love relationships, partly covering those *vanitates* which are of a lower order – a tambourine, lute, sabre, coat of mail and painter's palette, to name but a few. The statue of a mourning female figure in one of the niches bears great resemblance to the woman whose contours can be seen in Nicolas Poussin's famous self-portrait at the Louvre.[84] She can be regarded as a late successor to the weeping women who surround the altar tomb of Philip the Brave in Dijon.[85] Pieter Boel's painting contains all the features normally associated with baroque solemnity, i.e., pomp and splendour even where power and wealth have become subject to the darkness of death. However, although all earthly possessions and authority are marked as vain, the dialectic of the painting never leaves any doubt that their real substance remains undisputed in this world and that the earthly order is preserved intact.

 Compared with Boel's grand and dignified *pompe funèbre*, David Bailly's (1584-1657) vanitas still life, painted a little earlier, seems relatively modest and its objects appear to be rather plain (p. 84).[86] The border between the two genres of the still life and the portrait are blurred. On the one hand, there are several portraits (as paintings within the painting) forming part of a still life arrangement on the table. The arrangement that includes, among other things, a skull, an extinguished candle, coins, a wine glass on its side, a pocket watch, roses, a pearl necklace, a pipe, books and sculpture. Soap bubbles hover above them as

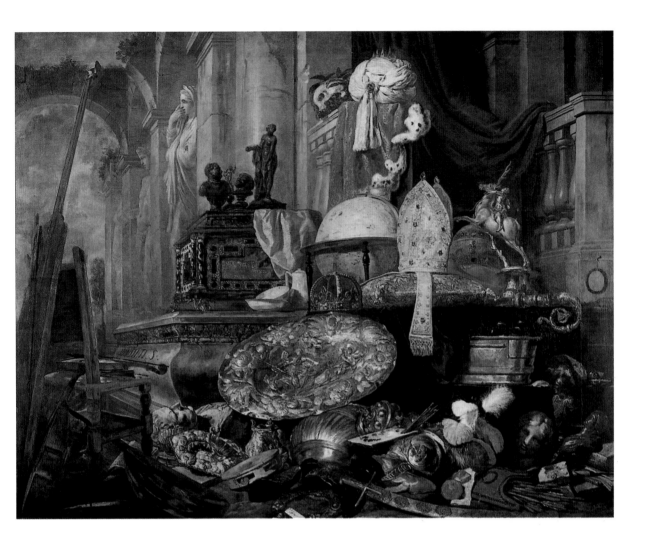

symbols of transience. On the other hand, the entire collection functions as a statement about the young man on the left, whose face displays the typical features of a self-portrait. It may therefore be somewhat irritating that the artist was in fact 67 years old when he painted this picture in 1651. However, the contradiction can be solved when we consider that his current features are shown in the small oval portrait, demonstratively held out towards the viewer – a medium which in itself already documents the transience of life. The youthful artist's face, by contrast, shows Bailly as he was at an earlier stage in his life, more than four decades previously. Thus, by changing the time references of past fiction and present reality, the painting suggests that the young artist is anticipating his future age, which – though part of the present in 1651 – appears to belong to the past, as conveyed through the medium of the portrait. The young man, who appears to be so real within the first-degree reality of the painting, really represents a state of the past. Unlike the repetitive, dull and often schematic topics of Dutch vanitas still lifes, the misleading time scale in Bailly's painting adds a new dimension to the whole subject.

Pieter Boel
Large Vanitas Still Life, 1663
Oil on canvas, 207 x 260 cm
Musée des Beaux-Arts, Lille

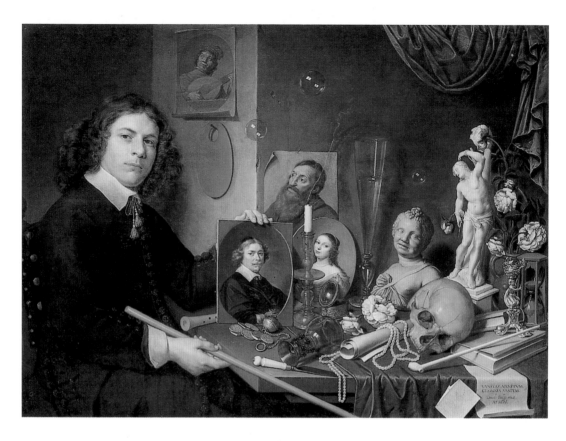

David Bailly
Self-Portrait with Vanitas Symbols, 1651
Oil on wood, 89.5 x 122 cm
Stedelijk Museum De Lakenhal, Leiden

Antonio de Pereda
Allegory of Transience, c. 1640
Oil on wood, 139.5 x 174 cm
Kunsthistorisches Museum, Vienna

Pereda's vanitas still lifes are like the *Knight's Dream* – full of allusions
to the problems of Imperial power. This is especially reflected in the
cameo which the angel is holding out towards the viewer in her left
hand. The cameo, which contains a portrait of the King of Spain and the
Emperor of Germany Charles V, is being held above a globe, intended to
show the extent of the Hapsburg empire, a realm in which 'the sun
never set down'. Nearly a century had passed since the Emperor's death.
Like the symbolic remnants of human existence towards the front of the
table – remnants which are totally subject to decay – his empire turned
out to be equally short-lived. *Nil omne* ('Everything is nothing') was
therefore the artist's message, written above the sand-glass. – Pereda
painted this picture at a time when Spain, under Philip IV (1612–1665)
had already suffered the secession of Portugal and Catalonia (1640),
had lost its hegemony after a hopeless fight in the war of independence of
the Low Countries (in the Peace of Westphalia 1648), and was facing
economic ruin.

Nearly all still lifes include – to a greater or lesser extent – the aspect of vanitas, a lament about the transience of all things. It is often symbolized by objects such as a skull or a clock, as in this still life (now at The Hague) by Pieter Claesz, where the effect is enhanced by an overturned wine glass and an extinguished candle. Claesz's metaphysical criticism concentrates on book knowledge and its futility in the face of eternity. The claim of the enlightenment that books contain knowledge, experience and thoughts that were permanently valid beyond the life-span of an individual is met with resigned scepticism. With hues of grey, brown and green that tend to add up to a general 'monochrome' impression, Claesz's still life was painted at a time when the European book market was going through a phase of considerable expansion.

Detail from illustration page 80

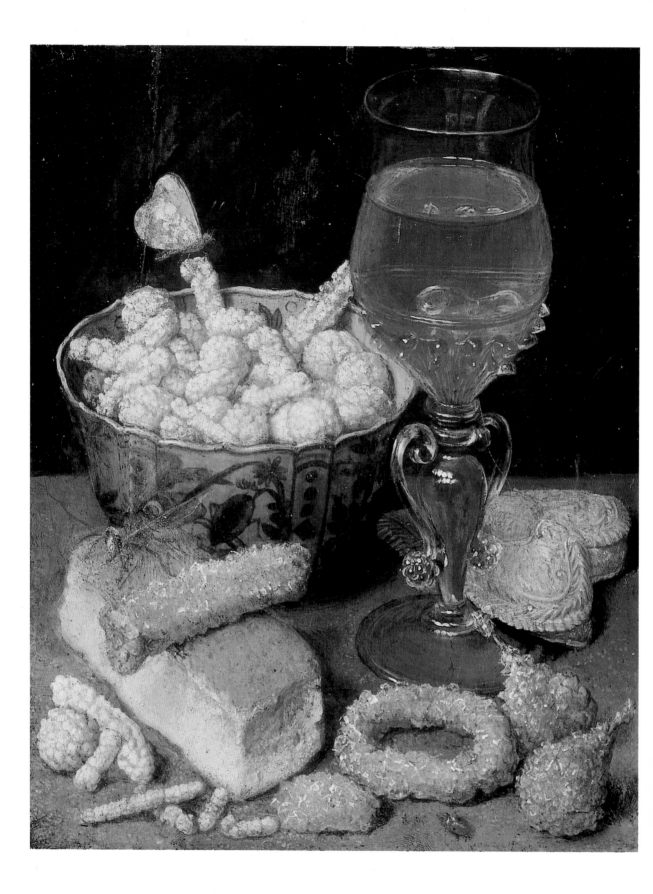

7 Dessert and Confectionery Still Lifes

In the culinary culture of the aristocracy and the patrician middle classes, banquets consisted of six to eight - sometimes even nine – courses and were always concluded by a dessert. Interest in desserts came to a climax at a time when numerous delicacies had been introduced as new luxuries. This was especially true for sugar confectionery, which appeared in still lifes around 1600 for the first time. The introduction of sugar marked a radical revolution of taste.[87] Initially it was only used for pharmaceutical purposes, but it soon replaced honey as a sweetener and a food. Sugar was only grown in tropical areas, at first in the East Indies, but then also in Madeira, the Azores, the Canaries and finally also Brazil, where it was farmed on large plantations for export to Europe. The sugar cane was pressed in mills as soon as it had been harvested, and the thick syrup was then put into cone-shaped vessels and shipped out for further processing.

The crystalline structure of the candied sugar made in Madeira and the Canaries was rendered especially accurately by Georg Flegel (1563-1638) in his confectionery still life (p. 88).[88] His painting, now in Frankfurt, shows candied fruit on a table in the foreground, including two figs on the right, encrusted with large sugar crystals. Some of the fruits have been cut up in the shape of letters, for example, a large 'O' can be made out as well as a crumbled 'A' beside the loaf of bread. A straight piece of sugar is lying across the loaf like a cross-beam and is being approached by a disproportionately large bee. The earthenware bowl with the blue pattern contains candied fruit dusted with icing sugar, and a brimstone butterfly, whose wings also show traces of sugar, has alighted on it. Flegel has added a religious dimension, because the seemingly innocuous arrangement is full of Christian allusions. For example, the letters 'A' and 'O' (Alpha and Omega) as the first and last letters of the Greek alphabet are a reference to Apocalypse 1:8 and 21:6, where Christ is referred to as the beginning and the end. The cross formed by the loaf and the piece of sugar emphasizes this aspect even further. Finally, as a reminder of the Eucharist, there is the bread and wine in the dainty glass, with decorations resembling amphora handles which drop down in the form of grape-like clusters at the bottom. The redemptive work of Christ is called to mind by the butterfly, an ancient symbol of the human soul as well of the resurrection, as new life comes forth from a seemingly dead chrysalis. The heart on the right is a specially shaped piece of bread, made from communion wafer dough, and is apparently meant to remind the viewer of the heart of Christ. In Flegel's art, sugar has entirely taken over the religious connotations of honey, which was understood as a symbol of 'spiritual sweetness' during the Middle Ages.[89]

This spiritualization of sugar is undoubtedly also due to people's appreciation of it as a new luxury product. In subsequent years, there was a change in

Frans van Mieris
A Meal of Oysters, 1661
Oil on wood, 27 x 20 cm
Mauritshuis, The Hague

Georg Flegel (1566-1638)
Still Life with Bread and Confectionery, undated
Oil on wood, 21.7 x 17 cm
Städelsches Kunstinstitut, Frankfurt

attitude when it was discovered that sugar was addictive. Christian Hofmann von Hofmannswaldau therefore felt that sugar was similar to lust ("Lust continues to be the sugar of our time"). And in one of his *Lovers' Arias* he writes: "The memory of sugary lust inspires me with fear. Damned food, it will harm us in a worldly way. If one has tasted something and is not supposed to taste it again, then it becomes empty and pathetic . . ."[90]

The arrangement of various desserts to form a spiritual scenery can also be found in other still lifes by Flegel. His small-format *Dessert Still Life* (p. 91), for example, is dominated by the contrast between a parrot and a mouse, representing the principles of good and evil respectively. The mouse is nibbling at the sweets and has already opened a walnut, which, according to St. Augustine, is a symbol of Christ, the shell pointing to the wooden cross and the sweet fruit to Christ's divinity.[91] Confectionery made of crystallized sugar, nuts, figs and raisins, some in a costly Chinese bowl and some outside it, represent spiritual principles which are being guarded, as it were, by the green-feathered parrot sitting on the far edge of the bowl.[92] The religious context is further emphasized by the grapes and the wine glass, and indeed also by the carnation. From the late Middle Ages onwards theologians saw carnations as a symbol of Christ's death on the cross, because of the nail-shaped form of petals and fruit. Furthermore, the coins at the front are probably another reference to the Passion, reminding us of Judas Iscariot's betrayal of Jesus for 30 pieces of silver.

In Flegel's *Large Display Meal* (p. 93) the food is arranged on several steps, similar to a buffet, thus reflecting Baroque table protocol. The viewer looks at the arrangement from the side, with the front edge of the table running parallel to the edge of the painting, as in earlier paintings of this kind. Again, only a section of the entire banquet is shown, displaying sugar confectionery and fruit for the dessert. At the centre of the composition is a cake stand of sugar confectionery. It is surrounded by tin plates laden with fruit, a damask knife partly cut off by the edge of the painting,[93] slices of bread, other sorts of bread and, rolls, costly goblets which in turn serve as supports for some raised fruit bowls and finally, a richly ornamented vase with an arrangement of flowers. Owing to some ingenious substructures, each item is raised in such a way that it is almost completely visible without being concealed by other objects. This method of depiction is typical of early still lifes where the artist and his patron were still largely interested in the optically intact and undivided rendering of the objects. The objects were regarded as too precious to be removed from the proud view of the owner merely for the sake of aesthetic principles. Again, Flegel incorporates elements that remind the viewer of the resurrection, such as the detailed motifs of the parrot, the butterfly (in the bottom left-hand corner) and the pomegranate.[94] The latter, in particular, had been interpreted as a resurrection symbol since the Middle Ages, when the ancient Proserpina myth was rediscovered.

The traditional principle of depicting isolated bowls, baskets and vases can also be found in the paintings of Osias Beert (c. 1580-1624), an Antwerp still life painter who also specialized in dessert motifs (pp. 95 and 97). He, too, enjoyed placing a raised silver bowl with sugar confectionery or a loaf of marzipan in the centre. One example is his Stuttgart still life (p. 95), which also contains a tin plate full of oysters in the top left corner, as well as olives floating in oil and a ceramic vessel as big as a saucepan filled with chestnuts, and lemons at the front. Oysters in late 17th-century Dutch genre paintings were generally interpreted as erotic – vaginal – symbols, as in the *Meal of Oysters* (p. 89) by

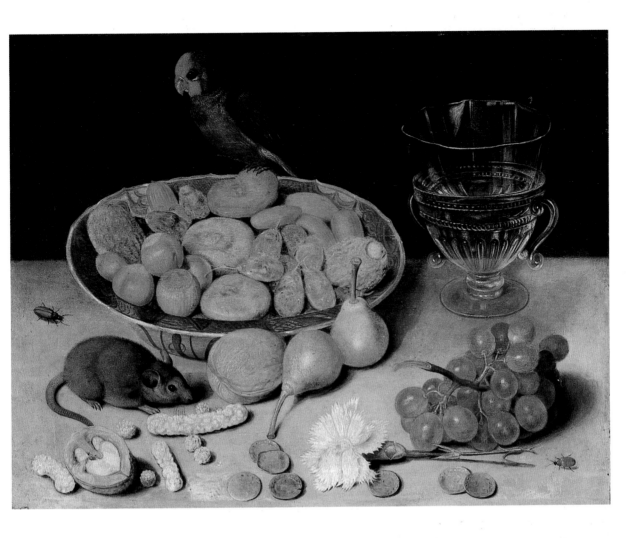

Frans van Mieris the Elder. Here, however, they probably still had the religious symbolism of the shell, with the meaning that had been given to it in a 3rd-century Christian book on animals, called *Physiologus*. Describing the behaviour of animals in 55 chapters, it then relates them to Christian doctrine. The shell is symbolically likened to Mary who gave birth to the 'pearl of great price,' Jesus.[95]

Clara Peeters' (1594 – after 1657) *Dessert Still Lifes* (p. 94) are very similar in character. Peeters was also from Antwerp originally, but later moved to Amsterdam (in 1612) and The Hague (in 1617). A classification of signed works is difficult as she seems to have taken over Beert's objects. Like Beert, she would avoid overlapping objects and line up additive groups of fruits, nuts, confectionery, baked items in the shape of letters, costly jugs and embossed goblets. Her Munich painting shows a table which runs strictly parallel to the edge of the painting. It is covered with a rug and a white damask tablecloth which serves to enhance the impact of the objects by providing a sharp contrast to them.

Georg Flegel (1566-1638)
Dessert Still Life, undated
Oil on wood, 22 x 28 cm
Alte Pinakothek, Munich

Instructions for Organizing a
Large Banquet in the French Style[96]

For a company of thirty distinguished persons who are to be served on a grand scale, a table is needed with as many places and serviettes as there are persons, and each plate the same width as a chair. There should be fourteen on either side, as well as one at the top and one or two at the bottom of the table. It is also important that the table should be wide enough that the tablecloth hangs down nicely on all sides and that there are many saltcellars, knives and forks as well as table rings in the middle of the table on which to place the lids of bowls when they are not needed.

First Course
To begin with, 30 bowls are served, containing nothing but soup dishes with minced meat on slices of bread. Fifteen of these bowls are to be filled with meat, and in the other fifteen the minced meat is to be placed on bread. These bowls are to be placed on the table alternately, with a good healthy soup on the one side and a *potage a la royne* on the other, made from numerous minced partridges and pheasants, further down a healthy soup again and the next containing minced meat with mushrooms, artichokes and other things. This, however, is to be followed by a bisque, then a *potage garny* with all manner of poultry offal, next to the bisque a Jacobine or some other dish. This alternation should continue until the end of the table, so that a milder dish is always next to a stronger one.

Second Course
This consists of all manner of dishes, such as venison fried briefly in stock, and also pies, both common ones and those made with puff pastry, snails, tongue, cold meat, sausages, black sausage, melons and fruit, depending on the season, and various small salads and herbs that can be placed on the saltcellars and the table rings in the middle of the table. Any improvements on this can be left to the discretion of the head butler. He must take care, however, always to be available on the right-hand side of the table whenever he can, as in this way he can have a freer hand to serve the bowls. This means that he must have an assistant on the other side who removes the previous bowl and takes no more time than is necessary to put down a second bowl. However, he must ensure that no more than four bowls are on the table at any one time. Thirdly, the butler must take care never to serve a large piece of meat to distinguished people, as this might either cause them to lose face or they would be obliged to let others help themselves first. Fourthly, he must place the bowls in such a way that a mild and a strong dish are at the same distance on both sides, and the bowls must be mixed in such a way that it is not obvious if a dish occurs twice.

Third Course
This consists of all manner of big roasts, such as partriges, pheasants, quail, wild or wood doves, young chickens, young hares, rabbits, whole lambs and suchlike. Some small bowls containing Seville oranges, lemons, olives and suchlike are also served.

Fourth Course
This consists of all manner of small roasts, such as water quail, fieldfares, larks, and suchlike. All manner of dishes in which two substances are separated from each other with a sieve can also be served, and the bowls should be mixed in such a way that a bowl with fried meat alternates with the sieved dish. Dishes with fruit and other things are placed on forks sticking up from the saltcellars and table rings.

Fifth Course
If fish cooked with ham are served, then the salmon, trout, carp and pike are to be served whole, alongside any pies that are also made from fish, interspersed with various bowls of turtle and crab fricassees, decorated with their shells or, if these are not available, Seville oranges or lemons.

Sixth Course
This consists of all manner of dishes made from butter and ham as well as various kinds of eggs, of which several are mixed with mutton gravy, others fried in pans, others again mixed with sugar. They can be eaten either hot or cold and in all manner of colourful jellies. Bowls with artichokes, cardoons and celery with oil and pepper are placed on the forks of the saltcellars and table rings.

Seventh Course
This consists of all manner of fruit, as permitted by the season, as well as cream and cakes. Almonds and walnuts without their shells are placed on the saltcellars and table rings.

Eighth Course
The final course of the banquet consists of all manner of preserves, marzipan both moist and dry, jams and confectionery. Decorated with different kinds of coloured sugar and spiked with little toothpicks, sticks of fennel are to be placed on top of the saltcellars and table rings, as well as several bowls of musk cakes and other ambergris and musk-scented sweets. The head butler must change the plates at least after every course and the serviettes between courses.

When clearing the table, the servant starts at the bottom end. Meanwhile, his assistant removes the plates, saltcellars and whatever else is on the table until he reaches the top, where he then prepares for the ablutions. In the meantime, the other servant is busy handing out the hand towels until this ceremony reaches the bottom of the table. The same person who holds the finger bowls may also change the water and pour it out.

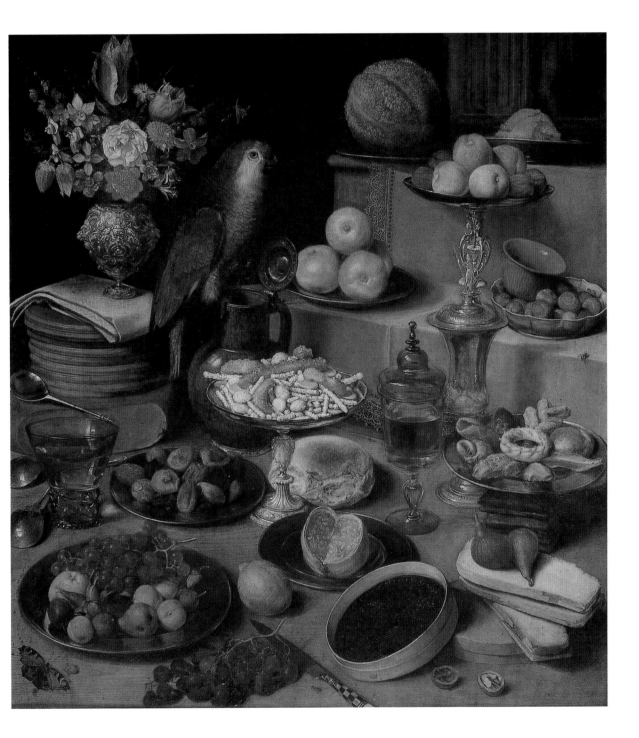

Georg Flegel (1566-1638)
Large Food Display, undated
Oil on copper, 78 x 67 cm
Alte Pinakothek, Munich

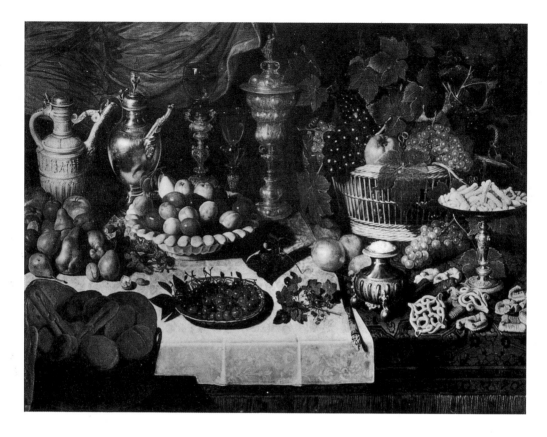

Clara Peeters
Dessert Still Life, 1597
Oil on oakwood, 93.5 x 122.8 cm
Alte Pinakothek, Munich

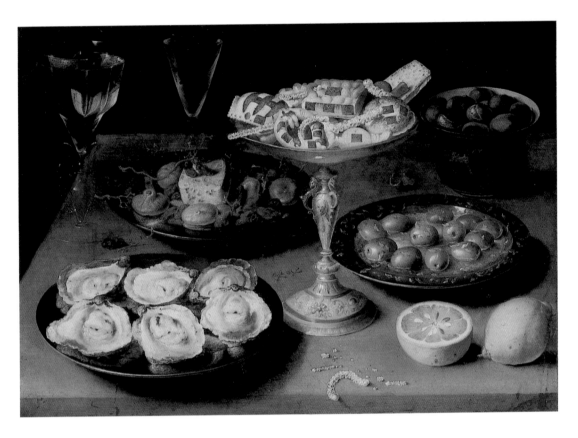

Osias Beert
Still Life with Oysters and Pastries, c. 1610
Oil on copper, 46.6 x 66 cm
Staatsgalerie, Stuttgart

Jean-Baptiste Simeon Chardin
'La Brioche' (Cake), 1763
Oil on canvas, 47 x 56 cm
Louvre, Paris

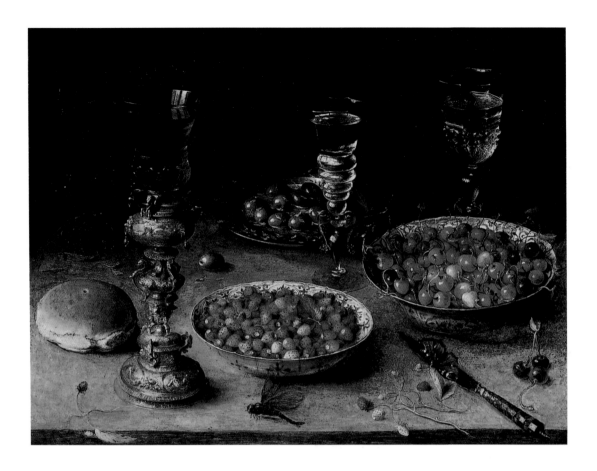

Osias Beert
Still Life with Cherries and Strawberries in
China Bowls, 1608
50 x 65.5 cm
Stiftung preußischer Kulturbesitz, Staatliche
Museen, Berlin

The composition of Beert's dessert still life represents an early phase of
this genre. The picture shows two precious Chinese porcelain bowls
from the Wan Li dynasty (1573-1619) – modern import products at the
time – filled with strawberries and cherries, as well as a pewter plate full
of olives, and several goblets. The surface of the table seems tilted in an
old-fashioned way so as to allow an unobstructed view of the various
luxury objects which have been depicted with hard precision and
without atmospheric density. We are looking at the last or penultimate
course of an eight to nine-course banquet. The knife in the foreground,
still largely the only piece of cutlery at the time, was shared by all the
participants of the feast. – The dragonfly and the butterfly add an
emblematic dimension to this everyday motif. Like Georg Flegel, Osias
Beert shows the forces of good and evil fighting for man's soul in the
form of animals. The human soul is represented by strawberries and
cherries, which were considered to be fruits of Paradise. The butterfly,
as a symbol of salvation and resurrection, is in opposition to the
dragonfly which – according to Ulisse Aldrovandi and Thomas Moufetus
– was seen as a subspecies of the common fly. With reference to Kings
1:1ff (Beelzebub = lord of the flies), they considered flies to be creatures
of the devil.

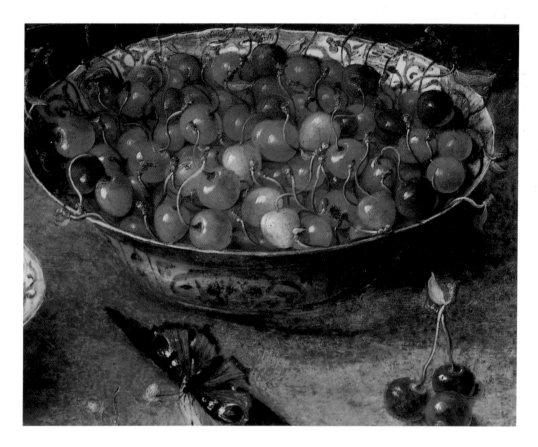

Detail from illustration page 97

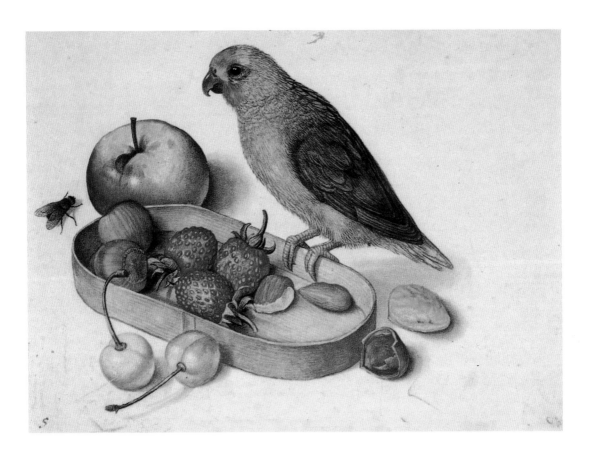

Georg Flegel (1566-1638)
Still Life with Pygmy Parrot, undated
Water coloured Drawing (KdZ No. 7498),
c. 23.4 x 17.2 cm
Kupferstichkabinett, Stiftung Preußischer
Kulturbesitz, Staatliche Museen, Berlin

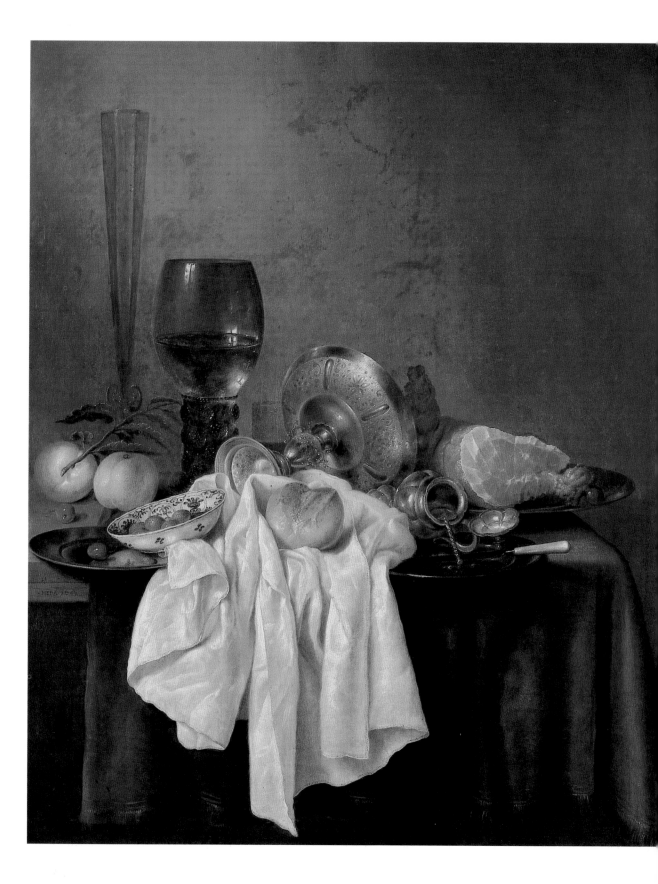

8 *Ontbijtjes* – Laid Tables

The aesthetically conservative principle of tables arranged strictly parallel to the horizontal edges of the painting was also followed by Nicolas Gillis (p. 102), Floris Claesz van Dijck (p. 103) and Floris van Schooten.[97] Predecessors were probably family paintings such as Marten van Heemskerck's from 1530 (p. 118), where the table with its rather frugal food and drink was pushed down to the lower portion of the painting. Ingvar Bergström classified Gillis', van Dijck's and van Schooten's still lifes as *ontbijtjes* – perhaps best translated as 'breakfast still lifes.' According to R. van Luttervelt, *ontbijt(je)* was a light meal which could be taken at any time of the day.[98] Strictly speaking, most of the paintings by Gillis, van Dijck and van Schooten are dessert still lifes, developed at roughly the time by Osias Beert and Clara Peeters (cf. pp. 94 and 95). All these artists show a table with a table runner and a carefully ironed, white damask tablecloth whose creases, regardless of the laws of perspective, run in parallel lines towards the back of the painting. A relatively high viewpoint was also chosen, apparently to afford a good overall survey of the objects, which are arranged side by side or in a circle, hardly ever touching or overlapping. The precious drinking vessels and pieces of textile show very clearly that the arrangement is that of a privileged household. In accordance with etiquette, fruit, pies, nuts and confectionery were served as a dessert. Cheese, which had a central role in Gillis' and van Dijck's art, was also part of the dessert. Zedler's *Universal Lexicon* states that "cheese is a common food which is widespread among the common people, though in polite society it is only served as a dessert."[99] Gillis and van Dijck build up pyramids of hard cheese in two or three layers: at the bottom there is half a large cheese with a rich, yellow hue, indicating that it is still very young, while on top the cheeses are smaller and more brownish, almost grey in colour, showing that they are older and more mature. The irregular traces of cuts with a knife – the only piece of cutlery on the table – are rendered extremely well.

Although there can be no doubt that these paintings are a display of culinary luxuries, the food was quite probably linked to religious ideas and symbols which were diametrically opposed to such abundance. Cheese, particularly among Protestants, was regarded as Lenten fare. "Tertullian writes that it was seen as a fare of immortality, as it is solidified milk, whereas Christ himself is heavenly milk."[100] Joseph Lammers quotes a six-line poem by the Dutch poet Jacob Westerbaen, in which cheese is described as "a metaphor of the powerful flavour of a simple repast."[101] However, this obligation to fast probably only applied to the lower social classes and seems to have had virtually no force outside Protestant circles. According to Zedler, Roman Catholics were supposed to avoid not only the 'flesh of beast and bird' but also 'eggs, butter and cheese,'[102] whereas

Detail from illustration page 114

Willem Claesz. Heda
Still Life, 1651
Oil on wood, 99 x 83 cm
Gallery of the Duke of Liechtenstein, Vaduz

101

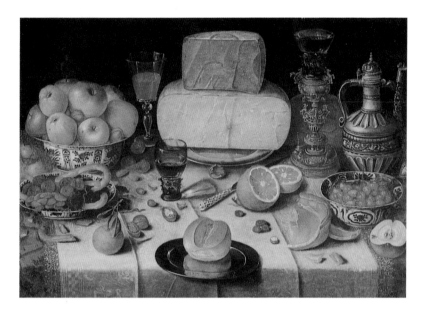

fish, fruit and wine were permitted. It follows that cheese was not Lenten fare among 17th and 18th-century Roman Catholics. The extent to which Protestants really followed strict fasting rules would have to be made the object of more thorough historical research. Luther criticized such obligations as legalistic, emphasizing that man could be 'justified by faith alone' and that fasting should therefore not be made into a law. Huldrych Zwingli and John Calvin, on the other hand, did advocate fasting as something that enabled man to overcome the flesh and prepare his heart for prayer and devout meditation, while at the same time expressing humility and confessing one's sinfulness before God.[103]

Monochrome *Banketjes*:
Pieter Claesz and Willem Claesz. Heda

Pieter Claesz (1597/8-1661)[104] was born in Burgsteinfurt, Westphalia (now part of Germany), and later moved to Haarlem in the Netherlands. His earlier paintings, some of the main representatives of *ontbijtjes*, were still dominated by the aesthetic principles and compositional structures used by van Dijck and van Schooten. He, too, included meticulously ironed tablecloths with parallel creases in his paintings, while placing the various elements, such as bowls, jugs and fruit, far apart from each other so that they rarely touched or overlapped (even the individual grapes were arranged side by side rather than above each other). Claesz used a high centre of perspective as late as 1622, though a year later he began to place the far edge of the table somewhat lower. This meant that the drinking vessels could stand out more prominently, while the plates looked as if they had been pushed in front of each other and were hardly distinguishable as units. This was accompanied by a quantitative reduction of elements, reflecting no doubt the simple character of middle-class *ontbijtjes* and thus of consumer habits that were no longer privileged. However, it may also be an expression of increasingly refined eating habits in the sense of Norbert Elias's 'civilization curve,' a development where it was no longer

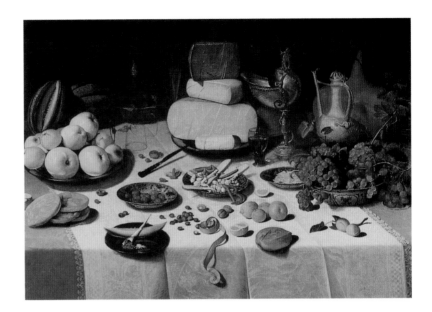

Floris van Dijck
Laid Table, 1622
Oil on wood, 100 x 135 cm
Private collection, Amsterdam

important to display the extravagant style of feudal economy. As soon as such a standard had actually been reached, it seemed – at least for a certain time – that it was no longer necessary to make a demonstrative display of sumptuousness and abundance in the form of paintings. Artists were now able to add visual impact to the aesthetic refinement of taste. Occasionally, Claesz returned to the conservative compositional structure of table still lifes, for example, in his painting of 1627, though this was probably to satisfy the taste of his genteel patron. His painting in Count J.C.N. van Lynden's collection (in Zegenwerp, Holland)[105] therefore shows a turkey pie with a stuffed bird that is typical of the households of the landed gentry and Patricians of the time. The bowl, shaped like a nautilus shell, in front of the pie and the blue-and-white Chinese grape bowl, placed diagonally, seem to confirm this idea. In the 1630s, Claesz limited himself to a very small number of objects. His fish still life from 1636 (p. 105)[106] contains a tall, narrow, almost cylindrical glass with hyphen-shaped protrusions placed at regular intervals. The glass, which flares only slightly towards the top, forms a vertical counterpoint against the silver plate beside it with the herring. The oval fish has been cut into small parallel pieces arranged alternately and set against the edge of the plate to emphasize the herring's original contours. The same method of cutting up fish was already in evidence in Pieter Aertsen's paintings. There can be no doubt that this fish was intended to have Lenten associations. It is paralleled by Georg Flegel's still life of 1635 (p. 106), where a herring has also been cut up, though without any sophisticated pattern or ornamentation. Flegel emphasized the fasting motif even more clearly, with leeks on the table to show that it was a 'humble repast.'[107] Placed between the Eucharistic symbols of wine and bread (in the form of a small loaf), the fish was probably also mystically identified with Christ,[108] who is being attacked by evil in the form of a stag beetle.[109] The herring, cut into segments but with its skin left intact like a 'cloak,' was regarded as Lenten fare, together with onions and cheese. It can also be found in Jakob Flegel's still life from 1620 (p. 112).

Pieter Claesz was one of the first artists to paint monochrome *banketjes*. Like landscape artists – especially Jan van Goyen – he began to tend towards

atmospheric unity in the 1620s. The strong local colours, which were still characteristic of older table still lifes, were replaced by an overall hue of greenish grey, submerging the objects into an aura that encompassed each one of them. Pieter Claesz's brush-stroke is subtler than that of Willem Claesz. Heda was another Haarlem painter who achieved an even finer balance of tonal values. Claesz's broader brush-strokes may well be due to the alla prima style of Frans Hals who dominated art in Haarlem at the time.

In the early 1630s Heda, too, began to use the compositional structures developed by Gillis, van Dijck and van Schooten. Unlike those artists, however, he placed the white table cloth on the left or right-hand edge of the table, so that the middle of the table is not covered and is no longer symmetrical. In subsequent *banketjes*, the tablecloth was pushed further and further aside – as early as 1638 in Heda's paintings – until it was actually crumpled. Whereas for quite some time food was shown as almost untouchable, precious and just for display – even though these were not intended as mere display meals in the more narrow sense of the word! – increasing traces of consumption are now visible. The objects were no longer merely intended to embody status-defining values, but became evidence of spontaneous acts which disrupted the festive structures of the framework. A parallel development can be seen in the abandonment of rigid postures in Frans Hals' portraits, where the models are painted swinging casually on their chairs. Following the secession of the northern Netherlands from the Spanish Hapsburg empire at the beginning of the century, such attitudes were reflections of a new self-awareness among the middle classes, as well as their renunciation of feudal standards and the emergence of new behavioral patterns in which people were seeking, as far as was possible, to shed all ceremoniousness.[110]

One of Heda's early still lifes (p. 104) shows drinking vessels and a salt-cellar made of gold-plated metal with delicately engraved ornamental patterns that gently reflect the light. In fact, the overall monochrome character of the

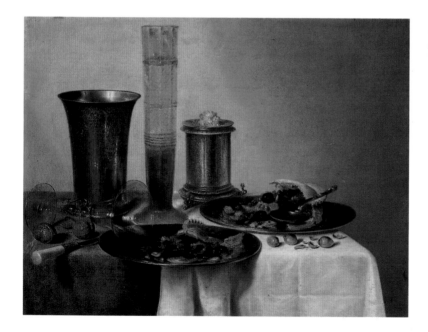

Willem Claesz. Heda
Breakfast Still Life, 1637
Oil on wood, 44 x 56 cm
Louvre, Paris

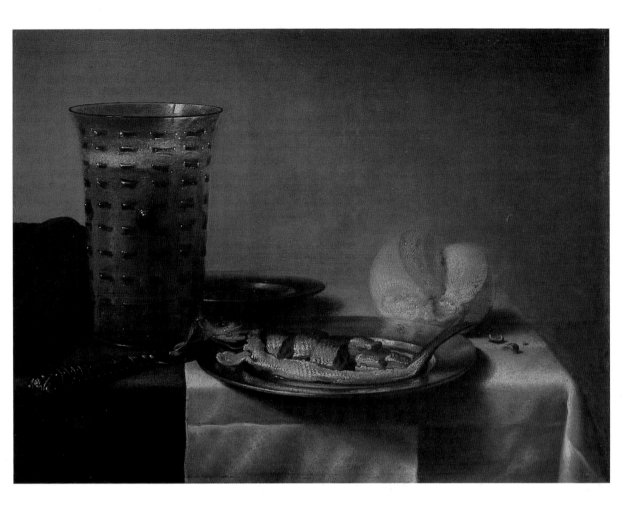

Pieter Claesz
Fish Still Life, 1636
Oil on wood, 36 x 49 cm
Museum Boymans-van Beuningen, Rotterdam

painting only admits a faint sheen. A tall, slim polygonal glass with horizontal grooves and a diamond structure towers above the table like a column. In front of it, almost like a counterpoint, there are two plates, one with left-overs from a berry pie and the other with a berry pie that has only been half eaten. On the left, an empty glass is leaning on the plate. Between the glass and the plate a knife has been precariously placed so that it is threatening to fall off the table at any time. Finally, there are some walnuts and hazelnuts, suggesting that this, too, is a dessert still life.

Heda did not start to paint diagonal compositions until the mid-1630s: the compositions start with flat plates, continue with pieces of ham and goblets, and culminate in a zenith-like fashion with a beer or water jug. At times this pattern was of course broken, especially when Heda had to depict the valuable crockery of distinguished households, such as columbine goblets, cups of welcome, etc. Heda then went back either to his triangular or his pyramid-shaped compositions. But it is noticeable that whenever he did this, he also increased the incidence of 'chaotic' elements, showing, for example, the white tablecloth extremely crumpled (e.g., in 1651, p. 100) as well as an overturned jug or one with a bread roll pushed into it. (The overturning of goblets goes back to an ancient custom, and in the 16th and 17th centuries goldsmiths, for example,

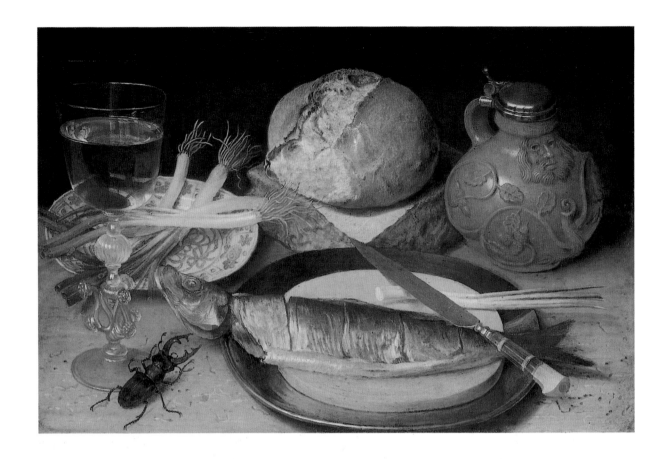

fashioned special goblets that had to be emptied all at once so that they could be placed on the table upside down).

Abraham van Beijeren

In the second half of the 17th century *ontbijtje* and *banketje* still lifes, as developed by Claesz and Heda, were replaced by more lavish compositions that gave more emphasis to ostentatious elements. Abraham van Beijeren's still lifes were typical in this respect. Van Beijeren (1620 or 1621 – 1690) was born in The Hague at the time when Claesz had already become successful with his first paintings. His *Large Still Life with Lobster* (1652, p. 107) is composed diagonally. The velvet runner and white tablecloth have been pushed together in artistic disarray so that the left-hand edge of the table is visible. The painting shows a silver drinking bowl with a handle, a nautilus goblet on a silver tray, a lobster, a glass bowl of fruit, grapes and melons and, finally, a hardly recognizable lidded glass goblet which is one quarter filled with wine. These objects form a cluster which draws the eye to the chest in the background, where a piece of melon and a wine glass with an elaborate handle are the focus of attention. This mountain range of precious objects rises above a landscape that becomes visible to the left of the columns. These columns, which are really symbols of feudal dignity, suggest a palace-like interior. They often provide a background in the aristocratic paintings of G.B. Moroni and Anthonis van Dyck, where

they serve as symbols of 'fortitude' (*fortitudo*) or 'constancy' (*constantia*) and – to an even greater extent – of power and prosperity. The entire composition is made to seem important by the presence of a soffit-like curtain, pulled aside, which makes the whole arrangement seem like a revelation – a revelation of wealth which is proudly displayed here. This impression is hardly softened by the presence of the vanitas symbol of an open pocket watch with a decorative ribbon – a reminder of the transience of all earthly possessions. With these lavish banquet still lifes, van Beijeren met the demands of the merchant classes who wanted to express their prestigious position and their identity. Once these classes had stopped re-investing the wealth they had acquired through capitalist endeavours, they withdrew to their estates where they were now imitating the lifestyle of the landed gentry.

Willem Kalf

After 1650, van Beijeren's contemporary, Willem Kalf (1619-1693), who was born in Rotterdam, began to paint still lifes that reflected the tastes of genteel

Abraham van Beijeren
Large Still Life with Lobster, 1652
Oil on canvas, 125.5 x 105.5 cm
Alte Pinakothek, Munich

culture. He spent his early years (1640-1646) in Paris, where – like Adriaen Brouwers – he specialized in peasant-style interiors (i.e., junk shop motifs). He then started to reduce not only the number of objects, but he also introduced a highly differentiated aesthetic element which reached a hitherto unparalleled degree of perfection. This certainly distinguished his art from van Beijeren's. Although he always depicted decorative objects – such as Chinese porcelain soup tureens, preciously decorated nautilus goblets and costly carpets – his paintings seem to have been dominated not so much by wealth and prosperity as by the aesthetic values and optical qualities of perception that emanated from these objects. Thus, the refraction of the light on the objects and the modification of the colours as mirrored by each of the other objects become the real subject of his art. In all likelihood, Kalf made use of a camera obscura for his preliminary studies or sketches in order to study the lighting and colour effects in greater depth, and to enhance his sensitivity to colour values. While Jan Vermeer (1632-1675), who also used this medium, had already succeeded in creating tonal values with a high degree of independence from the objects themselves, Kalf's colour values are still closely connected with them, as he continued to emphasize the solid ontological firmness of the surface for each of the objects he depicted.[111]

Kalf achieved his effects by giving objects a bright luminescence, further emphasized by a dark background (p. 109) – a method which made him a remote kinsman of the Caravaggists. His objects only exist to the extent that they can be perceived, but in order to be perceived they need light to dispel that darkness which is the original state of the world. (This theory had already been developed by Nikolaus von Kues and was expanded in 17th-century art theory by writers like Nicolas Poussin).

However, unlike Caravaggio and his successors, Kalf avoided beaming any harsh shafts of light onto an object. Instead, his light is more subdued and diffuse, with a source that cannot be exactly identified (though it usually comes from above). It gives each object a minimum of brightness so that it shines faintly and transparently from within here and there, for example on the edge of a silver bowl, although there are also brightly shining spots in some places. The light dissolves, as it were, the material properties of the objects: delicately thin Chinese porcelain is perceived as fragile, brittle and transparent, penetrated softly by the light. The bowl of a nautilus goblet, touched gently by shafts of light, seems to be filled with mysterious vapours hazily engulfing the faintly transparent pearl-coloured glass walls, which are coloured slightly yellow by the wine inside them. Half-peeled oranges and lemons, with their skins spiralling down artistically, have their fruity flesh displayed in such a way that their drop-like fibres flicker golden in the light. Wine-glasses – or rather, Venetian-style goblets with wing-shaped stems (as produced in Liège, Amsterdam, Haarlem and other towns in the Low Countries) – are hardly distinguishable from the dark background. Only the edges of a wine-filled glass are touched erratically by some very thin reflections of light, so that the glimmering colour of the wine seems to hover in the dark space as if it had become detached from the vessel that holds it.[112]

Willem Kalf
Still Life with Nautilus Goblet, 1660
Oil on canvas, 79 x 67 cm
Thyssen-Bornemisza Collection, Lugano

Detail from illustration page 109

OPPOSITE PAGE:
Willem Kalf
Still Life with Lemon, Oranges and Glass of
Wine,
c. 1663/64(?)
Oil on canvas, 36.5 x 30.8 cm
Staatliche Kunsthalle, Karlsruhe

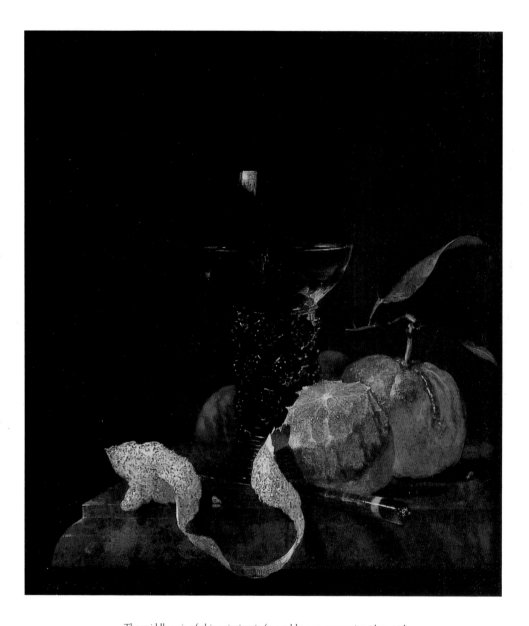

The middle axis of this painting is formed by a roemer wine glass with an elaborate handle. Placed in front of a dark niche, it is partly lit by the small amount of light that shines on it. The light is also refracted by the transparent glass and the wine itself. On the marble table there are three bergamot or Seville oranges and a lemon. Jutting out over the table's edge, a knife with a polished agate handle protudes through the bright yellow lemon peel, and the porous strip of skin, peeled off in one piece, curls around like a festoon, forming a decorative counterpart to the narrow pointed orange leaves. Showing sweet and sour citrus fruits together in this way, the artist symbolically admonishes the viewer to be temperate and to add lemon and orange juice to the wine, as they were considered to have medicinal, humoral and pathological properties.

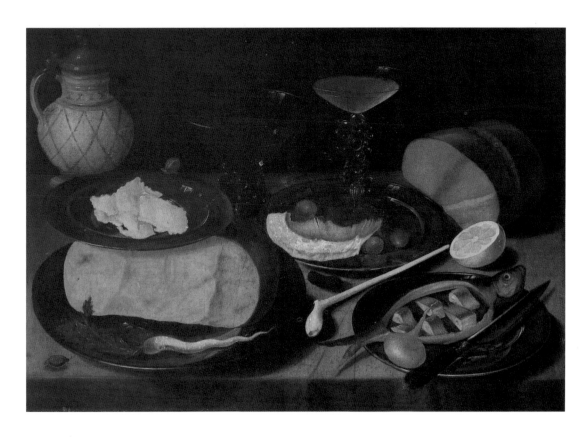

Jacob Flegel (1563-1638)
Fish Still Life with Onion and Cheese, undated
Oil on wood, 51 x 74 cm
Kunstmuseum, Düsseldorf

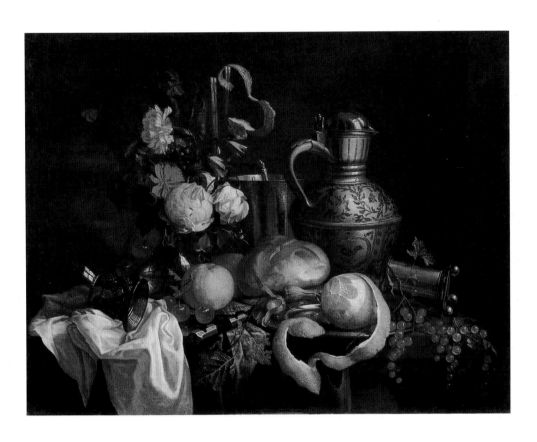

Jan Davisz., de Heem (1606-1683/84)
Still Life, undated
Oil on canvas, 47 x 61 cm
Kunstmuseum, St. Gallen

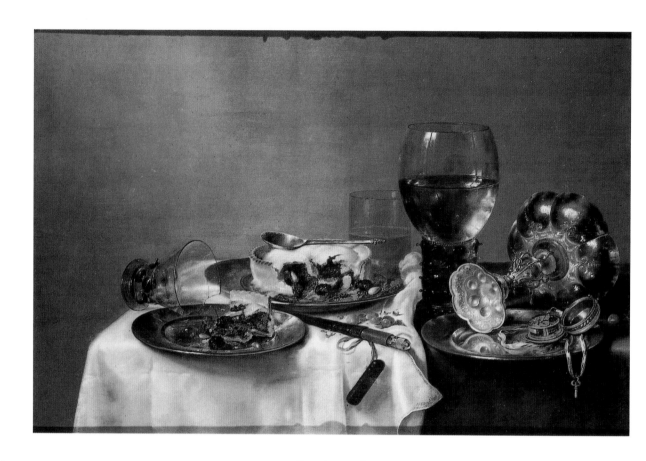

Willem Claesz. Heda
Breakfast Still Life with Blackberry Pie, 1645
Oil on wood, 54 x 82 cm
Staatliche Kunstsammlung, Dresden

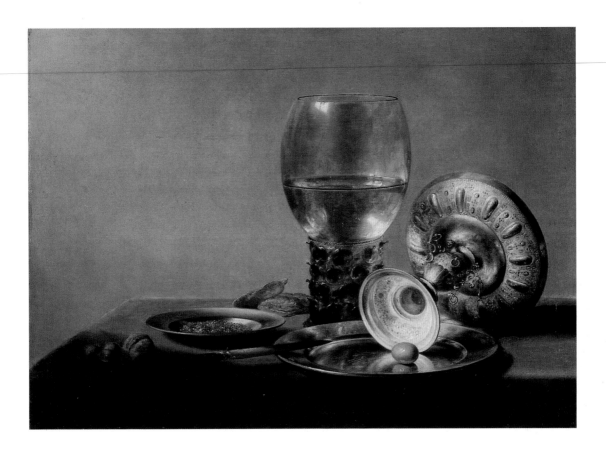

It is worth noting that in this *monochrome banketje*, which is
dominated by shades of grey, green and silver, the elements of the
painting have been reduced to a small number of vessels. Thus the
composition of the painting is determined by an overturned silver
goblet, a half empty wine glass and two pewter plates. Although this is a
so-called 'breakfast still life' (an *ontbijtje*), hardly any food is shown, but
only the sparse left-overs of a meal, such as the olive on the plate, where
it forms some kind of optical barrier between the hollow foot of the
goblet and the plate that reflects it. Unlike the overabundance of food in
earlier Flemish still lifes, this painting emphasizes a refinement of taste.
Naive consumerism has been replaced by aesthetic sublimation under
the influence of Protestant introspection and asceticism.

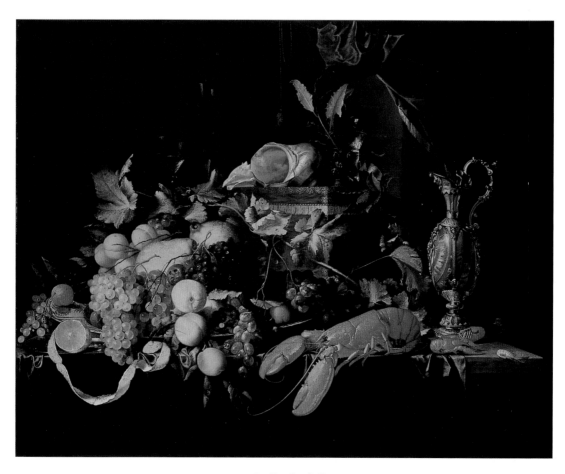

De Heem, who was born in Utrecht, painted this still life during his first
Antwerp phase. Compositionally, it is close to the ornamental still lifes
by Abraham van Beijeren of the early 1650s, who was no doubt
influenced by de Heem (cf. p. 107), especially with regard to the terraced
arrangement of the fruit, the mussels, the tableware and the jug. Also,
both artists painted lobsters. Unlike van Beijeren, however, de Heem's
art scintillates with bright colours and an unsurpassable attention to
detail. Influenced by the Jesuit artist Daniel Seghers, de Heem
frequently incorporated hidden religious symbolism in his paintings. In
this still life, for example, the mussel and the lobster are allusions to the
resurrection and are related to the 'Eucharistic' grapes.

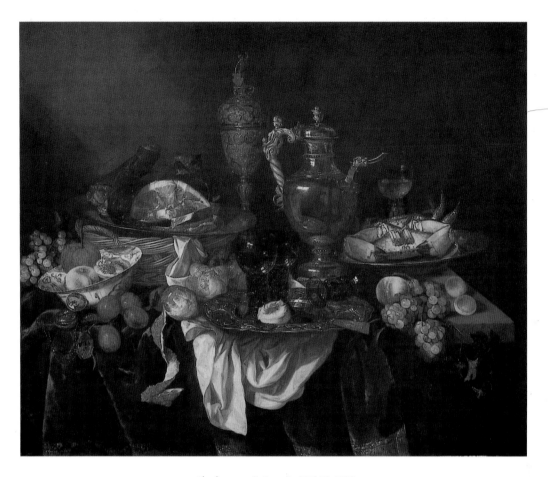

Abraham van Beijeren (c. 1620/21-1690)
Banquet Still Life, undated
Oil on canvas, 99.5 x 120.5 cm
Mauritshuis, The Hague

This large-format banquet still life by Abraham van Beijeren, bought by
the Mauritshuis in 1977, was probably painted during the same phase of
the artist's life as his Munich still life (p. 107), i.e., in the 1650s.
Although it contains some typical vanitas elements (such as an open
pocket watch on the left), the overabundance of silver and china
tableware and exquisite food, arranged in a pyramid, positively bears
witness to a new luxury culture that arose in Holland after the turn of
the century and which reflected the process by which the leading middle
classes became increasingly akin to the landed gentry.

Marten van Heemskerck
The Haarlem Patrician Pieter Jan Foppeszoon with His
Family, c. 1530
Oil on oakwood, 119 x 140.5 cm
Schloß Wilhelmshöhe, Staatliche Kunstsammlungen,
Kassel

Sebastian Stosskopf
Still Life with Glasses and Bottles, c. 1641-44
Oil on canvas, 122 x 99 cm
Stiftung preußischer Kulturbesitz, Staatliche
Museen, Berlin

Stosskopf, who was born in Alsace and learned to paint from the Antwerp-born still life artist Daniel Soreau in the Flemish painters' colony at Hanau, specialized above all in glass still lifes with delicate light effects. Joachim von Sandrart was to point out in 1675 that Stosskopf had painted 'many beautiful and outstanding works of still objects, such as tables and silver crockery' (*Teutsche Academie*, ed. by A.R. Pelzer, Munich 1925, p. 182). The still life above shows a large number of thin, Venetian-style glasses in a wicker basket. Surrounded by other glass, clay and china vessels the basket, which is parallel to the edge of the painting, has been placed on a brilliantly white tablecloth that hangs down over the edge and forms a sharp contrast to the dark background. Stosskopf may well have depicted the costly drinking vessels of an aristocratic patron.

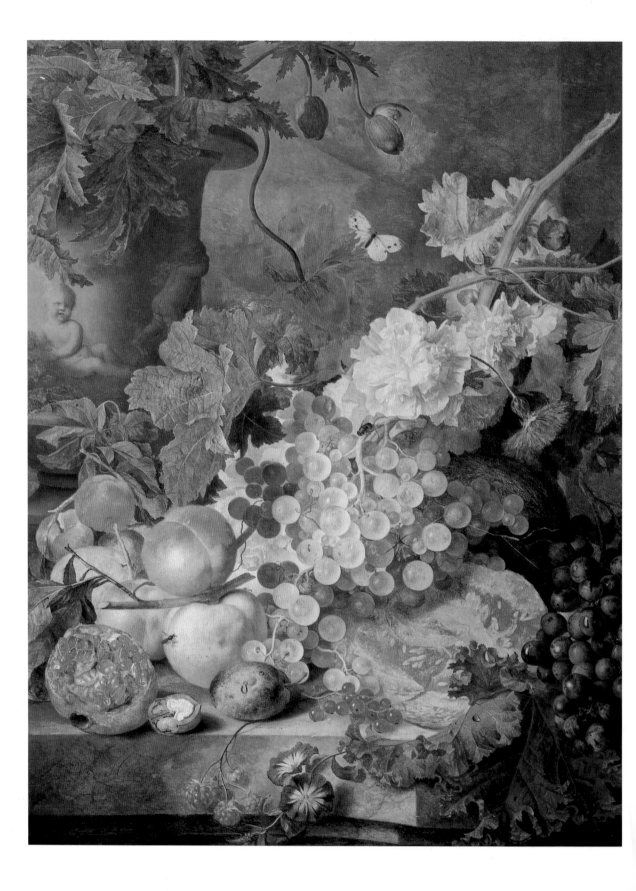

9 Fruit Still Lifes (Fruit Baskets)

The intensification of agriculture from the early 16th century onwards was accompanied by the promotion of the botanical sciences (e.g., the numerous herbal manuals by Brunfels, Gessner, Clusius and others). These new insights then influenced the pater familias literature, which also included advice on the improvement of fruit farming. It is worth noting that early market, kitchen and pantry paintings (e.g., by Joachim Beuckelaer, Frans Snyders and Adriaen van Utrecht) displayed not only vegetables piled up in baskets, but also fruit of all kinds, bulging out over the edge of the plate. Fruit included everything that grew on trees, such as apples, pears, nuts, cherries, plums, peaches, apricots, quinces, chestnuts, etc., as well as shrub fruit, such as blackberries, raspberries and currants. As we learnt from Osias Beert (p. 97) and Clara Peeters (p. 94), fruit was always one of the last courses in a banquet. In the cuisine of the landed gentry and the merchant classes, great emphasis was therefore placed on the more refined fruits: wild fruit from the woods, fields and meadows were considered inferior, as they were smaller and had less taste. Every larger household therefore had an orchard that was laid out and cultivated according to the latest knowledge, where summer and winter fruits were grown that had to be frost-resistant and suitable for longer storage. Similar to nowadays, people valued firmness and a rich, juicy consistency, brought about by hybridization and special methods of cultivation.

In earlier still lifes the different fruits were still neatly separated, and depicted either as market products or freshly harvested and straight from the trees or shrubs, as in Vincenzo Campi's paintings (1536-1591, pp. 126/127). Later, the motif of the market or pantry with its emphasis on variety was increasingly given up in favour of isolated fruit baskets where different fruits were put together like flower arrangements. One of the first – if not *the* first example – is Caravaggio's *Fruit Basket* from about 1596 (p. 8).[113] There has been considerable speculation about the purpose of this painting. One obvious explanation is that it was intended as an illusionist sopraporte painting (i.e., on the wall above a door). This is suggested by the fact that the ledge on which the basket is placed seems to be on the same level as the viewer's eyes, as a kind of raised shelf. This means that the picture was in the Dutch tradition of *betriegertjes* – paintings that were meant to deceive the unsuspecting passer-by. In order to emphasize this trompe l'œil effect,[114] Caravaggio therefore avoided any spacial references that might facilitate orientation. The basket is shown against an indeterminate yellowish ochre wall and does not even cast a shadow. The basket, which protrudes slightly from the edge (with no more than a trace of a shadow below it, to enhance its three-dimensional effect) is packed tightly with freshly picked fruits: grapes,

Roemer Visscher
'Vroech rijp, vroech rot'
(Soon Ripe, Soon Rotten)
From: Sinne-Poppen, Amsterdam 1614
Copper engraving

Jan van Huysum (1682-1749)
Fruit Still Life
Oil on copper, 50.5 x 42.5 cm
Rijksmuseum, Amsterdam

121

apples, figs, a pear and a quince. The stalks and leaves protrude from the basket's edge like sails rigged up on a ship. Some of them show traces of having been gnawed at by insects, while others are already dead and have shrivelled up. The apple has obviously been got at by worms. This shows that Caravaggio was not interested in showing the perfection of the fruits (as was the aim of earlier market paintings with their naive product aestheticism), but to express their transience. It is unlikely that the painting contains any deeper symbolism than this. In its isolation the basket was undoubtedly also different in function and meaning from Caravaggio's *Giovane con canestro di frutta* ('Young Man with Fruit Basket', p. 128), where the fruits were obviously attributes that supported an erotic (or homo-erotic?) motif.[115]

Typically, Italian and French fruit still lifes tend towards a strictly objective description of the actual phenomena (as in Jacopo Chimenti, Daniel Soreau and Louise Moillon). The Dutch, on the other hand, were still more in the tradition of "disguised symbolism" (to quote Erwin Panofsky) as something that gave depth to empirical precision.[116] Balthasar van der Ast's *Fruit Basket* (p. 123), for example, contains enough additional elements to show that he is concerned with more than a realistic rendering. Again, the vanitas theme is emphasized by the presence of bruises, bad spots and wormholes, as well as insects such as butterflies, dragonflies and house flies, as well as a lizard – a rather unusual sight on a table – which is nibbling at one of the apples outside the basket. Grapes, of course, often have a christological reference (cf. John 15:1), and Eddy de Jongh has convincingly shown the significance of grapes as religious symbols in family motifs of Dutch 17th-century paintings.[117] If we consider further that, in the context of the Virgin Mary, apples symbolize redemption and victory over sin, whereas insects and lizards were often associated with the principle of evil, then this harmless everyday motif suddenly turns into a scene (though on a smaller scale) of good versus evil in the history of salvation. Depending on the context, a fruit bowl or basket could have a positive or negative meaning. In genre paintings such as Jan Vermeer's *Sleeping Girl* (now in New York), the fruit bowl on the table refers to the 'fruits of evil': the young woman has lost her sense of responsibility, given herself to heavy drinking and possibly also committed adultery.[118] A bowl of fruit tends to have the meaning which Roemer Visscher gave it in his emblem which bore the motto *Vroech rijp, vroech rot* ('Soon ripe, soon rotten', p. 121)[119] (In Amos 8:1 the basket of ripe fruit seen by the prophet is described by God as a sign of the end – a Bible passage which often gave rise to negative interpretations and evaluations of a moralizing, warning or admonishing kind.) In Emmanuel de Witte's family painting, now in Munich, a child can be seen handing a bowl of fruit to his parents, and the father is taking out a bunch of grapes, thus signalling domestic harmony guided by religious rules and morals.

Fruit and vegetable still lifes were given a particularly strong aesthetic character in Spain. Despite enormous imports of precious metals from the American colonies, the country had become impoverished around 1600 because the gold had not been invested in any productive way. What is more, the working classes (such as the Moors) had suffered various waves of persecution, and the masses of the population were exposed to an unbearable yoke of taxes and duties. The lack of food was also reflected in the still lifes of Sánchez-Cotán and Juan van der Hamen where the composition is generally simple and avoids complexity. Sánchez-Cotán's still life (p. 124) contains only a small number of fruits so that they seem almost sanctified by virtue of their geometrical

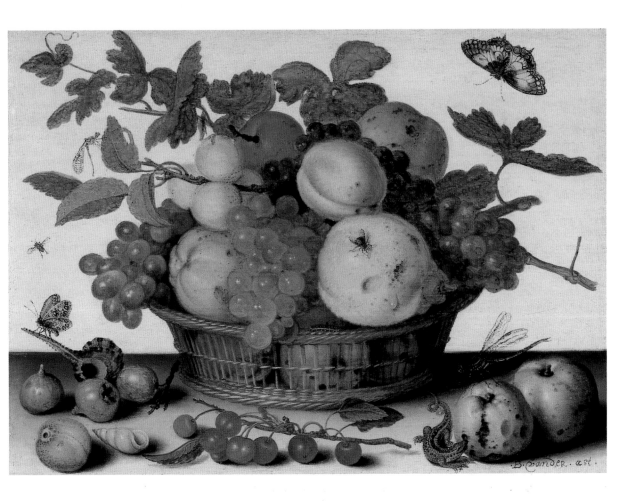

arrangement. Indeed, the festive presentation of these everyday objects was inspired by mystical notions surrounding St. Teresa of Avila (1515-1582) or St. John of the Cross (1542-1591), who were close to the people and emphasized the sacred nature of a simple, ascetic lifestyle, radically opposed to the wastefulness of the royal court. The parabolic arrangement of the fruit was to pay homage to neo-Platonic theories of proportion and harmony, as proclaimed in the Italian Renaissance. However, it can also be related to traditionally Christian and medieval ideas of beauty, where reference was frequently made to the Book of Wisdom (11:21): "Thou hast ordered all things in measure and number and weight" ('Omnia in mensura et numero et pondere disposuisti'). Calderón also alludes to this apocryphal Bible passage in *El Divino Orfeo*.

Balthasar van der Ast
Fruit Basket, c. 1632
Oil on wood, 14.3 x 20 cm
Stiftung preußischer Kulturbesitz, Staatliche Museen, Berlin

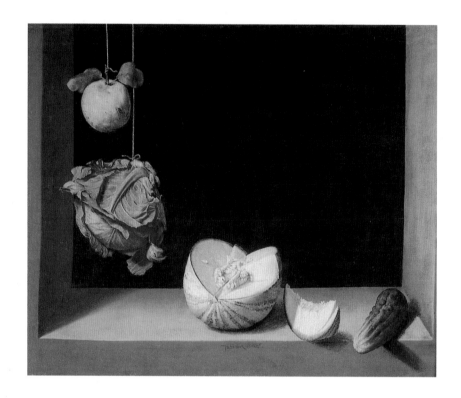

Juan Sánchez Cotán
Quince, Cabbage, Melon and Cucumber, c. 1602
Oil on canvas, 69 x 84,5 cm
Gift of Anne R. and Amy Putman
San Diego Museum of Art, San Diego, CA

In 1603 Sánchez-Cotán joined the Carthusian monastery El Paular as a
lay brother. During the same year, or shortly before, he painted the still
life above. With its strict geometrical structure it was totally different
from similar Flemish motifs which seem considerably more overloaded.
Aesthetically, it is akin to Caravaggism. The festive presentation of
simple everyday objects was undoubtedly inspired by mystical notions
surrounding St. Teresa of Avila (1515-1582) or St. John of the Cross
(1542-1591). The parabolic arrangement of the fruit was to pay homage
to neo-Platonic theories of proportion and harmony, as proclaimed in
the Italian Renaissance (Alberti, Pacioli et al.). However, it can also be
related to traditionally Christian and medieval ideas of beauty, where
reference was frequently made to the Book of Wisdom (11:21): "Thou
hast ordered all things in measure and number and weight" ('Omnia in
mensura et numero et pondere disposuisti'). Calderón also alludes to
this apocryphal Bible passage in *El Divino Orfeo*.

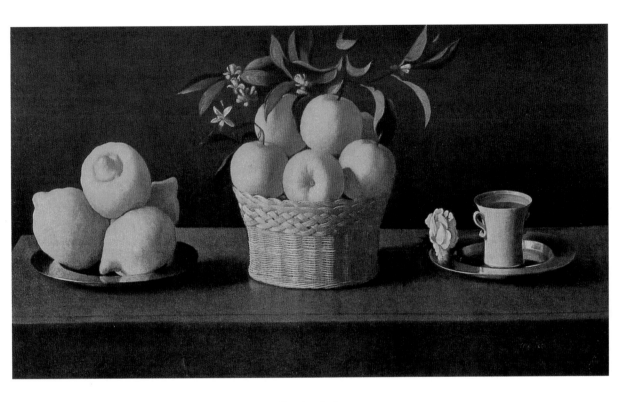

Francisco Zurbaran
Lemons, Oranges and a Rose, 1633
Oil on canvas, 60 x 107 cm
The Norton Simon Museum, Pasadena, CA

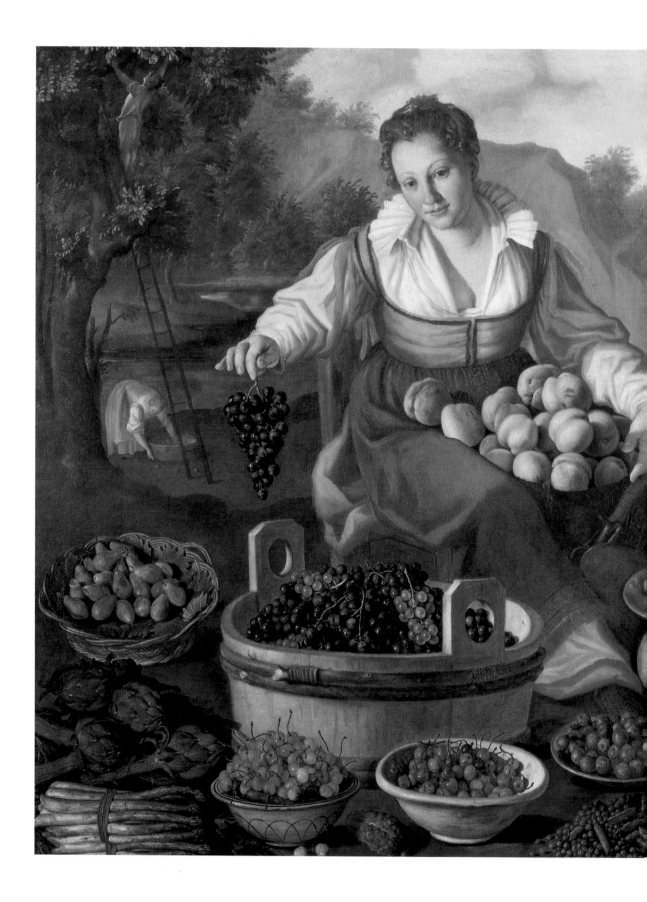

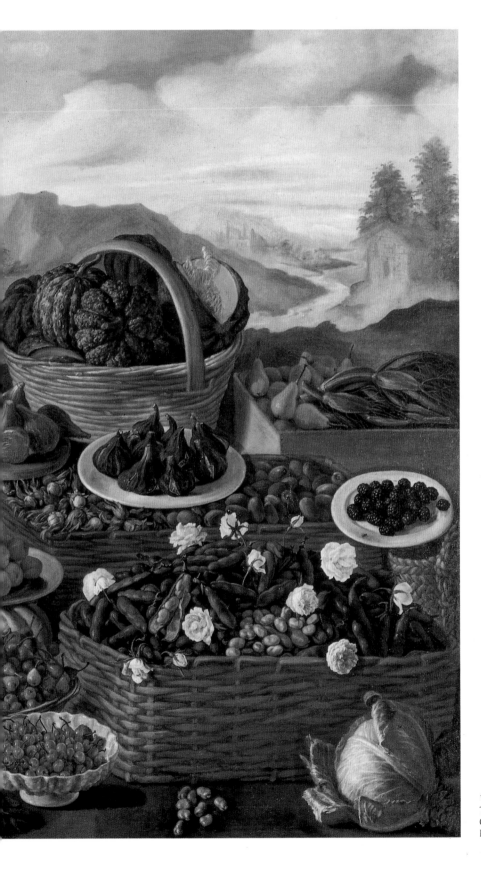

Vincenzo Campi
The Fruit Seller, c. 1580
Oil on canvas, 145 x 215 cm
Pinacoteca di Brera, Milan

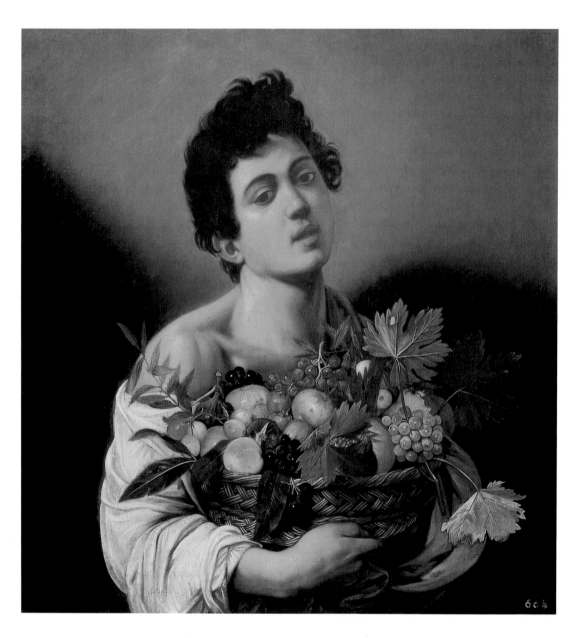

Michelangelo di Caravaggio
Young Man with Fruit Basket, c. 1593
Oil on canvas, c. 70 x 69 cm
Galleria Borghese, Rome

Louise Moillon came from a strictly Calvinist family. In 1640 she married the wealthy timber merchant Etienne Girardot de Chancourt, also a Huguenot. From then onwards she painted exclusively the motif of a fruit-laden plate or – as in this case – wicker basket on a table. Her colours were always cool, and she did not undergo any significant stylistic changes. Unlike Balthasar van der Ast (p. 123) she never painted insects or reptiles – animals which symbolically referred to the history of salvation. Peaches (Latin *malum persicum*) were regarded as a subspecies of apples in the 17th century and were associated with the same symbolism. However, it is unlikely that the artist intended any opposition between the 'Eucharistic' grapes and the peaches as a possible symbol of evil (*malum*). Rather, the co-occurrence of grapes and peaches was probably prompted by a theory of juices. According to Julius Caesar Scaliger (*In libros de plantis, Aristoteli inscriptos, commentarii*, Geneva 1566, lib. II) peaches before a meal prevent drunkenness from excessive wine-drinking.

Giuseppe Arcimboldo
Summer, 1573
Oil on canvas, 76 x 64 cm
Louvre, Paris

Giuseppe Arcimboldo
Autumn, 1573
Oil on canvas, 76 x 64 cm
Louvre, Paris

These paintings belong to a four-part cycle which was frequently
repeated by the Milan artist for the Imperial court at Vienna and
Prague. This particular series, which is now in Paris, had been
commissioned by the Emperor Maximilian II for the Elector August of
Saxony. – The Italian art historian Giovanni Paolo Lomazzo (*L'Idea del
Tempio della pittura*, Milan 1590, p. 154) described Arcimboldo's
allegories as *teste composte* (composed heads). The underlying principle
of these compositions is the use of elements from an object area which is
clearly distinct from others and in such a way that they add up to a
personified figure. The individual elements as such do not have any
mimetic properties; they only receive them when they co-occur with
others.

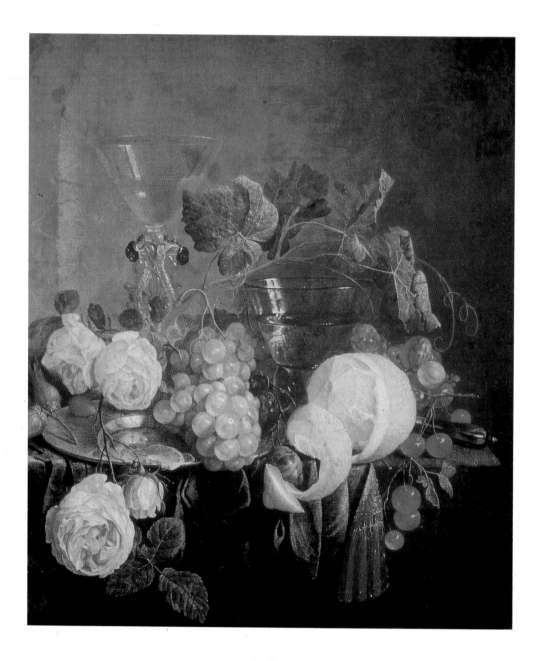

Jan Davidsz. de Heem
Still Life with Flowers and Fruit, c. 1650
Oil on canvas
Art Gallery and Museum, Cheltenham

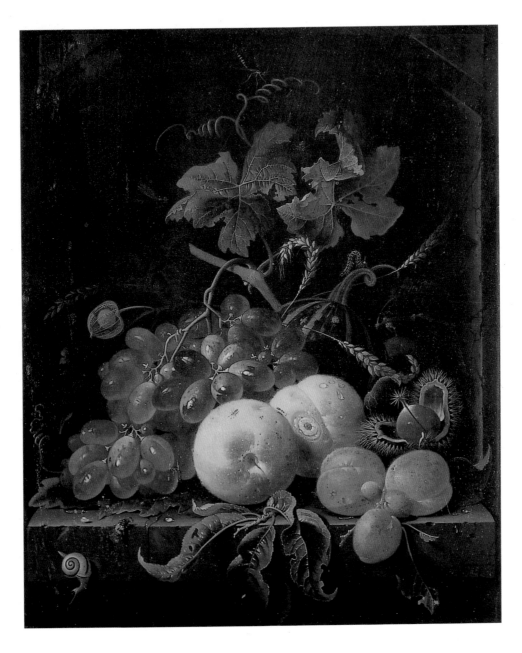

Abraham Mignon (1640-1679)
Fruit Still Life with Peaches, Grapes and Apricots,
2nd half of 17th century
Oil on wood, 40 x 32.5 cm
Staatliche Kunsthalle, Karlsruhe

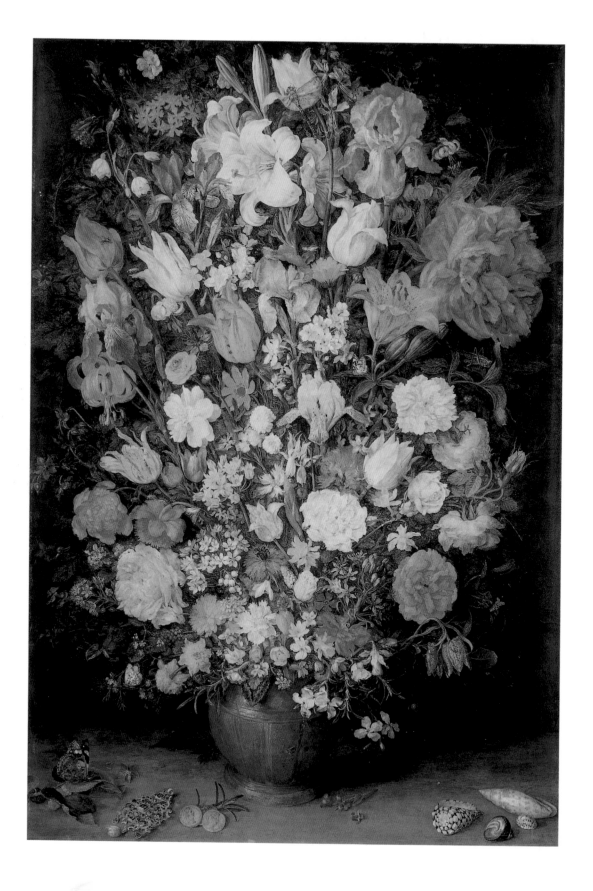

10 Flower Still Lifes

In the late Middle Ages it was above all flower still lifes which opened up the whole gamut of independent subjects, so that they were no longer dependent on other themes, such as the Virgin Mary. If the motif of flowers in a vase had already figured in numerous early Dutch scenes of the Annunciation – such as the centre panel on the Mérode Altar of the Master of Flémalle – this subject had become sufficiently widespread by the 15th century to achieve a measure of independence. However, this was by no means a sudden change, and at first flowers still occurred in conjunction with other paintings. When Hans Memling, for example, depicted a majolica vase on a table with a runner, it was quite typical of the time that he painted it on the reverse side of a donor portrait (1490).[120] The vase is decorated with Christ's monogram and filled with white lilies, irises and honeysuckle. All these flowers, which also have an important iconographic position in Hugo van der Goes's Portinari Altar, are related to the Virgin Mary.[121] *Lilia candida* were regarded as a symbol of chastity and Mary's immaculate conception, and irises – as a special form of lilies – symbolized Mary's rank as *regina coeli* ('Queen of Heaven'). The honeysuckle (*aquilegia*), on the other hand, was seen as a symbol of the Holy Spirit who, according to the Gospels, overwhelmed Mary at the Annunciation. The fact that the vase merely appears on the back of another painting shows that it only has a secondary, attributive function in relation to the person on the portrait. The Marian flowers bear witness to a vow taken by the client to the Mother of God, so that the entire panel is akin to a votive image. In accordance with the medieval method of interpreting pictures, flowers were still understood as symbols of a hidden, religious meaning, symbolic *integumenta* ('exteriors')[122] or *figurae*.

The homiletic and devotional literature of the late Middle Ages could be extremely subtle in its use of symbolism, and frequently made use of all available registers. To explain Christ's salvation of mankind and questions of morality the authors particularly delighted in using flowers, partly because they satisfied man's sense of beauty and partly because they had an extremely important role in folk medicine. They were regarded as medicinal herbs, and were always grown in the gardens of monasteries and convents for their pharmacy. Spiritual and physical wholeness – i.e., salvation through Christ and medical healing – were seen as one indissoluble unit.[123] Honeysuckle, for example, was valued for its healing properties and soothing effect during childbirth and was generally used as a gynaecological medicine, so that it could easily be related theologically to Mary and the whole area of conception and birth.

These ideas are reflected in the *Vases of Flowers* by Ludger tom Ring the Younger, painted in 1562 (p. 137), which show white lilies in the one painting

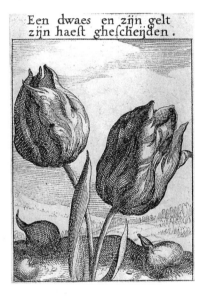

Romer Visscher
'Een dwaes en zijn gelt zijn haest gheschejden'
('A fool and his money are soon parted'),
in: Sinne-Poppen, Amsterdam, 1614
Copper engraving

Jan Brueghel the Elder
Bouquet, 1606
Oil on copper, 65 x 45 cm
Pinacoteca Ambrosiana, Milan

and golden brown irises in the other. Both vases bear the same Latin inscription, running diagonally downwards. According to Paul Pieper, the complete sentence would have read 'IN VERBIS IN HERBIS ET LA[PIDIBUS DEUS]' ('God is in words, in plants and in stones').[124] This aphorism summarizes the link, derived from the Bible, between the preaching of God's Word and botanical symbols of salvation. (It is also reminiscent of flowers as symbols of rhetorical devices – so-called *redebluomen* or 'speech flowers' in Middle High German – which denoted the embellishment of one's language). Ludger tom Ring seems to have intended these *Vases of Flowers* as wall decorations for a pharmacy, as the aphorism can be regarded as a motto which reflects pharmaceutical theory and practice as proclaimed by Paracelsus a quarter of a century earlier. This is further corroborated by the words 'in lapidibus' ('in stone'). Alistair C. Crombie has shown that this was also the time when the use of minerals as medicines was beginning to establish itself in the pharmaceutical and medical disciplines.[125]

Ludger tom Ring's method of painting flowers in a meadow was typical of illustrations in a 16th-century book on botany, these being increasingly based on exact observation. This interest in the appearance of individual flowers and herbs was in fact in evidence at a very early stage in Dürer's famous *Large Patch of Grass* (p. 145). One of his students was Hans Weiditz, who illustrated Otto Brunfels's Book of Herbs in 1530 (p. 144).[126] In his woodcuts, which far exceeded the text in their precision, he sought to capture everything that was important about a plant: "the form and order of roots and twigs, the shape of the leaves and the colour and form of the flower."[127] The same applies to his illustrations of books by Hieronymus Bock (1539) and Valerius Cordus (1561), who were not yet interested in comparative morphology, i.e., the comparison of the shapes of plants.

It is not possible to deal with the further development of botanical book illustrations here.[128] However, it is obvious that these illustrations led directly to 'pure' still lifes of flowers, though another source can also be seen in pattern books such as Joris Hoefnagel's *Archetypa* (p. 144), which aimed to satisfy the curiosity and interest of aristocratic clients. In 1576 Hoefnagel took up employment with Duke Albrecht V of Bavaria, and was later called to the Imperial court in Prague. He painted a large number of detailed studies of nature for Rudolf II. Their edges were still structured very much like the ornamental borders of miniature paintings in late medieval homiletic books such as *Hortulus Animae* ('Little Garden of the Spirit'). His "naturalism" (to quote Ernst Kris)[129] was based on the maxim, 'natura sola magistra' ('nature is the only teacher'). Nevertheless, his extremely precise depictions of nature are not free from witty aphorisms and mysterious hieroglyphs that were intended to refer to deeper meanings.

After Carel van Mander, Lodewijck van den Bosch was said to be the first artist to paint pure flower still lifes,[130] though not a single work of this genre has been preserved. It was under his influence that Jacques de Gheyn II and Ambrosius Bosschaert, both from Antwerp, painted flower still lifes that subsequently became prototypes. Having worked in Middelburg, the capital of the Dutch province of Zeeland, for a long time, Bosschaert even started a whole 'dynasty' that specialized in this subject, and the tradition he had started was continued by three sons, two brothers-in-law and a son-in-law.[131] The most famous of his works is no doubt his *Vase of Flowers* (p. 139), placed in front of a round, arched window. It is a small-format painting (64 x 46 cm) in the style of trompe l'œil pictures (as suggested by its strict parallel lines) and affords a view of the outside, showing a landscape with chains of hills and mountains, merging into a coastline in the distance, where its

LEFT:
Ludger tom Ring the Younger
Vase of Flowers with Reddish Brown and Yellow Iris Blossoms, 1562
Oil on oakwood, 63.8 x 26.6 cm
Westfälischer Kunstverein, Münster

RIGHT:
Ludger tom Ring the Younger
Vase of Flowers with White Lilies and Brown Iris Blossoms, 1562
Oil on oakwood, 63.4 x 24.6 cm
Westfälischer Kunstverein, Münster

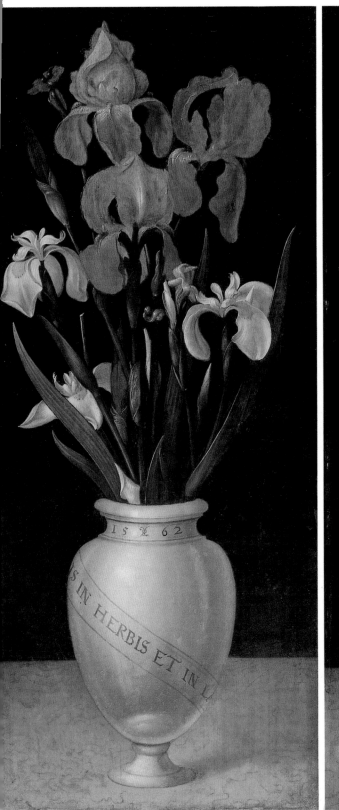
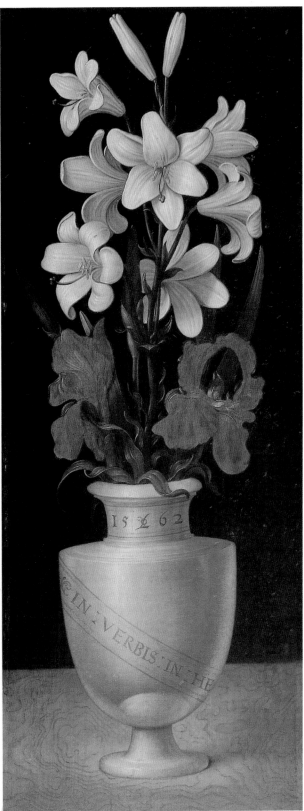

contours become delicately blue and hazy. The brownish glass vase with mask-like faces in relief at the bottom has been abundantly filled with a large number of flowers. Roses protrude over the edge, with an intertwining hyacinth and a lily of the valley. Above and beside them we can see, among others, honeysuckle flowers (by the window frame on the left), various kinds of tulips, violets, marigolds, anemones, crowns imperial and a yellow iris at the very top. Two carnations lie on the window-sill, on the left – one a bud and one a fully opened flower. On the right there are two rare shells. It has been observed that Bosschaert's still lifes, which are composed radially, combine flowers that blossom at different times, so that this is an idealized flower still life, a painted botanical encyclopaedia. Depictions of curio galleries have shown that pictures like these were often painted for the noblemen's collections devoted to the *scientia amabilis* (the 'delightful science'). They were an optical substitute for the real blossom which was so transient. The same may also be true of the *Bouquet*, by Jan Brueghel the Elder, painted shortly after 1607 and now in the Alte Pinakothek in Munich (p. 146). A smaller variant (from 1607) can be found at the Kunsthistorisches Museum (the Museum of Art History) in Vienna.[132] Unlike Bosschaert, Brueghel did not use landscapes as a background. Rather, protruding upwards from a wooden tub (a *blompot*, 'flower pot'), his myriads of flowers are set against a pitch-dark background, so that the contrast gives them a luminous quality. While Bosschaert prefered more cultivated flowers – rather costly at the time – and only depicted a few flowers of the fields and meadows among them, it is precisely these delicate plants that gave Brueghel the idea for a 'tapestry' of flowers. Indeed, there is such an abundance of different species that they often defeat identification – over 130 kinds have been counted up to now. It is indeed a tapestry, as all the blossoms seem to crowd towards the front, just as in a two-dimensional space. Brueghel's bouquets always build up from relatively small flowers at the bottom to increasingly larger ones at the top, completely against all our current aesthetic 'laws' of compositional gravity. The picture is dominated by a long-stemmed crown imperial – like a real crown. Below are some blue fleurs-de-lis, flanked by white lilies on the left and the red umbel of a peony. The centre is occupied by various kinds of tulips, which were also given special attention by Bosschaert. The exposed position of the crown imperial suggests that Brueghel intended it as a deliberately political and imperial symbol. In 1607, when this Viennese picture was painted (shortly before the Munich one), the Protestant and free imperial city of Donauwörth was occupied by Duke Maximilian of Bavaria in the name of the Emperor Rudolf II, who had been educated by Jesuits and inculcated with their Counter-Reformational ideas. The city was forced to revert to Catholicism and all its possessions were confiscated. This victory prompted all Protestant princes to align themselves in the Evangelical Union, and it also led to the formation of a counter-organization, the Catholic League (1609). It was a victory that was celebrated as the triumph of the Emperor's power to act as the protector of the Catholic faith.[133]

Furthermore, Brueghel also included strawberries, raspberries and black-berries in his bouquet (p. 146). This is because, right until modern times, no fundamental difference was made between decorative flowers and other flow-ers. Strawberries, for example, which blossom and bear fruit at the same time, were therefore generally included among flowers. This was already in evidence in still lifes such as the *Little Garden of Paradise*, painted around 1410 (p. 143). Strawberry blossoms were regarded as flowers of paradise, as the food of children who had died prematurely and as symbols of the Virgin Mary.[134]

Ambrosius Bosschaert
Flower Vase in a Window Niche, c. 1620
Oil on wood, 64 x 46 cm
Mauritshuis, The Hague

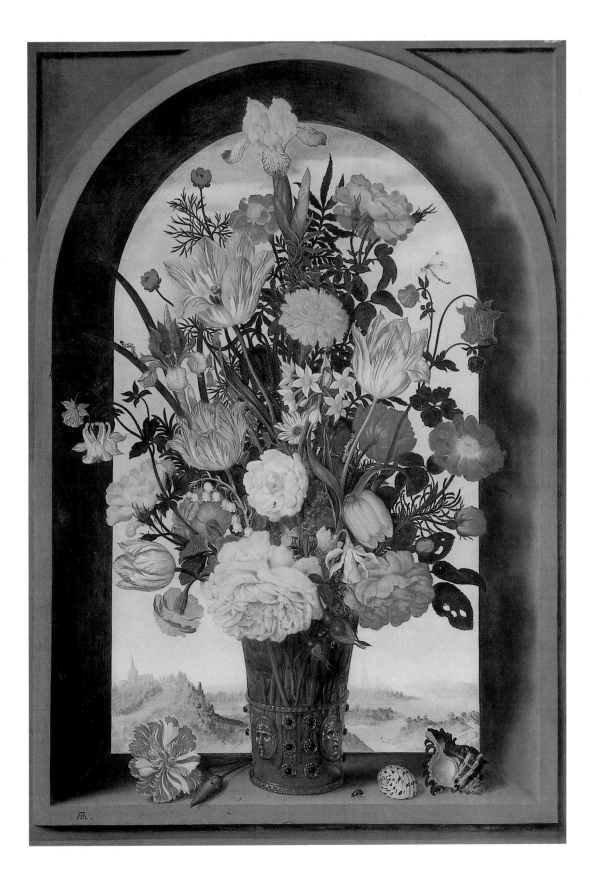

Tulipomania[135]

Both Jan Brueghel the Elder and Bosschaert were particularly interested in various kinds of tulips. At the turn of the 17th century this flower was still something of a horticultural novelty. In the mid-16th century it had been spotted for the first time by the Imperial Hapsburg tutor and ambassador of Ferdinand I at the Turkish court in Constantinople, Gislain de Busbecq, whereupon he sent tulip bulbs to the botanical gardens of Western Europe. Shortly afterwards, it was commented on in botanical literature, such as Conrad Gessner's *De Hortis Germaniae Liber*. Gessner, who claimed that he had seen tulips in the garden of an Augsburg patrician in 1559, described it as an extraordinary plant. Charles de l'Ecluse had them cultivated in the Imperial garden in Vienna and devoted a scientific essay to them, published in a book on plants in Antwerp in 1583. By 1629 more than 140 varieties had been produced through cross-breeding. Some were particularly rare and achieved high prices. In fact, during the 1630s, the Dutch tulip trade (in Haarlem, Utrecht, Leiden and Rotterdam) assumed such proportions that a special tulip exchange was set up to coordinate it. However, as commodity exchanges are closed market events that concern absent and standardized goods, such hectic transactions with non-standardized, highly perishable tulips were bound to lead to economic

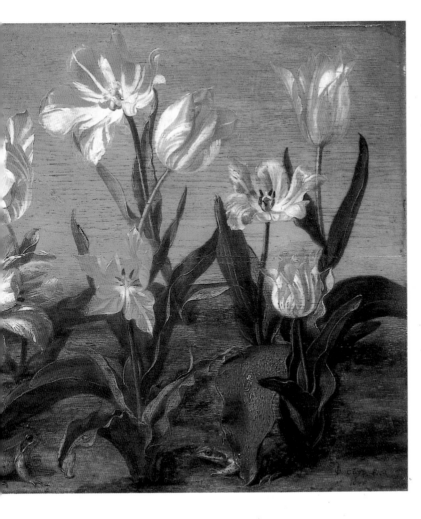

disaster. The tulip fever took hold of members of all classes who were involved in these speculations, and it did so to an extent that can hardly be imagined nowadays. In February 1637 prices sank so rapidly that, to prevent speculators from being ruined, the Dutch Parliament tried to subsidize them in an edict of April 27, 1637, though its attempt remained unsuccessful.

The fact that there was such a large number of Dutch tulip still lifes (pp. 140-141) in the first quarter of the 17th century must be seen in the context of this tulip boom and its breakdown, which led to financial ruin among large parts of the population. Balthasar van der Ast's *Beautiful Summer Tulip* is a good example. A single flower in a vase, it is apparently a specimen of a particularly valuable and rare species. (The most valuable tulip was considered to be the 'sky-blue' tulip which, according to Zedler's Universal Lexicon, had been seen by no more than a tiny number of people. The next on the scale were the speckled and the spotted ones, which included van der Ast's tulip). On the tulip exchange these paintings had to be used instead of the real objects, which only existed potentially in the form of bulbs. Thus their primary aesthetic purpose was that of supporting the economic process of buying and selling. Their beauty was not merely a matter of aesthetic pleasure; they were always looked at with a commercial value in mind.

Detail from illustration on facing page

A painter from the Upper Rhineland
Little Garden of Paradise, c. 1410
Oil on wood, 26.3 x 33.4 cm
Städelsches Kunstinstitut, Frankfurt

DeNARCISSO, & Hermodactylo.

Otto Brunfels
'Herbarum vivae eicones: De Narcisso &
Hermodactyl', 1530
Woodcut, c. 13.8 x 13.5 cm
Herzog-August-Bibliothek, Wolfenbüttel

George Hoefnagel
Archetypa studiaque patris, 1592
Etching, 15.2 x 20.6 cm
Private collection

Albrecht Dürer
Large Plot of Grass, 1513
Water-colour and gouache, 41 x 31 cm
Graphische Sammlung Albertina, Vienna

Unlike the extremely stylized depictions of flowers in the Middle Ages, Dürer's *Patch of Grass* already reflects a considerable degree of empiricism: all botanical details are rendered with almost microscopic precision, and Dürer tried to give the impression that this partial view was totally accidental by showing a chaotic arrangement of grasses, leaves and meadow flowers. The plants that have been identified are daisies, yarrow, plantains, dandelions, pimpernels and cocksfoot. Symbolic aspects are not likely to be involved here. Dürer was probably more interested in the medicinal and herbal aspects, as well as the healing powers, of different kinds of sap.

Giuseppe Arcimboldo
Spring, 1573
Oil on canvas, 76 x 64 cm
Louvre, Paris

Arcimboldo's *Spring* forms part of the artist's cycle of the Four Seasons which he painted a number of times. It is another *fantasia* or *invenzione* developed by him together with Giovanni Battista Fonteo. The motif is on the border between flower still lifes and stylized portraits (probably of the Emperor Maximilian II as a young man). It is worthwhile comparing it with Arcimboldo's *Vertumnus* (Autumn), a portrait of Rudolf II. – Both paintings show a systematic approach, reflecting the new system of scientific classification that was beginning to emerge. They display 'pure' flora, ranging from the herbs and flowers of the meadow (bottom) to the flesh-coloured, 'nobler' flowers that make up the face.

Jan Brueghel the Elder
Bouquet, after 1607
Oil on wood, 125 x 96 cm
Alte Pinakothek, Munich

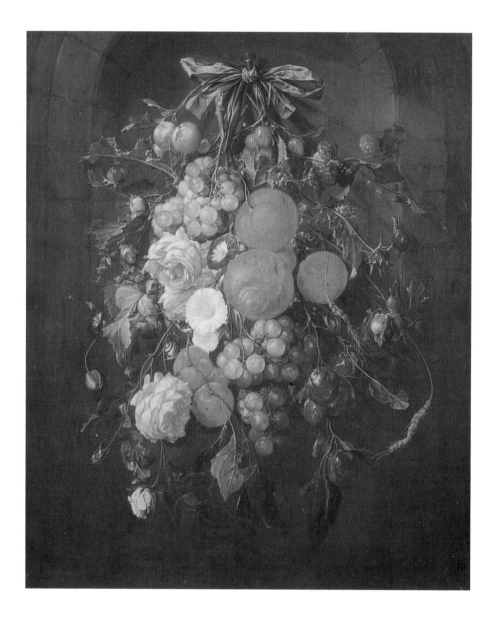

Cornelis de Heem
Still Life with Flowers, c. 1660
Oil on canvas, dimensions unknown
Private collection

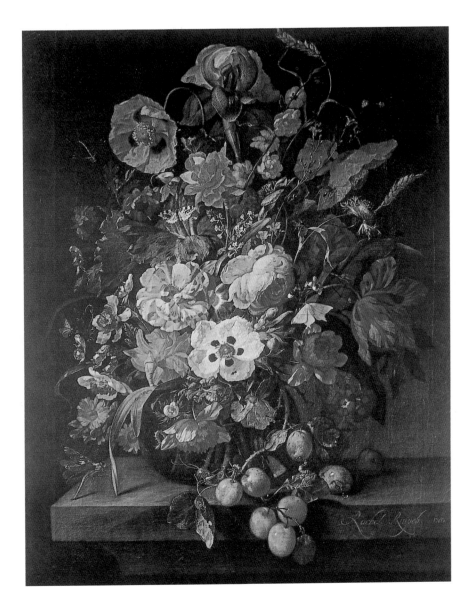

Rachel Ruysch
Bouquet in Glass Vase, 1703
Oil on canvas, 84 x 68 cm
Gemäldegalerie der Akademie der Bildenden
Künste, Vienna

11 Religious Still Lifes of Flowers and Fruit

Religious flower still lifes are a special category, first developed by the Fleming Daniel Seghers.[136] Born in Antwerp in 1590, Seghers was a pupil of Jan Brueghel the Elder and was made a master painter in his home town in 1611. On December 10, 1614 he became a lay brother of the Jesuit order and took his vows in Brussels in 1625. This order was still very young at the time, and his membership therefore secured him a measure of independence from the restrictive statutes of the Painters' Guild. Like Hugo van der Goes 150 years earlier, Seghers joined a monastery as a lay brother and then worked for high-ranking rulers, whom he was allowed to receive there. He was commissioned by numerous European princes, such as Prince Frederick Henry of Orange and Nassau, who repeatedly sent him gifts. He was visited in his studio by potentates such as Charles I and Charles II of England, and the Archdukes Ferdinand and Leopold Wilhelm. Seghers, who always signed his paintings with the words 'Societatis Jesu' (or S.J.) after his name, was famous far beyond the borders of his country. He received a large number of commissions, was also renowned as a landscape artist and exerted a lasting influence on a large number of pupils.

While Dutch paintings of flowers, particularly tulips, clearly showed a tendency towards secularization (with a noticeable emphasis on the economic and aesthetic value of flowers rather than their religious significance), Seghers tried to recover their spiritual symbolism, in accordance with the counter-reformational aims of his order.[137] They are set against dark backgrounds of cartouches or niches in shades of brown, with floral wreaths in glowing colours climbing up like garlands. Instead of being illuminated from outside, the wreaths seem to have a luminosity of their own (p. 150). This style can be traced back to the *Madonna in Floral Wreath* by Peter Paul Rubens and Jan Brueghel the Elder (p. 152, painted around 1620 and now in Munich's Alte Pinakothek museum), a picture within a picture[138] with an authoritative religious significance, encircled by a floral arrangement and cherubs.[139] Unlike Seghers, however, Rubens did not quote Mary and Jesus as historical traditions or pictorial relics. Instead he preferred to give the impression that they were physically present, even though the motif of a picture within a picture would have been ideally suited for illusionist stylization. Seghers, on the other hand, generally had the Madonna (and, depending on the purpose, at times also other 'pictures within pictures') painted in relief by some artist colleague before surrounding it with flowers and/or fruit. Thus his pictorial concept served to emphasize its character as a religious object, without any real presence of Mary or Jesus. They were devotional pictures, intended to confirm the practice of church worship, communicated through the illusionist reproduction of the religious object itself. It was not the artist's intention to produce a true-to-life

Detail from illustration page 152

Daniel Seghers (1590-1661)
Cornelis Schut and *J. van Thielen*
Floral Wreath with Madonna and Child, undated
Oil on copper, 107.5 x 79.5 cm
Museum voor Schone Kunsten, Ghent

151

fictitious reality that would enable the believer or viewer to bypass the Church and to enter into devout communication.

Apart from the Virgin Mary, Seghers and his pupils also had a preference for Eucharistic motifs. They particularly enjoyed painting arrangements of garlands around a niche in a wall in brown hues, showing a communion chalice with a host suspended above it. The host has a mysterious lumiscent quality which emphasizes the process of transubstantiation (the changiong of bread and wine into the body and blood of Jesus). This subject was painted especially frequently by Jan Davidsz. de Heem,[140] an artist who was born in Utrecht but spent a considerable amount of time in Antwerp, where he died in 1683 or 1684. It is assumed that de Heem learnt to paint in Utrecht, under Balthasar van der Ast, and he was probably also influenced by David Bailly who worked in Leiden, though de Heem was inspired far more by Daniel Seghers in Antwerp. Like Seghers, de Heem succeeded in adding a phosphorescent luminosity to his garlands, which also have an enamel-like clarity about them and richly colourful nuances. In his Eucharistic motifs they consist of fruit – particularly grapes – and bundles of grain, as well as apples, pears, figs and maize. The human eye can hardly appreciate the infinitely delicate precision of the tender, thread-like stems and little twigs winding around the jumble of the painstakingly detailed fruits (p. 153). The Eucharist had a particularly prominent place in the Catholic Counter-Reformation, as a response to the Protestant doctrine that bread and wine merely had a symbolic value during communion.[141] It was no coincidence that the *Triumph of the Eucharist*, which was celebrated in whole series of tapestries (e.g., by Rubens) was seen in the light of Catholic theology and understood as a triumph of the Roman Catholic Church. For the same reason, the most religious potentates at the time, who saw themselves as *propugnatores* (pioneers or champions) of the Church, were particu-

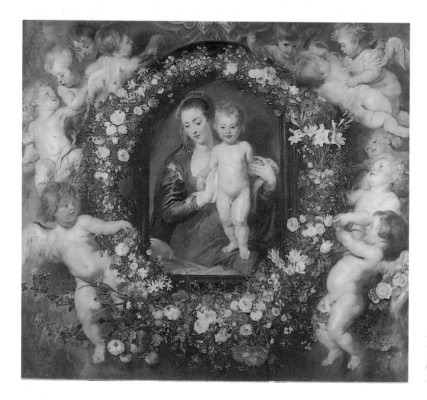

Jan Brueghel the Elder and
Peter Paul Rubens
Madonna in Floral Wreath, c. 1620
Oil on oakwood, 185 x 209.8 cm
Alte Pinakothek, Munich

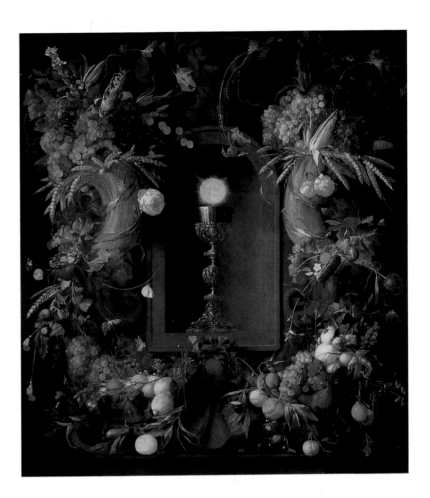

Jan Davidsz. de Heem
Eucharist in Fruit Wreath, 1648
Oil on canvas, 138 x 125.5 cm
Kunsthistorisches Museum, Vienna

larly concerned with the cultivation and protection of eucharistic rites. Unlike the 'rationalist' interpretation of communion by the Christian reformers, the Roman Catholic doctrine of transubstantiation emphasized the element of magic which continued to be popular among the people. On the other hand, ever since the Hussite wars (1420-36), there had already been opposition on the part of the laity to the claim that sacraments could only be administered by the clergy, and particularly the idea that the chalice should be reserved entirely for the priest. Instead, it was demanded that the laity should be treated as equal and allowed to participate.[142] De Heem's paintings, and those of other artists, show that the Roman Catholic Church of the Counter-Reformation had not substantially revised its position with regard to the Lord's Supper: as before, the tall, ornate chalice was given an unmistakeable festive dominance. Also, the communion host was shown as luminescent during the process of transubstantiation. It is true, of course, that the demands of the laity to partake of communion *sub utraque specie* (i.e., both kinds) was recognized in the painting by the prominent position given to the communion host. But it was no longer what it used to be, i.e., the spiritual property of the laity. Instead, it was depicted as a remote object of awe and a miracle performed by the clergy in a sacred act. This veneration of the host, as celebrated by de Heem's painting, was the recognition of the superior spiritual position of the clergy.

153

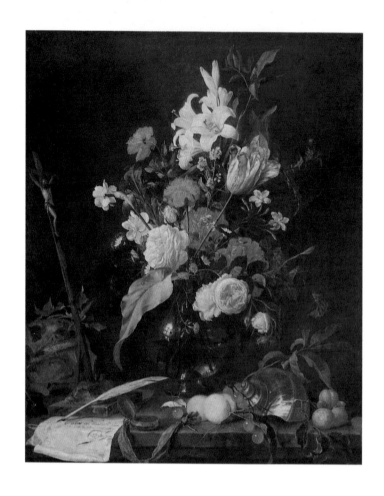

Jan Davidsz. de Heem and
Nicolas van Veerendael
Flower Still Life with Crucifix and Death's-
Head, c. 1665
Oil on canvas, 103 x 85 cm
Alte Pinakothek, Munich

OPPOSITE PAGE:
Jan Brueghel the Elder (1568-1625) and *Pieter
van Avont* (1600-1632)
Holy Family in a Flower and Fruit Wreath,
undated
Oil on wood, 93.5 x 72 cm
Alte Pinakothek, Munich

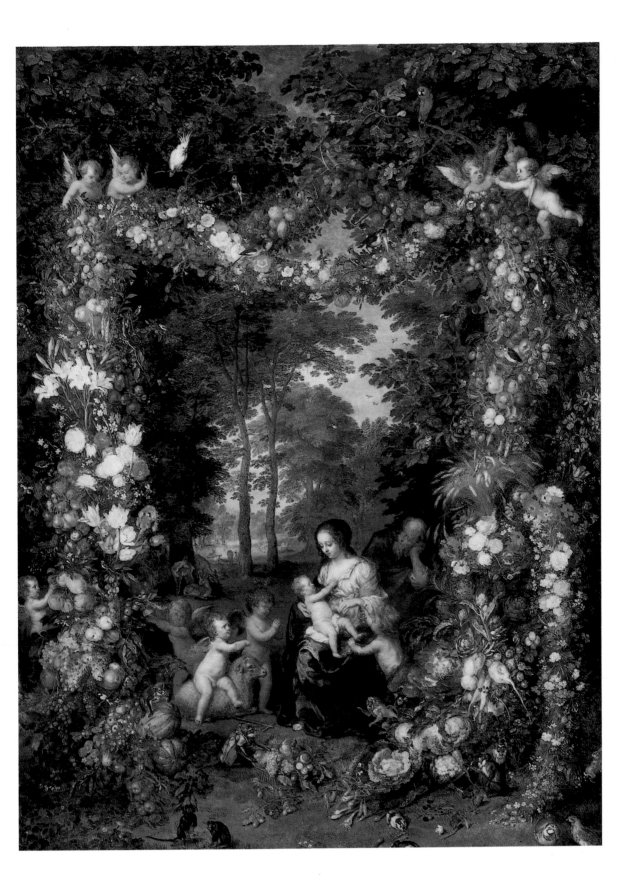

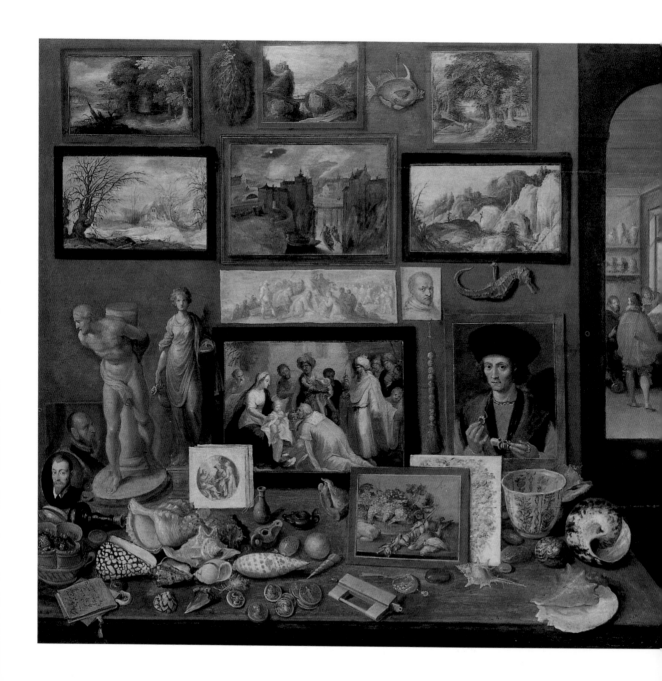

12 'Museums', Wonder Chambers and Natural History Collections

A number of developments had taken place which revolutionized the whole area of knowledge and had a lasting effect on traditional scientific methods, and indeed on man's general understanding of science. Technological innovations had led to the production of luxury goods, zoological and botanical studies had brought about the improvement of agricultural production and horticultural techniques, and geographical voyages of discovery, aimed at importing gold and silver, had covered the hard cash deficit that was crippling trade. Until the late Middle Ages man had adhered to one concept of nature handed down from antiquity, in particular a belief in the miraculous. The model of *natural history*,[143] as developed by Aristotle and Pliny the Elder in *Naturalis Historia*, was still considered to be exemplary and valid. In the Middle Ages it merely underwent some minor modifications, with moral allegories and theological content added to it, as for example in the *Physiologus*.[144] Ancient and medieval science was still largely marked by notions of magic and clairvoyance – typical reflections of a stationary system of barter economy, as well as a poorly developed infrastructure and system of distribution. Many gaps in people's knowledge had to be filled by their imagination and, although the principle of official certification and reliability already existed (as shown in Herodotus' reflections on his method of historical presentation), the economic and infrastructural conditions of communication still made it impossible for such a principle to reach any high degree of accuracy.

All this began to change radically from the late 15th century onwards. It was no coincidence that Ermolao Barbaro (1453-1493), the editor of the works of Dioscorides and Pliny, wrote a book with the characteristic title *Castigationes Plinianae*[145] – 'Castigations of Pliny,' in which he pointed out several thousand errors made by the ancient scientist. Even Aristotle and Theophrastus (in his *History of Plants*) came under considerable criticism for their description of Mediterranean plants and animals. Until then the pronouncements of these writers had been understood as irrefutable. Now, however, they were being replaced by an author's own insights, gained through empirical observations and captured mainly in the form of illustrations. Indeed, to communicate scientific discoveries nothing was considered to be more relevant than illustrations. This could be seen especially clearly in botanical works, e.g., Otto Brunfels' book on herbs,[146] which is worth noting for its abundance of illustrations, drawn by artists who were celebrities at the time but who were not always mentioned in the book. Marie Boas has correctly pointed out that the graphic immediacy of these pictures was necessary because no technical terminology or descriptive techniques were available.[147] Hans Blumenberg has shown that in early modern times scientific

Detail from illustration pp. 168/169

Franz Francken II
Art Room, after 1636
Oil on wood, 74 x 78 cm
Kunsthistorisches Museum, Vienna

157

objects had to be visible and perceptible.[148] It was not until the 19th century that botanical and zoological illustrations began to display elements of morphological abstraction in order to show biological regularities. As before, Horace's maxim of *delectare et prodesse* was followed – giving pleasure and being useful. Leonhard Fuchs wrote in 1542, "What more should I say about the pleasure and the joy of acquiring knowledge about plants? Everybody knows that there is nothing more enjoyable and beautiful in life than walking through the woods, hills and valleys decked with little flowers and plants of different kinds and eagerly examining everything. But this pleasure and enjoyment are considerably enhanced when complemented by some knowledge of the forces and effects of the same."[149]

Scientific thought in the early modern era was governed by the principle of *curiositas* ('curiosity' or 'inquisitiveness').[150] In the theological literature of the Middle Ages man's search for new things and his joy in making independent discoveries was looked upon as something negative. (Nevertheless, although curiosity was branded as a cardinal sin – and indeed for the first time by St. Augustine[151] – there had always been innovative insights, even from theologians, and we are therefore not entirely justified in following Hans Blumenberg's otherwise very inspiring study and only dealing with aspects of the history of ideas.) However, a change began to occur at the beginning of the 16th century, as documented by Leonardo's *Fragment of Speleology* (i.e., the study and exploration of caves), where the author states at the very beginning that as soon as he had entered a cave he was seized by a strong feeling of desire. Two feelings had got hold of him – horror and craving: "horror of the menacing darkness of the cave and a craving to explore it, to find out whether something fascinating might be found inside . . ."[152] Leonardo's words about this cave are a reflection of *curiositas* as it was generally understood by his contemporaries. Whenever people at the time were confronted with something strange that had been unveiled or discovered through man's curiosity and inquisitiveness, they were filled with pleasurable terror. This, indeed, was the impression they gained from natural history collections and wonder chambers, also known as curiosity cabinets. Olaus Worm's engraving from 1655 (p. 159), displayed at Elzevier's in Leiden, shows a collection of cabinet pieces which convey some of this delight mingled with horror. Suspended from the walls and ceiling there are exotic stuffed animals, such as bears, fish, crocodiles, the shells of giant water tortoises, armadillos and the like – all of them trophies brought home from dangerous voyages. Adam Olearius, the court scholar who in 1674 described the Gottorfisch collection in great detail, praised the potentates for their excellent efforts and for not sparing any expense in their 'research of nature and promotion of the sciences.'[153] And, indeed, these royal collections – sometimes even called 'museums' – were centres of expensive research in which princes like Rudolf II himself sometimes took an active part. Of course, they were not yet guided by an interest in classification (though we can gather from the labels on some of the display cases in Worm's engraving that the first hesitant beginnings were being made). Rather, they were guided by a naive craving and feeling of awe for the miraculous, and anything strange and uncanny. *Naturalia* – *objets trouvés* such as pearls and shells – were mixed quite happily with *arteficialia*, that is, precious man-made objects including coins, medals, paintings, sculptures, Nautilus goblets, astronomical gadgetry, etc. Frans Francken II's (1581-1642) *Collection of Cabinet Pieces* (p. 156) is a good example.[154] The paintings that were propped or hung up in these cabinets often had the function of replacing the reality

Olaus Worm
Museum Wormianum, 1655
Copper engraving, 35.6 x 22.6 cm
Schleswig-Holsteinisches Landesmuseum,
Schleswig

depicted in them. This is especially true of flower still lifes which were to make certain species permanently available to the viewer, even though they were in blossom at different times. It was one of the late effects of a magical view of art, verging on illusionism, in which pictures were seen as substitutes for reality.

Like Francken II, Jan van Kessel (1626-1679) also painted curio cabinets. He was a grandson of Jan Brueghel the Elder through his mother Paschasie. Together with Erasmus Quellinus (1607-1678) van Kessel painted four *Allegories of Continents* in the form of wonder chambers as large as palace rooms (pp. 160-169). In his artistic principles he followed Jan Brueghel the Elder's depictions of the Five Senses, now in the Prado. Van Kessel's cycle (in Munich)[155] gives an intercultural, ethnographic comparison of the four continents that were known at the time – Europe, Asia, Africa and America. Surrounded like a frame by views of cities (some of them attributed to the wrong places), the inside panels bear impressive witness to the culture of each continent, together with collections of animals, diagram-like pictures of insects, etc.

Europe (p. 162) – represented by Rome, with the Castel Sant'Angelo visible on the left – revolves entirely around the Christian faith, symbolized by the Bible on the left ('Biblia ad vetustissima exemplaria castigata . . .'), a recent bull from Pope Alexander VII (1665) and a cardinal's hat. In the foreground, in front of the continent's personification in the form of cherubs and a horn of plenty, are some objects of Europe's cultural heritage which probably do not refer to any of its glory, as they are more representative of various vices: a wine jug, backgammon a game, playing cards, a painter's palette (!), a tennis racket, a *Römer* wine-glass with a lemon, a coin box with a piece of paper showing someone's debts at the baker's and the brewer's, and a purse with coins. (An emblem by Roemer Visscher with the motto 'Pessima placent pluribus' – 'Most people like the worst things' – shows a man behind a cartouche with dice,

Jan van Kessel
Europe (centre panel), 1664-66
Oil on copper, 48.5 x 67.5 cm
Alte Pinakothek, Munich

playing cards, tennis rackets and backgammon counters. He is drinking from a
cup, and refilling it again immediately. Thus the emblem depicts two vices –
intemperance and gambling.)[156] The objects in the picture also include Pliny's
Naturalis historia. Perhaps the artist already found it scientifically unreliable in
the sense of Ermolao Barbaro's *Castigations of Pliny* and he therefore put it into
this negative context. Van Kessel's paintings of flowers, animals and particularly
insects were indeed closer to the new empirical approach of microscopic analysts
(such as Marcello Malpighi, Jan Swammerdam, Antoni van Leeuwenhoek)[157] than
the views of botany and zoology handed down from antiquity, even though his
continent pictures still had not shed entirely a belief in the miraculous. – The easel
with mandrake creatures, placed at an angle on the left, is rather an oddity. The
mandrake, a turnip-like root shaped like a human figure, was believed to have
magic powers and was used as an aphrodisiac.[158] Numerous botanists and zoologists
- such as Hieronymus Bock – took an interest in this anthropomorphic plant, with
special reference to Pliny and Dioscorides.

In the middle of the *Europe* painting a bearded man, possibly the artist
himself, is pointing at various species of butterflies, insects and flowers on

Jan van Kessel
Europe, 1664-66
Oil on copper, centre panel, 48.5 x 67.5 cm
16 plates, 14.5 x 21 cm each
Alte Pinakothek, Munich

Jan van Kessel
Africa, 1664-66
Oil on copper, centre panel, 48.5 x 67.5 cm
16 plates, 14.5 x 21 cm each
Alte Pinakothek, Munich

pictu... ...e also the painter's
... ...form of wriggly
w...

smo... ...his child. He is
... ...America (!).
Theyly imported
from Ja... ...knowledge
was rath... ...ated on a
tame lion,ed by the
presence ofy have been
put up betwee... ...olonies' the Greek
philosopher di... ...mpire of the Ptolomies in
Egypt by Alexa... ...special attention in this painting
because of his de... ...Africa. On the walls above we can see
pictures of mythica... ...ch as a harpy (a woman with the body of a bird),
a hydra-like seven-h...ed bird, a phoenix and a griffin. Van Kessel also gave
special prominence to a nautilus goblet (on the right), generally associated with

[Handwritten note:] Willem Kalf / Abraham mignon / Giuseppe Arcimboldo / Jan van Huysum

163

Africa, because the shells frequently used by goldsmiths on these goblets originated there. Africa is not represented by a capital city, but the centre plate bears the inscription 'Le temple des idoles' which points to the depiction in the background of natives worshipping an idol in a cave.[159]

Asia (p. 164), on the other hand, does have a spiritual centre. It is represented by Jerusalem, of which the Anastasis Rotunda can be recognized in the background on the left. The female personification of the continent is wearing rich blue clothes with a veil pinned up, indicating Moslem custom. Standing next to her is a Turk with a turban and a sceptre. As an equivalent of the mandrake figures in *Europe*, *Asia* contains a small shrunken body, in the bottom left-hand corner, without lower arms and feet. Van Kessel saw Asia as consisting of two empires - the Ottoman Empire (Asia Occidentalis), whose religious teachings are laid down in the Koran (indicated by an open book on a chair, with the words 'Alkoran Sive Lex Turcarum Et Sarracenorum A Mahomete Pseudopropheta Corrasa, Impres . . .') and the Chinese Kingdom (Asia Orientalis), whose religion is represented by a statue of Buddha (the god Ninifo) and oil lamps. It is a motif which van Kessel had taken from Joan

Jan van Kessel
Asia, 1664-66
Oil on copper, centre panel, 48.5 x 67.5 cm
16 plates, 14.5 x 21 cm each
Alte Pinakothek, Munich

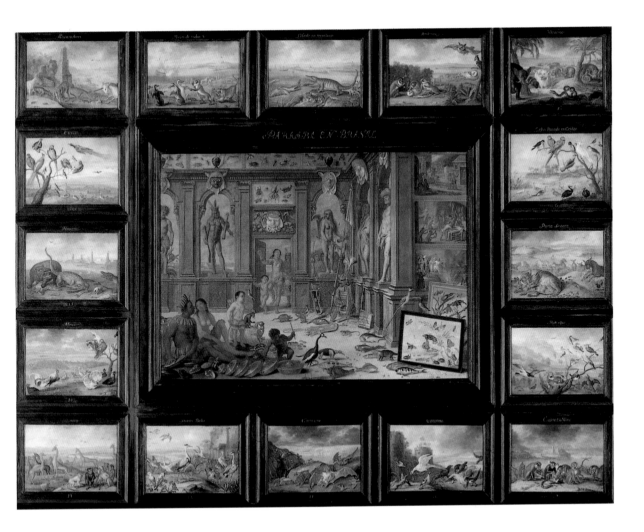

Jan van Kessel
America, 1666
Oil on copper, centre panel, 48.5 x 67.5 cm
16 plates, 14.5 x 21 cm each
Alte Pinakothek, Munich

Nieuhoff (*Het Gesamtschap der Neerlantsche Oostindische Compagnie*, Amsterdam 1665).[160]

America (p. 165) was painted in 1666 and is represented by a large room that resembles a conservatory or orangery, with sculptures of American Indians at the back and of two scholars in the arches on the right. The crowns of the arches are decorated with two masks. Seated on the floor are a black man with a head dress, and an Indian woman with her little son who is already carrying a quiver full of arrows. Again, van Kessel has made a number of ethnographic mistakes: the gongs the little black boy is playing with come from South East Asia, as does the Samurai armour in the corner of the room. These inaccuracies show that, although the painter was obviously concerned with the empiricist idea of *experimentum* (which still meant 'experience' at the time) in the various details, his art was still dominated by his love of the extraordinary and the exotic – elements which pervaded the general spirit of the royal wonder chambers and natural history collections. However, it is worth noting that the different continents and their cultures are already depicted as being equal in value. Visually at least, Europe is not given an overtly predominant position.

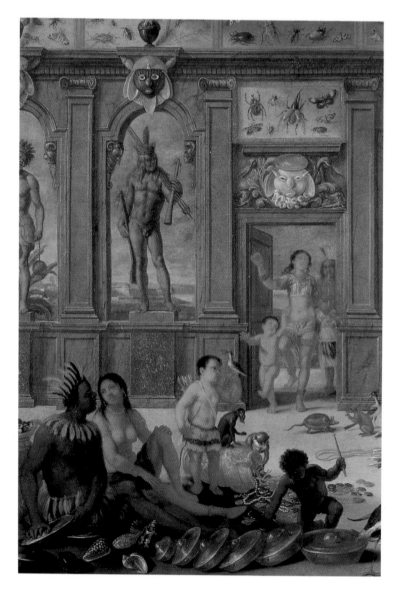

Detail from illustration page 165

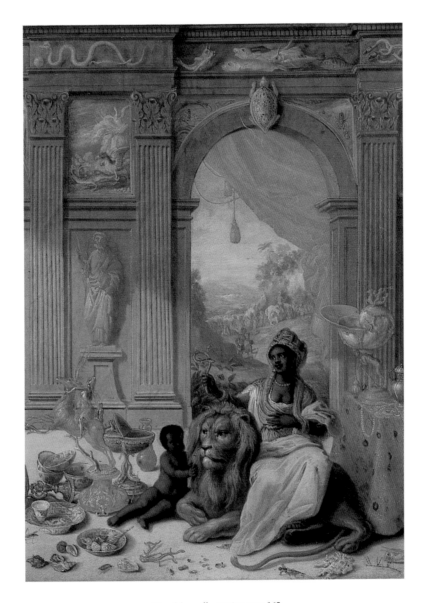

Detail from illustration page 163

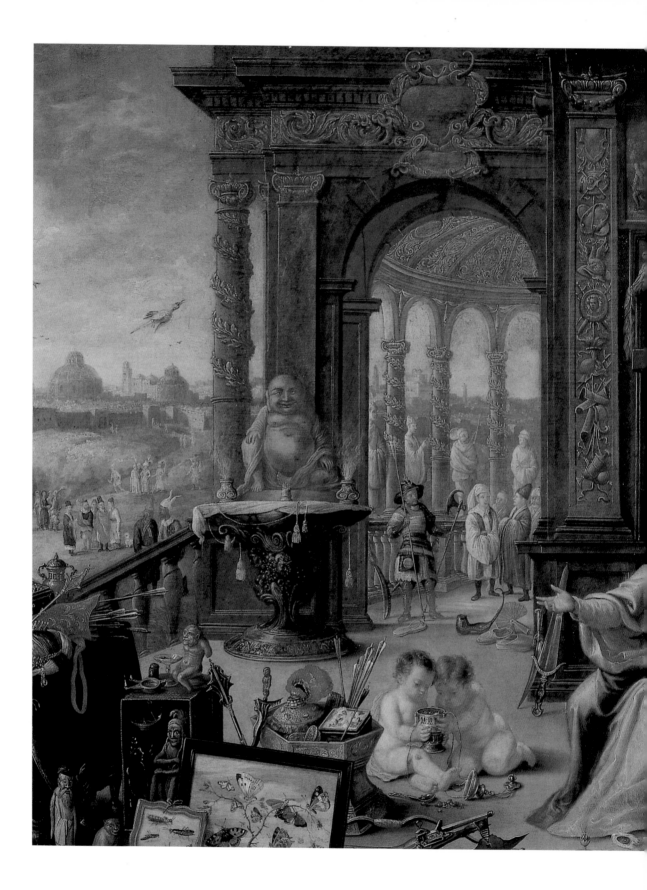

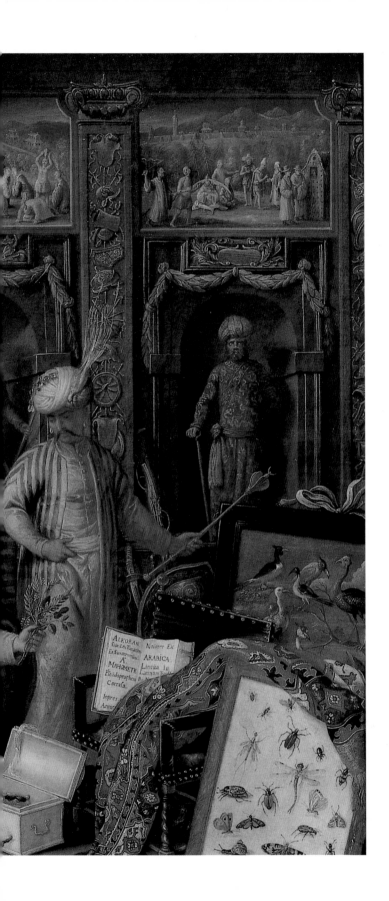

ALKORAN
Siùe Lex Turcarum
Et Saracenorum
A'
MAHMETE
Pseudoprophera B
Coriala.

Noùtrer Ex
ARABICA
Linùùa in
Latinùm

Jan van Kessel
Asia (centre panel), 1664-66
Oil on copper, 48.5 x 67.5 cm
Alte Pinakothek, Munich

13 Musical Instruments

Musical divertimenti had been a popular artistic theme since the 15th century. At first they occurred in a biblical or religious context, such as angels giving praise to God with music (as on Jan van Eyck's altar in Ghent). Later, however, artists made increasing use of allegorical and pagan or mythological motifs. One subject was the power of music, expressed in the myth of Orpheus soothing animals with his stringed instrument.[161]

A famous early 16th-century musical scene is Giorgione's *Fête champêtre* from 1510. Two men with different social backgrounds are playing music in the company of two allegorical female nudes on the hill of an Arcadian *terra ferma* landscape. Music here is understood as a symbol of harmonious communication between different social classes.[162] Music was, of course, the subject of many Italian Renaissance paintings, as well as Dutch 'merry society' paintings in the late 16th and early 17th centuries (pp. 74/75), where easy-going and erotically exuberant youngsters are shown singing or playing music in pubs or elegant palaces,[163] and music was also depicted as a positive symbol of family harmony[164] (p. 179). When we consider that still lifes of musical instruments as a special genre were derived from these conversation pieces and also from religious or mythological scenes, it is all the more surprising that they were really only cultivated in any pure form by a single artist – Evaristo Baschenis.[165] Very little is known about this artist. Born in 1607 (or 1617?) to an old family of painters, he lived and worked in his home town until his death in 1677. Baschenis trained for the Roman Catholic priesthood, but in addition to his profession as a clergyman he also worked as a painter. Musical instruments were not his only subject, he also specialized in fruit and vegetable still lifes. In addition, there are a number of genre pictures painted by him, as well as a group portrait showing the artist himself at a harpsichord, together with an older man accompanying him on the lute.

Baschenis painted his musical instruments for aristocratic clients, and even today many of his works can be found in palaces and villas in and around Bergamo. It seems likely that he depicted almost exclusively string instruments and, indeed, the especially valuable ones that belonged to his aristocratic patrons – the kind that were produced by the Amatis, a family of violin makers in neighbouring Cremona. Amati violins – as, for example, in his famous still life of the Galleria dell'Accademia Carrara in Bergamo (p. 175) – are frequently at the centre of his compositions. Our glance passes from the scroll to the peg-box, where the rather long ends of the tight strings have curled up, then to the bridge between the F-holes. As the string instrument has been depicted in an extremely foreshortened manner, the bridge functions as the highest point in the arrangement of the painting, composed as a segmental arch. Baschenis had

Detail from illustration page 173

Michelangelo da Caravaggio
Eros as Victor, 1596-98
Oil on canvas
Stiftung preußischer Kulturbesitz, Staatliche
Museen, Berlin

apparently developed an acute awareness of the three-dimensional character of the instruments and their precious varnished woodwork, and it is typical of this artist that he arranged them in well-thought-out chaos on a table parallel with the edges of the picture, so that the elegant reddish brown of the instruments makes them stand out against the dark, homogeneous wall. The centre of perspective is so low – in fact on the same level as the bridge of the violin – that the instruments, which partly cover and overlap one another, can only be perceived incompletely. On the right, for example, an isolated scroll and peg-box of a cello protrude, while very little can be seen of the resonant body of the cello itself, propped up against the narrow side of the table. A lute and a theorbo have been placed on the table in such a way that we cannot see their flat sides with the sound hole and frets. The instrument on the left seems like a semi-circular segment with radiuses, of which only the light reflex and a faint gleam on the lustreless varnish gives a hint of its stereometric structure, whereas the lute placed upside down on the right,with the narrow intarsias, shows these structures very clearly.

The painting captures a situation after a concert when the players have put down their instruments and their shared music and left the room. It is this element of chance which particularly inspired Baschenis, so that the aesthetic content of the composition is less concerned with the functional aspect of the instruments than the craftsmanship and quality of their material.[166]

However, our image of Baschenis would be rather one-sided if we were to regard his depictions of musical instruments as *no more than* homage to the highly developed art of violin-making in Cremona. His pictures also have a symbolical meaning which – apart from the obvious allusion to our sense of hearing – goes back to a tradition of musical theory that had its roots in antiquity. Apparently, Pythagoras had already understood musical proportions – i.e., the principle of monochords or the length of different strings – as something that can be arranged numerically (*numerus*)[167] and which therefore reflects the harmonious structures of the universe. In 1491 St. Augustine's *De Musica* was published in Venice and subsequently became very common throughout Italy. Augustine maintains that all sensorily perceptible notes (the *numeri sonantes* of music) point to God as *creator omnium*.[168]

Ever since the Middle Ages a therapeutic function had been ascribed to music. In chapter two of his book entitled *Summa Musicae* Johannes de Muris (c. 1290 – c. 1351) wrote: "Musica medicinalis est et mirabilia operatur, musica morbi curantur, praecipue per melancholiam et ex tristia generati" ('Music is therapeutic and works miracles, and illnesses are healed by it, especially those arising from melancholy or sadness').[169] Aspects of cosmology and musical therapy are expressed more clearly in the *Still Life with Musical Instruments* (p. 173). Because of its 'leathery colours' stylistic critics have decided that it was painted in Baschenis' studio but not by the artist himself. Be that as it may, there can be no doubt that the painting is based on Baschenis' conception, and Marco Rosci has pointed out that the artist was usually commissioned for two paintings of musical instruments at a time, of which he painted one himself, while leaving the other to one of his associates. Only right at the end would he add the finishing touches so that it would match the one he had painted himself.[170] The painting, which is now in Cologne, has a pale, sombre quality about it and is dominated by hues of grey and black (e.g., as in the ebony cupboard with its inlaid ornamental carvings). The melancholy atmosphere is caused by the candlelight behind the

blackish curtain, which is draped across like an arch and absorbs the faint luminosity of the candle so strongly that only a dim light is cast on the instruments (a virginal, guitar, psaltery, bassoon, recorder, violin and lute), the cupboard and the celestial globe which has been placed at the very centre of the painting. Dark shadows are cast by the candle so that the instruments, which are difficult enough to recognize (e.g., the virginal and the psaltery), are enveloped by nocturnal darkness. The position of the celestial globe is particularly important, as the sign of the zodiac which faces us is that of Scorpio. Even as far back as antiquity Scorpio was believed to stand at the gates of Hades. And on the Emperor Henry II's star coat (now in the treasure chamber of Bamberg Cathedral), scorpions and crabs are described as symbols of evil: "Scorpio dum oritur, mortalitas ginnitur" ('When Scorpio ascends, death approaches').[171] Which concrete event was referred to in the Cologne painting cannot be reconstructed, though it probably reflects the patron's melancholy disposition. Being ruled by the sign of Scorpio, he was hoping that music would give relief to his suffering soul, though once it had stopped and merged into the darkness of the night, it might not be able to provide this relief any longer.

Evaristo Baschenis' Studio (1617-1677)
Still Life with Musical Instruments, undated
Oil on canvas, 94.5 x 117.5 cm
Wallraf-Richartz-Museum, Cologne

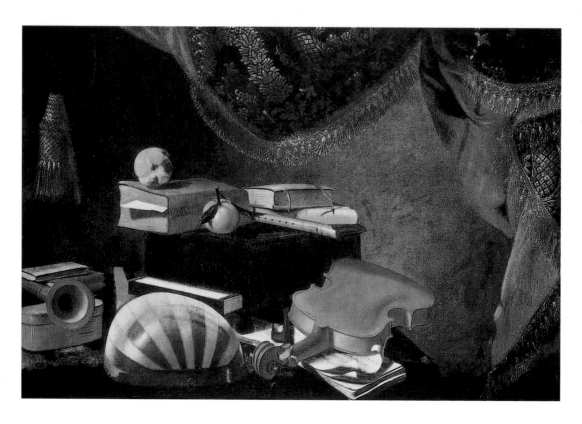

Evaristo Baschenis (1617-1677)
Still Life with Musical Instruments, undated
Oil on canvas, 97 x 147 cm
Pinacoteca di Brera, Milan

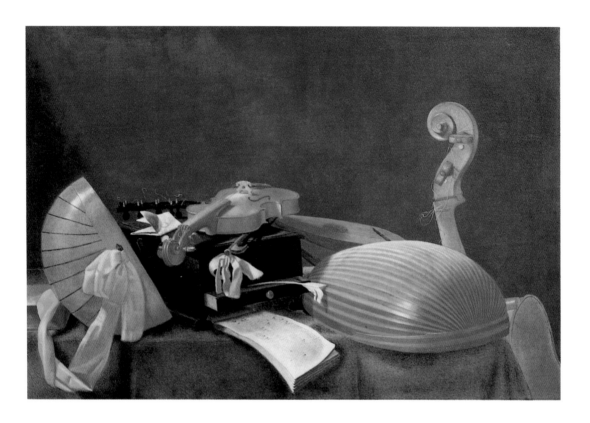

Evaristo Baschenis
Still Life of Musical Instruments, c. 1650
Oil on canvas, 75 x 108 cm
Pinacoteca dell' Accademia Carrara, Bergamo

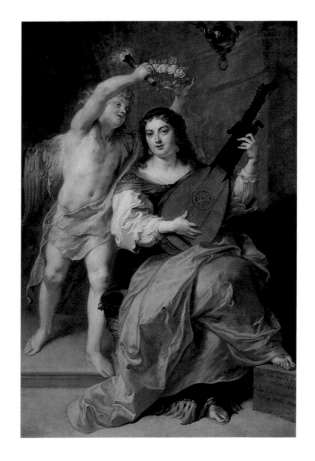

Theodor van Thulden
Harmony and Marriage, 1652
Oil on canvas, 194 x 135 cm
Musées Royaux des Beaux-Art, Brussels

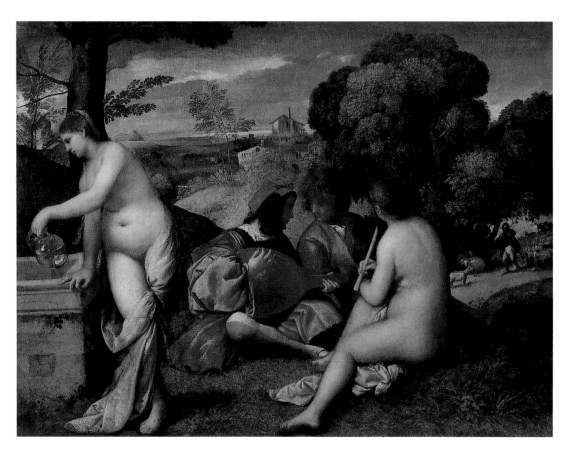

Giorgione (and *Titian?*)
Fête champêtre (Concerto in the Country), c. 1510
Oil on canvas, 110 x 138 cm
Louvre, Paris

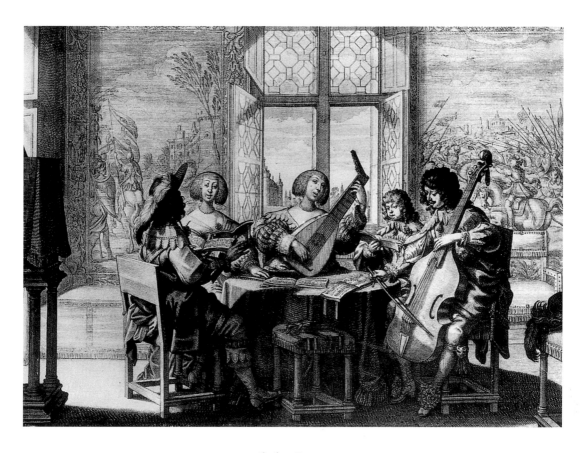

Abraham Bosse
Musical Society, c. 1635
Copper engraving, dimensions unknown
Bibliothèque Nationale, Paris

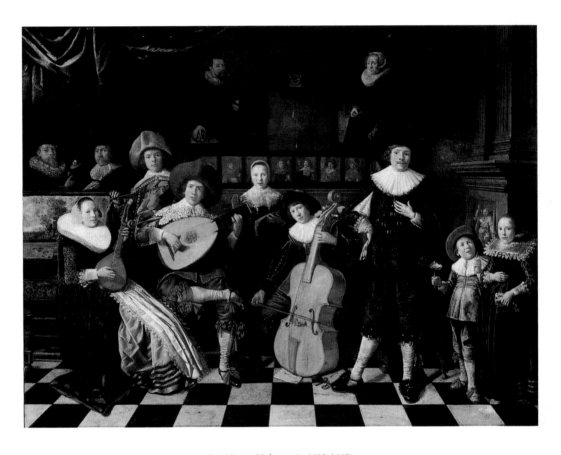

Jan Miense Molenaer (c. 1610-1668)
Family Portrait, c. 1650
Oil on canvas, 62.5 x 81 cm
Frans Hals Museum, Haarlem, on loan from the
Dutch National Board of Art Objects

Pieter de Ring (c. 1615-1660)
Still Life of Musical Instruments, date unknown
Oil on canvas, dimensions and whereabouts
unknown

Pierre Nicolas Huilliot
Still Life of Musical Instruments, 1st half of
18th century
Oil on canvas, 52 x 88 cm
Residenzgalerie, Landessammlungen, Salzburg

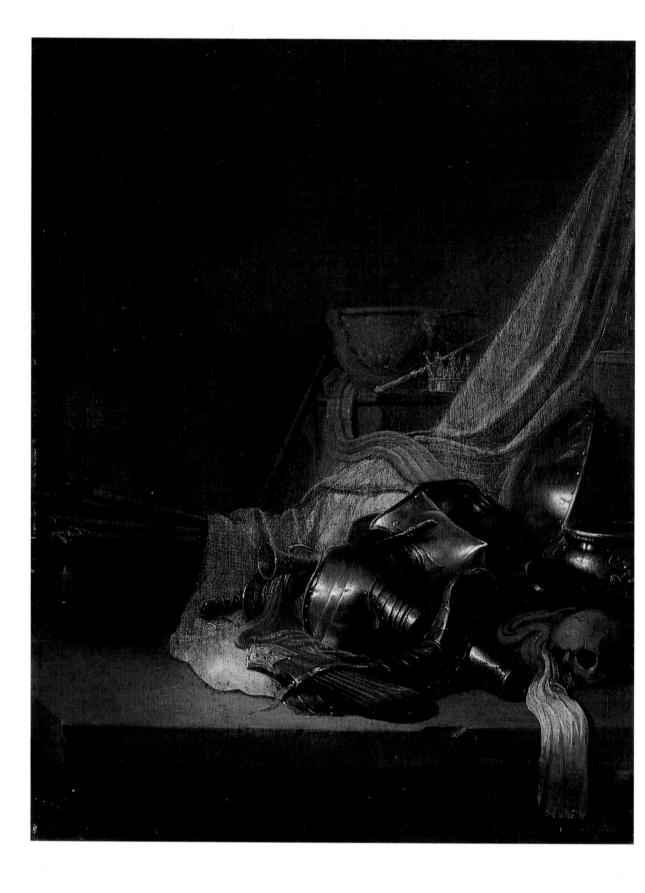

14 Weapons

It can hardly be a coincidence that armour and weapons often occur in still lifes painted during the Thirty Years' War. This war, which caused unimaginable suffering, was originally started by the Spanish-Austrian House of Hapsburg together with the League of Roman Catholic Estates of the Empire. They were committed to the Counter-Reformation and wanted to re-catholicize the rebellious Republic of the United Netherlands after it had become independent in 1609, and in particular to conquer the economic resources of this wealthy country. Subsequently, however, the war spread more and more widely, with the involvement of an increasing number of countries (such as Sweden under Gustav Adolf II in 1630). Dragging on interminably, the final phase was marked by soldiers pillaging, looting and brutally exploiting the civilian population.

This is the background of paintings like Willem de Poorter's (p. 182), who was one of Rembrandt's pupils. Painted in 1636, it provides an emblematic, impressionist commentary on the war.[172] In 1634 the Imperial troops had gained a victory at Nördlingen, so that the situation changed in favour of the League. This may well explain the *vanitas* character of the painting, expressed in the skull and the sarcophagus behind the banner which divides the picture diagonally into two parts. Thus, the victories of the other side are made to seem bearable, as they are mere vanity in the face of eternity. The crown and sceptre on the sarcophagus are a clear reference to the Emperor's power. His power, too, becomes the object of religious criticism, though in the final analysis the critics are powerless and seek comfort in the fact that, once the potentate has died, only the insignia of his power will remain – a view which was expressed in an emblem by Diego de Saavedra in 1640.[173] De Poorter's still life shows a quiver and parts of a coat of mail as worn by rulers and privileged noblemen in times of war. The banner behind it partly covers a bundle of spears. The pieces of armour are reminiscent of Giovanni Moroni's paintings where the noblemen portrayed by the artists have taken off their breastplates and scattered the individual parts across the floor.[175] While in the one painting, however, these military objects are symbols of the dual function of the nobility – that is, to be courtiers and warriors – the armour in the other painting, together with the insignia of the ruler, symbolizes remnants of an existence that is doomed to death. The argument which forms the basis of de Poorter's still life moves within the conventions of Dance of Death imagery where death as the final limit is seen as the great leveller which removes all distinctions between social classes.[175] While in early modern times weapons were still regarded as positive symbols of glory, bravery and courage, as demanded by the feudal ideology of the knights, they had now become negative heraldic signs of vanity and the tragic

Detail from illustration opposite

Willem de Poorter
Still Life with Weapons and Banners, 1636
Oil on wood, 23 x 18 cm
Herzog-Anton-Ulrich-Museum, Brunswick

consequences of military action. There may also have been criticism of the military glory of the rulers at the expense of the dead warriors, as expressed in an emblem by Guillaume de la Perrière.[176] It certainly contained the hope for an end to the war, as expressed by the German poet Johannes Rist in his 'Exhortation to Restore Noble Peace':

'O blessed Fatherland, wilt thou ever see the time
When swords and guns are beaten into ploughshares,
When banners cease to hover over tents,
When one no longer needs to listen for the guard,
When spiders weave their ropes around strong armour,
And when polished helmets have lost their bright gleam . . ."[177]

This pacifist theme – 'swords into ploughshares' – had already been depicted allegorically by Jan Brueghel the Elder and Hendrick van Balen.[178] A small copper painting (p. 185) shows the prophet Isaiah with a stone tablet bearing his prophecy (Isaiah 2:4) in Latin: "Iudicabit gentes et arguet populos multos in vomeres, et lanceas suas in falces/Iesaiae II" ('He will judge between the nations and settle disputes for may peoples. They will beat their swords into ploughshares and their spears into pruning hooks'). In this painting, Brueghel reverses his frequently used motif of the vulcanizing smithy, or rather, he re-defines it: in the background of the grotto, on the left, we can see the beating of weapons into sickles and scythes. In the foreground a genius is burning weapons, who can be identified as 'Pax' (peace) because of his inscription. In the right-hand corner three allegorical women personify that prosperity which everyone is hoping to regain after the war. The seated woman with the magic caduceus wand – the attribute of Mercury, the god of trade - is Felicitas (Happiness). She is being attended by Abundantia (Abundance), holding a horn of plenty, and the two women are arranged on either side of Pietas (Piety). The picture, painted in 1609, expresses the painters' hope for a long period of peace, to follow the cease-fire between Spain and the Netherlands. It embodies the ideas of Hugo Grotius, a liberal Protestant freethinker who had already condemned the war before this time.[179]

Jan Brueghel the Elder (1568-1625) and *Hendrick van Balen* (1575-1632)
Prophecy of the Prophet Isaiah, c. 1609
Oil on copper, 40.2 x 50.5 cm
Alte Pinakothek, Munich

Den vordantz hat man mir gelan
Dann jch on nutz vil bůcher hân
Die jch nit lyß/ vnd nyt verstan

Von vnnutzê buchern

Das jch sytz vornan jn dem schyff
Das hat worlich eyn sundren gryff
On vrsach ist das nit gethan
Vff myn libry ich mych verlan

15 Books

In his *Maxims and Reflections* Goethe noted with amazement that Shakespeare frequently used parables in his plays which referred to the metaphor of the book itself: ". . . The art of printing had been invented over a hundred years before: nevertheless books were still regarded as sacred, as we can see in the covers that were used at the time, and so they were cherished and honoured by the noble poet; nowadays, however, we bind everything in paper covers, respecting neither the cover nor the contents of a book."[180]

Thus Goethe aptly describes the gulf between technological achievements in production techniques on the one hand, and a conservative ideology about books on the other, whereby values were maintained that had long become doubtful in view of modern technology. Shakespeare's metaphors are reminiscent of an aura of books in the Middle Ages, when they were produced in a lengthy and laborious process in the scriptorium of a monastery. Furthermore, the medieval production of books still largely served theology.[181] Even after the invention of the printing press by Johannes Gutenburg (in about 1440) there was still considerably greater demand for the Bible and devotional literature than anything else. The Bible was considered to be the Book of books, a vessel of inspiration by the Holy Spirit as received by the prophets and the evangelists, and it was regarded as a codified expression of divine revelation. So highly was the sacredness of the Bible valued, in fact, that it could become the allegorical and metaphorical yardstick of everything that was created. This explains the oft-quoted verse by Alanus ab Insulis: "Omnis mundi creatura / Quasi liber et pictura / Nobis est et speculum." ('The creation of the whole world is to us like a book, a picture and a mirror.')[182]

The expansion of university education in the 13th century had already led to a greater demand for reading material, which was noticeable in the late Middle Ages, with scholars wanting to write commentaries on the authors of antiquity. And it is true that this increase had led to a reduction of quality in the outer appearance of books. Each university town had its own bookshop, called *stationarii* or *librarii*, and books which had been copied by less thorough copyists were becoming cheaper. In addition, from the mid-15th century onwards production costs could be lowered considerably by using paper instead of parchment. There can no longer be any doubt that the growth in literacy and the increase in education formed the background for the invention of the printing press. 'While the population had doubled between 1500 and 1600, the production of books had on average risen tenfold in Europe.'[183] Conversely, the enormous increase in output made it possible to disseminate information at a speed hitherto unknown, so that it became the pace-setter of 'democratic' conditions, as

Jost Amman
Card Game Manual, 1588

Sebastian Brant
Narrenschiff (Ship of Fools), Basle 1494

education was now no longer the privilege of a small elite but, in principle, availabe to everyone.

This tendency was rather worrying for conservative writers. Even if they were open-minded toward humanist ideas, they still supported the traditional feudal value system. This explains Sebastian Brant's characteristic criticism in the very first chapter of his *Narrenschiff* ('Ship of Fools) of 1494, where he attacks the reading of 'useless books.' Brant conjures up the image of an educational philistine who has a 'large stock' of books but only understands 'very few words' that are written in them. The woodcut (p. 186) which illustrates this complaint shows a buffoon – recognized by his fool's cap – sitting at a desk in his little cabinet which also serves as a bookcase, dusting the large, heavy tomes with a feather duster. Like any emergence of new media, the increase in the production of books and the resulting rise in the general level of education were perceived by conservative critics as a danger to the existing culture. They also condemned people's indiscriminate greed for books and expressed concern about the reduction in quality, now that books had become mass products. As a result, books were regarded as useless junk and could be used as symbols of vanity. In the year 1600 Barnaby Rich (1540?-1617) complained that the large quantity of books was one of the "great malaises of this time," as they "have overfilled the world so much that it is no longer able to digest the overabundance of useless material that is hatched every day and put

Jan Davidz. de Heem
Student in His Study, 1628
Oil on wood, 60 x 81 cm
Ashmolean Museum of Art and Archaeology, Oxford

out in the world." Similar lamentations were sounded by Robert Burton, though he admits in his *Anatomy of Melancholy* (1621) that he only knew the world from books.[184] Added to such pronouncements, there was the irritating realization that books – and indeed any written media – recorded things of the past, so that they could only ever contain experiences that would soon be superceded or had been superceded already.

Not surprisingly, therefore, still lifes such as Pieter Claesz's (dated 1630, p. 86), with a skull and bones as symbols of vanity, also include an empty candle-stick to indicate the end of a candle (following medieval practice of measuring time in terms of burnt candles)[185] as well as an open pocket watch to point to the passage of time. The idea of death literally dominates not only the book itself, whose poor quality can be gathered from the torn edges where the sheets have been cut, but also the action of writing, indicated by the tattered quill.

The idea of vanity is conveyed more indirectly, though without the topical, symbolic skull, in an anonymous *Still Life of Books* at the Alte Pinakothek in Munich (p. 192). It has certainly been correctly dated for the time, around 1628.[186] It is probably also true that there were painters in Leiden, the southern Dutch university town with a renowned university which had been founded in 1577. By the 17th century Leiden University was already equipped with a large library, and these artists may well have painted in Jan Davidsz de Heems' studio. He worked in Leiden between 1626 and 1636 and also specialized in still

lifes of books during that time (cf. his *Still Life of Books* in the Mauritshuis, p. 189).[187] A wild jumble of documents, engravings and numerous books, some of them with badly worn covers, bent out of shape by the damp, are lying on a table in the corner of a sparsely decorated room. Some of their titles can be identified, such as the works of Gaius Suetonius and *Titi Livii Opera* on the left. On the right, under the initials GAB, we can make out a book by the Dutch comedy playwright Gerbrand Adriaensz Bredero (1585-1618). This is his *Spaansche Brabander Ierolimo*, as we gather if we reconstruct the title – a comedy in which Spanish culture has been transferred into a Dutch environment, with motifs from the picaresque novel *Lazarillo de Tormes* adapted to the dramaturgy and moral of *rederijker* plays. (*Rederijkers* were poets, comparable to master singers, who had been active in the Netherlands since about 1400.) These plays were particularly popular in Holland at the time, not least because of the colloquial language used in them.[188] On a narrow shelf on the wall we can see the bronze head of the Roman emperor Vitellius, a child's head and a sketchy plaster replica of Michelangelo's *Aurora*. It is difficult to determine exactly what kind of room this is. It may be the corner of a room filled with antiques, as the books have not been carefully arranged by a proud owner, but carelessly browsed through, cast aside and left in a mess, so that some of the paperbacks are bent out of shape. However, it may also be the corner of a student's room, as painted by de Heem, where a student is shown with a melancholy expression on his face, head in hand, thinking about the contents of the books strewn across his desk (1628, p. 188). Another obvious element is the poor quality of the paper, which the artist apparently wants to criticize. One may also wonder whether the seemingly incidental combination of books and sculptures is really without any unifying significance. There certainly seems to be a connection between the book by Suetonius and the bronze head of Vitellius, which is so unusually small compared with the child's head. In the seventh book of his biographies of Roman emperors (*De Vita Caesarum* in eight volumes), Suetonius describes Galba, Otho and Vitellius.[189] Vitellius was a soldier king and was the head of the Roman forces in *Germania Inferior*, which also included the Netherlands. His life gave plenty of reasons for reflections on vanity, considering that his triumph very quickly turned into destruction and ruin: Vitellius was described by the Roman authors as an effeminate Epicurean and gourmet who left the business of governing to a former slave called Asiaticus and who did very little to defend himself against Antonius' enemy troops. Having ruled for only a few months, Vitellius was brutally murdered by soldiers of Vespasian's legion.

This condemnation of the vanity of Bredero's writings has its parallel in de Heem's still life, now in The Hague, which bears, among other things, the inscription "G. A. BR.DEROS Treur Spel van RODDRICK ende AL-PHONSVS" ('G.A. Brederos's Tragedy of Roderick and Alphonsus'). It is a verdict that may well be related to the vehement conflict around 1630 between *rederijkers* (including Bredero, as a member of the Amsterdam Chamber of Rederijkers, *De Eglentier*) and academics, a dispute that was to 'lead to the end of the Rederijkers' Chambers in the northern Netherlands.'[190] Thus the painter and de Heems may implicitly have taken sides with the academics.

Giuseppe Arcimboldo
The Librarian, c. 1566
Oil on canvas, 97 x 71 cm
Skoklosters Slott, Sweden

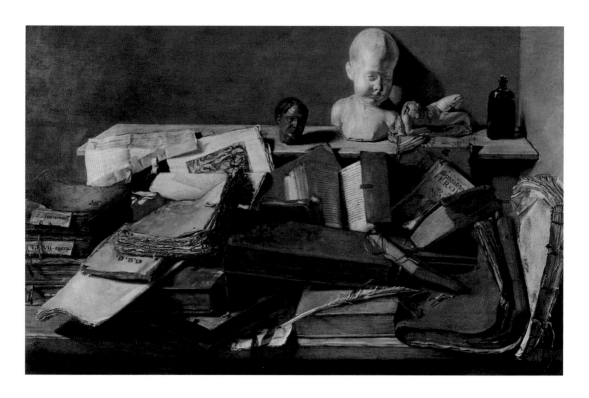

Leiden Master
Still Life of Books, c. 1628
Oil on oakwood, 61.3 x 97.4 cm
Alte Pinakothek, Munich

«We already have an immense chaos and jumble of books. We are overwhelmed by them, our eyes hurt from reading, and our fingers from turning the pages,» wrote Robert Burton in his *Anatomy of Melancholy*, which was first published in 1621. Some still lifes of books emphasize the *vanitas* aspect and lament the fact that the overabundance of books can make a person melancholy.

Spanish
Still Life of Books, 1st third of 17th century
Oil on canvas, 34.5 x 55 cm
Stiftung preußischer Kulturbesitz, Staatliche
Museen, Berlin

Statistical evidence shows that the desire to read grew considerably among large sections of the population at the beginning of the 17th century. Not only were more titles published, but the production figures of the individual works also increased rapidly. This development went hand in hand with a growing tendency towards secularization, and a decrease in the proportion of religious literature, which had dominated until then. It was a far-reaching shift which rather disconcerted many conservative theologians, humanists and artists, who came to regard books as useless junk and a superfluous luxury. Anyone who claimed that books were permanent, unchanging records of human experiences and knowledge was reminded of their frailness and transience. This explains the hour-glass in the background and the well-thumbed, tattered state of the books.

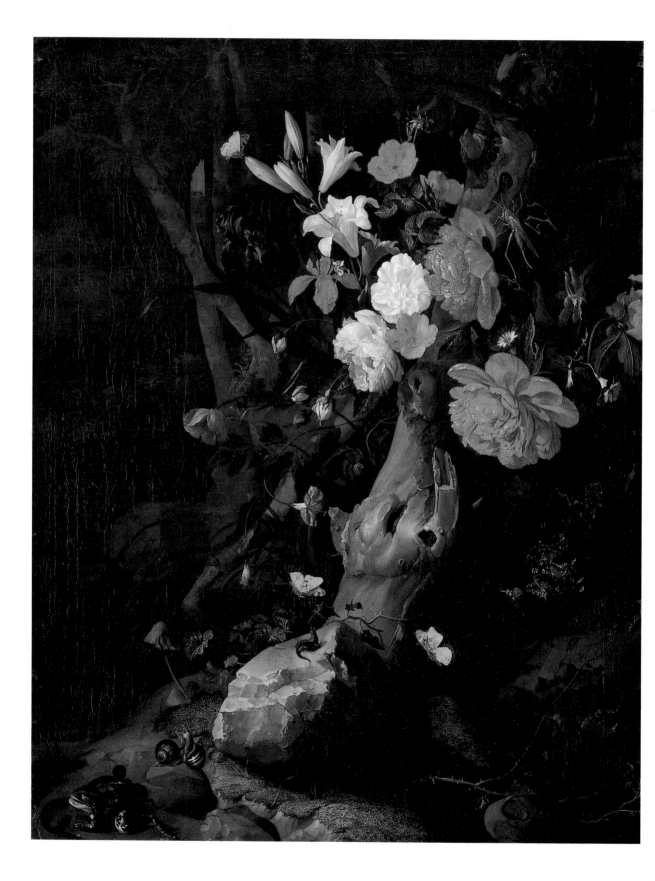

16 Forest Still Lifes

Among Dutch still-life painters Otto Marseus van Schrieck (1619-1678) has a special position. His somewhat exotic œuvre has only come to be appreciated in more recent decades, particularly by Ingvar Bergström in 1974, although V.C. Habicht drew attention to the 'forgotten visionary of Dutch art' as early as 1923.[191] However, it is doubtful whether the word 'visionary' is really appropriate, as Marseus' demonstration of the world of amphibians and insects (p. 197) has very little to do with artistic intentions in the sense of Symbolism or Surrealism. He nearly always presents a small section of the woods with thick dark undergrowth, and a hidden microcosm in which frogs, toads, snakes and lizards crowd together, fighting for their lives. Marseus knew the habits of these animals very well and is known to have bred reptiles and snakes himself.

 Jan Swammerdam and Antoni van Leeuwenhoek, on the other hand, were more interested in the anatomic and microscopic details of mollusks and amphibians. They examined, for example, the urinary and genital organs of these animals, conducted insemination experiments on them or depicted the capillary vessels of a tadpole's tail, whereas Marseus was more interested in the outer appearance of animals, such as the skin of a striped adder or a dark green snake, and the pockmarked skin of a toad (painting in Brunswick),[192] as well as their behaviour. He depicts, for instance, the movements of a snake approaching its prey, its immobility as it lies in ambush and the sudden jerk forward as it bites into a toad, contrasting sharply with the sluggish apathy of the victim. In the 17th century, all egg-laying vertebrates were grouped together under the criterion of red, cold blooded and regarded as a unified species. It was only later that biologists classified scaly amphibians (tortoises, lizards and snakes) as reptiles, while newts, toads and frogs – 'naked amphibians' – were grouped together as amphibians. In addition to these animals, Marseus' Brunswick painting of 1662 (p. 197) also shows bizarre botanical species, such as a coral fungus on the left and thistles, under which a lizard – a so-called lacerta – is hiding, about to attack the toad. Marseus has designed an idealized habitat, modelled on biological dioramas, which are illustrations with a three-dimensional effect. However, although the world of his paintings reflects the zoological and botanical interests of a well-versed science amateur, it is still not free from religious associations. Indeed, it is the religious meaning which determines the selection and composition of the animals and plants. The snake, the toad and the lizard, etc. are the 'unclean animals' mentioned in Leviticus 11:29ff.: "Of the animals that move about on the ground, these are unclean for you; whoever touches the carcass of any of them will be unclean." Because of God's curse that rested on the serpent ever since the Fall of Man (Genesis 3:14), it

Detail from the illustration opposite

Rachel Ruysch (1664-1750)
Flowers on a Tree Trunk, undated
Oil on canvas, 93 x 74 cm
Schloss Wilhelmshöhe, Staatliche
Kunstsammlungen, Kassel

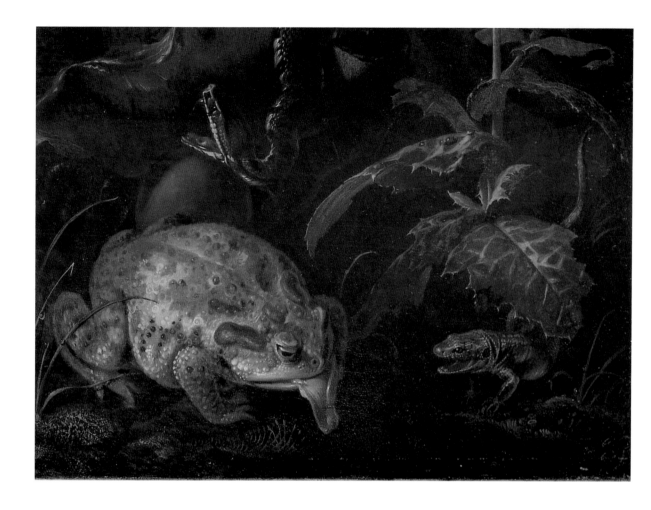

had negative connotations and was regarded as an incarnation of evil and, as such, was a favorite subject for depicting evil.

Closely following her teacher Marseus, Rachel Ruysch (1664-1750) also painted forest still lifes. Her work *Flowers on a Tree Trunk* (p. 194) is a particularly good example. As in Marseus' still lifes, we look at dark undergrowth, dried stump with knotholes surrounded by toadstools and moss underneath stones. Winding around the dead tree trunks are brightly coloured flowers of all kinds, including roses, lilies and bindweed. They have a luminous quality which seems to come from within them. Insects, reptiles and 'amphibians' such as snakes, toads and small lizards, are partly fighting one another and partly destroying the plants together. On the left a toad and a small snake are attacking one another, on the right a fire-breathing (!) toad with red flames darting from its mouth is trying to hold a small lizard in check. Opposing the world of half-dead, flowerless plants and minerals, the glowing colours of the flowers add an element of vitality. These must be understood with a view to the Christian doctrine of salvation, symbolizing the purity of the Virgin Mary as well as Christian virtues or fruit of the Holy Spirit. This is also the context for the bufferflies settling on the unopened blossom of a lily – undoubtedly an allusion to the mystical ('immaculate') conception of the Virgin Mary, as the

Detail from the illustration opposite

196

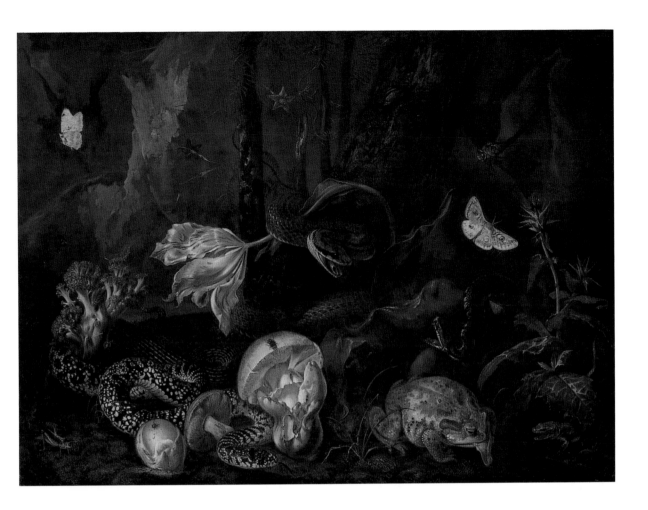

Otto Marseus van Schrieck
Still Life with Insects and Amphibians, 1662
Oil on canvas, 50.7 x 68.5 cm
Herzog-Anton-Ulrich-Museum, Brunswick

lily had been a fixed attribute of the Mother of God since the late Middle Ages. Other insects, by contrast, are interpreted in a negative way. The locust climbing from the dead tree trunk to the red rose in order to destroy it, together with the stag beetle on the branch above it, just below the upper frame, must be seen as an allusion to Psalm 105:34: "He spoke, and the locusts came, grasshoppers without number. . .", where German translations of the Bible read 'locusts and beetles without number'. From 1708 to 1716 Rachel Ruysch was the court painter of the Elector Johann Wilhelm von der Pfalz in Düsseldorf. Apparently she was well-versed in the theories and findings of Dutch anatomy and entomology; she was the daughter of the anatomist and entomologist Frederick Ruysch (1638-1731).[193] Like Marseus, however, despite her education, she alludes to the theory of antiquity whereby insects are brought forth by decay, without seeds, and in her art they seem to be coming out of the undergrowth.[194] In his book *De animalibus insectis libri septem* (Bologna 1602, p. 354), Ulisse Aldrovandi refers to Aristotle, whose theories he partly rejects on the basis of empirical research, though he does accept his idea that insects, particularly flies, are produced either 'ex coitu' (through reproduction) or 'ex putrescente humido' (through humid decay).

Like Marseus and Ruysch, Abraham Mignon also composed dioramic

situations in the form of forest still lifes (p. 199). Set against a dark background without clear spatial delimitations, we can see pedestals and stone plinths building up from the ground.[195] These are covered with an abundance of fruit and vegetables, with delicate stalks of grain winding themselves around pumpkins and corn cobs with blue and yellow kernels. Together with peaches, plums and grapes they combine to form an arrangement which has an affinity to de Heem's religious fruit still lifes (cf. chapter 11, illus. p. 153).[196] And indeed, this painting, too, includes an encoded Christian message. Because of its many seeds and its rapid growth, the pumpkin had been interpreted as a symbol of the growing Christian faith since the early Middle Ages.[197] Similar ideas were probably associated – as far as can be determined – with corn cobs and its many kernels, though corn is not mentioned in the Bible. Grapes and corn are well-known references to the Eucharist again. In Mignon's painting, which is now in Cologne, the artist arranged the fruit in such a way that it was framed vertically by branches growing upwards from the ground. These branches, which are probably intended to indicate an oak tree, are completely covered with moss and seem almost dried up, though some shoots can be identified which indicate the tree's ability to survive.[198] The nests in the branches refer to Psalm 84:2-3: "My soul yearns, even faints for the courts of the Lord . . . Even the sparrow has found a home, and the swallow a nest for herself, where she may have her young." This passage was interpreted more widely, with reference to the place of a redeemed Christian in the Kingdom of God.

But there are other symbols which show that Mignon also used the darkness, with its vegetation and fauna, as the scene of the fight between the antagonistic metaphysical principles of good and evil, so that we feel reminded of Thomas Hobbes' theory of everyone fighting against everybody else. There are the silhouetted mice gnawing at the ears of corn in the bottom left-hand corner, the snail on the right slowly making its way across the cantaloupe towards the top, the sphere of salvation, while at the same time trying to spoil the fruit, as well as the lizards and vipers, and of course the flies. In this almost Manichaean polarity of principles, these 'unclean animals' form a contrast with the birds and butterflies, symbols of the soul and the resurrection. The ultimate victory of good over evil, though slightly corrupted and damaged (as shown by the leaves eaten by insects and the peach which has grown mouldy), is indicated by the lizard lying on its back like the dragon defeated by St. George. Fighting for the Christian faith, a cross spider is descending on a bluebottle.[199] Apart from its Christian significance, this painting tends towards the ancient theory of spontaneous generation again, as the flies are understood to originate from the rottenness of the decaying wood or mouldy fruit. Scaliger, still an emphatic protagonist of this theory about insects, also referred to snails (particularly purpuridae) and lizards in his dicussion. He believed that snails covered their skin because of their supposed dryness. Cardanus, on the other hand, objected that lizards, which were not dry at all, covered their skins too, whereas trees and cantharides (a type of fly) did not cover their bark or integuments even though they were both very dry.[200]

Although these speculations were undoubtedly outmoded for Mignon, he nevertheless took them up and romanticized them, so that they added up to a compositional scheme with which he could conjure up the idea of a mysterious microcosm. The world he created was, however, completely 'naturalist', without any elements of the miraculous.

The secret 'correspondences' he evoked (which sprang from a real conviction rather than from the playfully fictitious aestheticism of the Symbolists)

Abraham Mignon (1640-1679)
Still Life, undated
Oil on canvas, 92 x 72.7 cm
Wallraf-Richartz-Museum, Cologne

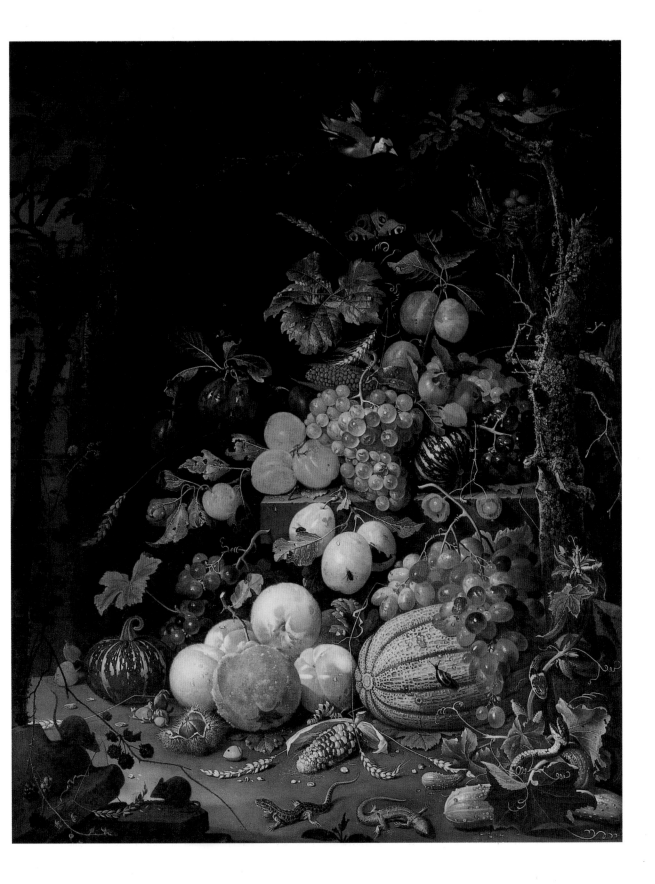

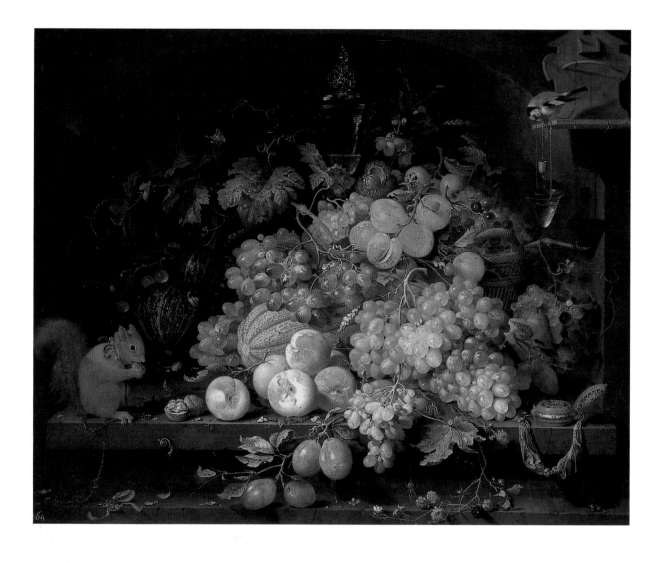

also characterizes his *Fruit Still Life* (p. 200), a variation on his style as described above. However, the individual objects are no longer scattered across the forest ground but are grouped together in an arched niche, to form a fruit-basket motif that resembles the display of a harvest festival. Again, the painting contains both Eucharistic symbols and an element of transience, indicated by the small number of rotten spots of the fruit, as well as the presence of a clock, and the dualism of good and evil. The two rather cute little animals, a squirrel and a goldfinch, are also in opposition to each other. The squirrel seems to be chained up, but on closer inspection we notice that it has managed to free itself. It has cracked open a walnut and is now eating its kernel. The squirrel had been regarded as a symbol of the devil since the Middle Ages. In this painting it embodies the unleashing of evil in the form of harmlessness.[201] The bell collar around its neck also identifies it as a 'fool' and thus a sinner. The meaning of a squirrel eating a walnut becomes obvious when we consider that St. Augustine saw the walnut as a symbol of Christ, with the shell as the wood of the cross and the kernel as the life-giving nature of Christ.[202] Unlike the squirrel, it is a christological

Abraham Mignon (1640-1679)
Fruit Still Life with Squirrel and Goldfinch, undated
Oil on canvas, 80.5 x 99.5 cm
Schloss Wilhelmshöhe, Staatliche Kunstsammlungen, Kassel

symbol, particularly with reference to the Passion. Its positive meaning can be gathered from its position in the upper portion of the painting (top = sphere of salvation). The actions of the bird are worth noting. Chained to an arched semi-circle, from which it can peck food out of a small container, it is pulling up a thimble-sized receptacle from the left-hand edge of the shelf. It is filled with water or – more likely – wine (as a Eucharistic symbol of the blood of Christ), which has been scooped out of a conical glass without stem or base. Mignon had by no means invented this motif. It is not an artistic whim but goes back to a description of this bird's behaviour by Isidor of Seville and Albertus Magnus, who interpreted it in terms of moral theology. This can be seen particularly clearly in Konrad von Megenberg's (1309-1374) *Buch der Natur* (Book of Nature) which, in turn, is based on Thomas de Chantimpré's *Liber de Natura*:[203]

"The goldfinch," according to Isidorus, that is a small bird which lives on thistles, and it is a great miracle that this bird should sing so well yet be nourished by the sharp stings of the thistles." It is then compared to Christ: "you yourself sang on earth until bitter death." Furthermore, "it is its nature that as soon as it is captured and put in a cage, it uses its beak to draw water from a vessel suspended by a thread which it holds for hours by its foot while it is drinking. It is a miracle of nature that it should have imparted so much skill to a little bird, a degree of intelligence unsurpassed by cattle or donkey or any large animal. In the same way it happens that a very clever little baby is born to poor, humble folk and a fool or ass to great princes. Thank you, Lord, that you have never disdained the poor."

This connection between 'teaching, edification and entertainment'[204], which is so typical of Konrad von Megenberg's description of nature and its history, also characterizes the world of Abraham Mignon's paintings and his image of the world. In view of the advances of empirical principles in science and philosophy, the appreciation of sensory perception and the resulting denial of metaphysical implications, Mignon, Marseus, Rachel Ruysch and many other painters like them made a last attempt to restore the dwindling religious dimension that was left in the semantic content of art. It was a last endeavour to counteract the breaking of the magic spell whereby the meanings of traditional symbols were destroyed by deism and early Enlightenment. These painters wanted to achieve this by confirming the dogmas of the ancient faith in the imagery of theodicy, that is, the proof of God's justice in the face of moral evil in the world.[205]

Not too long afterwards, the aesthetic principles of still lifes changed and finally shed all religious symbolism. The semantic content of art was reduced to secular problems related to the world itself and the demonstration of middle-class virtues and values. With growing sensualism in the theory of knowledge, still lifes became more and more a medium that reflected the painter's artistic perception and process of realization.

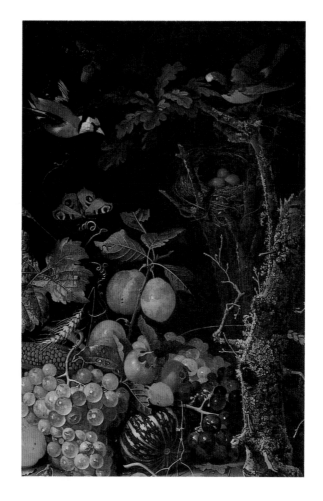

Detail from illustration page 199

Carel Fabritius
The Goldfinch, 1654
Oil on wood, 33.5 x 22.8 cm
Mauritshuis, The Hague

Ever since A. Bredius acquired this still life of Rembrandt's pupil Carel Fabritius for the Mauritshuis, it has been regarded as one of the most significant 17th-century Dutch paintings. The small-format picture was probably intended as a trompe l'œil (or *betriegertje*). The wooden board is uncommonly thick, probably because it was originally an integral part of a piece of furniture or panel. A goldfinch is called 'putter' in Dutch, which also means 'water-drawer' (cf. Abraham Mignon's painting in Kassel, p. 201). It is therefore assumed that Fabritius may have painted it for his friend Abraham de Potter (also spelt 'Putter'), as an allusion to his name. – It is worth noting that the coarse alla prima structure of the paint, which the artist had learnt from Rembrandt, contradicts the predominant tendency of the time towards an illusionist attention to detail.

Notes

1 Ingvar Bergström, *Dutch Still Life Painting in the Seventeenth Century*, London/New York 1956, p. 4.

2 Anne-Marie Logan Saegesser, *Die Entwicklung des Stillebens als Teil einer größeren Komposition in der französischen Malerei vom Beginn des 14. bis zum Ende des 18. Jahrhunderts*, doctoral thesis, Zurich 1968 (Winterthur 1968), p. 9.

3 Albert Dresdner, *Die Entstehung der Kunstkritik*, Munich 1968, pp. 91 ff.

4 Carl Prantl, *Geschichte der Logik im Abendlande*, Leipzig 1855-1870, 4 volumes (reprinted in 1955), volume 2, p. 345, note 132. The Porphyrian Tree (*arbor porphyriana*) was named after the philosopher Porphyrios who lived in late antiquity.

5 Cf. Richard von Dülmen, 'Formierung der europäischen Gesellschaft in der frühen Neuzeit,' in: *Geschichte und Gesellschaft 7*, 1981, pp. 5-41.

6 'Il Caravaggio disse, che tutta manifattura gli era a fare un quadro buono di fiori, come di figure' (cf. Howard Hibbard, *Caravaggio*, London 1983, p. 83)

7 Denis Diderot, *Ästhetische Schriften*, ed. by Friedrich Bassenge, Berlin 1984, volume 1, pp. 352 and 540.

8 Cf. Gerhard Langemeyer, 'Stilleben,' in: *Die Kunst*, December 1979, issue 12, pp. 817 ff., here: p. 818.

9 Arnold Hauser, *Sozialgeschichte der Kunst und Literatur*, Munich 1972, p. 507.

10 Cf. Miriam Milman, *The Illusions of Reality. Trompe l'œil Painting*, Geneva 1982, p. 6. – C. Mayhoff (ed.), *Plinii Secundi Naturalis Historiae*, Stuttgart 1967, volume V, pp. 252 ff. (Book XXXV, pp. 61-63).

11 Milman, p. 20 ff.

12 Hugh Honour and John Fleming, *Lexikon Antiquitäten und Kunsthandwerk*, Munich 1984, pp. 288 ff. ('Intarsia'). – André Chastel, *Der Mythos der Renaissance 1420-1520*, Geneva 1969, p. 101. – Charles Sterling, *La nature morte de l'antiquité à nos jours*, Paris 1952, p. 30 ff.

13 Milman, see note 10, p. 50.

14 L. Servolini, *Jacopo de' Barbari*, Padua 1944, p. 125. – *Alte Pinakothek* catalogue, Munich 1983, p. 58f. – For the Scheurl quotation see H. Lüdecke (ed.), *Lucas Cranach im Spiegel seiner Zeit*, Berlin 1953, p. 50.

15 Milmann, see note 10, p. 58 ff.

16 Leon Battista Albertis *Kleinere kunsttheoretische Schriften*, translated into German by Hubert Janitschek (reprint of the 1882 edition), Osnabrück 1970, pp. 98 f.

17 Leonarda da Vinci, *Das Buch von der Malerei*, German edition by Heinrich Ludwig (reprint of the 1882 edition), Osnabrück 1970, pp. 98 ff.

18 Cf. Sterling (see note 12), p. 25, figures 3, 4 and 23.

19 See chapter 10.

20 Cf. Norbert Schneider, 'Zeit und Sinnlichkeit. Zur Soziogenese der Vanitasmotivik und des Illusionismus,' in: *Kritische Berichte 8*, 1980, issue 4/5, pp. 8-34.

21 Cf. André Chastel/Robert Klein, *Die Welt des Humanismus*, Munich 1963, pp. 199ff, esp. p. 203.

22 Cf. Friedrich Ohly, 'Vom geistigen Sinn des Wortes im Mittelalter' (1958), in: ibid., *Schriften zur mittelalterlichen Bedeutungsforschung*, Darmstadt 1977, pp. 1–31. – Hennig Brinkmann, *Mittelalterliche Hermeneutik*, Tübingen 1980, pp. 169-213 (on the theory of an *integumentum*-'husk'-of a hidden meaning).

23 Erwin Panofsky, 'Early Netherlandish Painting. Its Origins and Character', Cambridge/Mass. 1953, vol. 1, pp. 131 ff.

24 Cf. Ingvar Bergström, 'Disguised Symbolism in *Madonna Pieces* and Still Life,' in: *The Burlington Magazine* 97, 1955, pp. 303-308 and 342-349. - See also Claus Grimm, in: *Natura in posa*, Milan 1977 (German translation: Stuttgart 1979).

25 Cf. Albrecht Schöne, 'Emblemata. Versuch einer Einführung', in: *Deutsche Vierteljahresschrift für Literaturwissenschaft und Geistesgeschichte* 37, 1963, pp. 197-231.

26 Horace, *Ars Poetica*, v. 333 ff. Cf. Eddy de Jongh's introduction in: *Tot lering en vermaak*, Amsterdam 1976, pp. 14ff, here: p. 27.

27 Cf. Jakob Rosenberg/Seymore Slive/E.H. ter Kuile, *Dutch Art and Architecture 1600-1800* (*The Pelican History of Art*), Harmondsworth 1977, p. 333.

28 Cf. J. Kulischer, *Allgemeine Wirtschaftsgeschichte des Mittelalters und der Neuzeit*, 4th edition, Darmstadt 1971, vol. I: *Das Mittelalter*, pp. 163 ff.; vol. II: *Die Neuzeit*, pp. 97 ff. – H. van der Wee, *The Growth of the Antwerp Market and the European Economy*, 3 volumes, Louvain 1963. – S.D. Skaskin et al., *Geschichte des Mittelalters*, vol II, Berlin 1958, pp. 3-32. – J. de Vries, *Economy of Europe in an Age of Crisis 1600-1750*, Cambridge 1976. – D. Sella, 'European Industries 1500-1700,' in: *The Fontana Economic History 2: The Sixteenth and Seventeenth Centuries*, 4th edition, Glasgow 1979, pp. 354 ff.

29 For 16th-century agriculture cf. Wilhelm Abel, *Agrarkrisen und Agrarkonjunktur. Eine Geschichte der Land- und Ernährungswirtschaft Mitteleuropas seit dem hohen Mittelalter*, 2nd edition, Hamburg/Berlin 1966. – F. W. Henning, *Landwirtschaft und ländliche Gesellschaft in Deutschland*, vol. I: 800-1750, Paderborn 1979. – A. de Maddalena in *The Fontana Economic History* 2 (see note 28), pp. 273 ff. – I. Wallerstein, *The Modern World System. Capitalist Agriculture and the Origins of the European World Economy in the Sixteenth Century*, New York 1974. – On paterfamilias literature cf. J. Hoffmann, *Die 'Hausväterliteratur' und die 'Predigten über den christlichen Hausstand.' Lehre vom Hause und Bildung für das häusliche Leben im 16., 17. und 18. Jahrhundert*, Weinheim/Berlin 1959.

30 Städelsches Kunstinstitut, Frankfurt, Inv. No. 1378. – On Pieter Aertsen, cf the older, but still useful study by J. Sievers (Leipzig 1908).

31 Cf. Munich catalogue 1983, p. 35. – D. Kreidl, 'Die religiöse Malerei Pieter Aertsens als Grundlage seiner künstlerischen Entwicklung,' in: *Jahrbuch der kunsthistorischen Sammlungen in Wien* 68, 1972, pp. 72 ff.

32 Cf. J.A. Emmens, '"Eins aber ist nötig" – Zu Inhalt und Bedeutung von Markt- und Küchenszenen des 16. Jahrhunderts,' in: *Album Amicorum J.G. van Gelder*, The Hague 1973, pp. 93-101. – Kenneth M. Craig, 'Pars Ergo Marthae Transit. Pieter Aertsen's "Inverted" Paintings in the House of Martha and

Mary,' in: *Oud Holland* 97, 1983, pp. 25-39. –
G. Irmscher, 'Ministrae voluptatum. Stoicizing
ethics in the market and kitchen scenes of Pieter
Aertsen and Joachim Beuckelaer,' in: *Simiolus*
16, 1986, pp. 219-232. – See also the study by
Keith P.F. Moxey, *Pieter Aertsen, Joachim
Beuckelaer and the Rise of Secular Painting in
the Context of the Reformation*, New York/
London 1977 (doctoral thesis, Chicago 1974).

33 Georg Lukácz, *Geschichte und Klassenbewußt-
sein* (1923), Neuwied/Berlin 1968, pp. 170 ff.

34 Max Weber, *Soziologie. Universalgeschicht-
liche Analysen. Politik*, edited by J. Winckel-
mann, Stuttgart 1973, passim and also p. 481.

35 On Beuckelaer cf Moxey (note 32).

36 Henning (see note 29), pp. 183 ff.

37 Cf. *Catalogue de la Peinture Ancienne.
Nouvelle édition avec 86 ill.*, Brussels 1957, No.
235 (p. 57), plate XLVI. – R.A. d'Hulst, 'Jacob
Jordaens en de "Allegorie van de Vruchtbaar-
heid,"', in: *Bulletin Musées Royaux des
Beaux-Arts*, Brussels, 1, 1952. – R.A. d'Hulst,
Jacob Jordaens, Stuttgart 1982, ill. 79, pp. 110
ff.

38 Cf. H. Bodmer, 'Die Kunst des Bartolommeo
Passarotti,' in: *Belevedere* 13, 1938/39, pp. 66-
73. – Corinna Höper, *Bartolommeo Passarotti
(1529-1592). Manuskripte zur Kunstwissen-
schaft* vol. 12, Worms 1987, 2 volumes.

39 Cf. Patrick J. Cooney/Gianfranco Malafarina,
L'opera completa di Annibale Carracci, Milan
1976, Cat. No. 4.

40 Quoted from the *Tot lering* catalogue (note 26),
p. 117

41 This particular detail makes if questionable, of
course, whether the entire scene really is a
'butcher's stall' (as the commonly accepted title
suggests). More likely, it is the presentation of
products after a slaughter in an agricultural
household.

42 For Rembrandt's *Slaughtered Ox* cf. Chr.
Tümpel, *Rembrandt, Mythos und Methode*,
Königstein im Taunus, 1986, Cat. No. 124
(Paris) and 125 (Glasgow), illus. p. 376. – K.M.
Craig, 'Rembrandt and the "Slaughtered Ox"'
in: *Journal of the Warburg and Courtauld In-
stitutes* 46, 1983, pp. 235-239.

43 On the subject of obscene gestures in Dutch
market and sales paintings (especially scenes
where poultry is sold) of the 16th and 17th
centuries cf. Eddy de Jongh, 'Erotica in vogel-
perspectief. De dubbelzinnigheid van een reeks
17de eeuwse genrevoorstellingen,' in: *Simiolus*
3, 1968/69, pp. 22-74.

44 On the subject of the 'entire house' cf. Otto
Brunner, *Adeliges Landleben und europäischer
Geist*, Salzburg 1949, pp. 237 ff.

45 Ludger tom Ring the Younger's, *Kitchen Piece*
was burnt in an air raid in 1945.

46 On Joachim Anthonisz Uytewael (or Wtewael)
cf. the catalogue *Staatliche Museen zu Berlin,
Gemäldegalerien, Holländische und flämische
Gemälde des 17. Jahrhunderts im Bode-

Museum*, East Berlin, 1976, No. 2002, p. 85. –
J. Bruyn, 'Een keukenstuk van C.C. van Haar-
lem,' in: *Oud Holland* 66, 1951, p. 47.

47 Emmens (see note 32), also: E. de Jongh (see
note 43)

48 Sebastian Brant, *Das Narrenschiff. Text und
Holzschnitte der Erstausgabe 1494, Zusätze der
Ausgaben 1495 und 1499*. Frankfurt 1980, p.
233. Also: Norbert Schnieder, 'Holländische
Genremalerei des 17. Jahrhunderts,' in: *ten-
denzen* No. 148, 25th year, 1984, pp. 49 ff.,
here: pp.55 ff. (on the depiction of servants).

49 *Die Sprache der Bilder* catalogue, Brunswick
1978, No. 30, pp. 136 ff. – Catalogue of the
Herzog Anton Ulrich Museum, Brunswick *Die
holländischen Gemälde. Kritisches Verzeichnis
von Rüdiger Klessmann*, Brunswick 1983, pp.
181f.

50 *Die Sprache der Bilder* catalogue (see note 49),
No. 24, pp. 120 ff. – *Die holländischen
Gemälde* catalogue (see note 49), pp. 152f. –
Rüdiger Klessmann, 'Ad Tragoediam non ad
vitam,' in: *Ars Auro Prior. Studia Joanni
Bialostocki sexagenario Dicata*, Warsaw 1981,
pp. 367 ff. According to Klessmann, the back-
ground scene shows the poisoning of a slave in
the presence of the Roman military commander
Antony (after Pliny, *Hist. Nat.* XXI, 9). – How-
ever, I think the scene may also be a reference to
Mark 9:14ff, where a boy with an evil spirit is
healed in the presence of some Scribes. The
possessed boy is described as 'like a corpse'
('quia mortuus est'). After the healing Christ
says, 'This kind (i.e., the demons who were
ravaging the soul of the possessed boy) can
come out only by prayer and fasting' ('Hoc
genus in nullo potest exire, nisi in oratione et
ieiunio'). The necessity of fasting is further
emphasized by the criticism of people's greed
which is implicit in the lavish display of large
quantities of meat.

51 For the symbolism of cloves cf. the catalogue by
Sam Segal, *Niederländische Stilleben von
Brueghel bis van Gogh*, Amsterdam/Brunswick
1983: cloves were seen as symbolizing Christ's
nails on the cross. Theophrastus called them
'flowers of Zeus' or 'flowers of God.'

52 Gemäldegalerie, Kassel, Inv. No. GK 156.

53 Cf. *Mauritshuis, the Royal Cabinet of Paint-
ings. Illustrated General Catalogue*, The Hague
1977, No. 260, p. 231. Also: J.J. van Thiel in
Openbar Kunstbezit 14, 1970, No. 40.

54 Enriqueta Harris, *Velázquez*, Oxford 1982, pp.
37ff., especially p. 44.

55 For Cornelis Jacobsz Delff's still lifes cf. P.
Eikemeier in the *Alte Pinakothek* catalogue,
Munich 1983, No. 116f.

56 Cf. Jonathan Brown, *Velázquez. Painter and
Courtier*, New Haven/London 1986, No. 21, p.
16. – For 17th-century Spanish still lifes cf.
Jutta Held, "Verzicht und Zeremoniell" in the
catalogue *Stilleben in Europa*, Münster/Baden-
Baden 1979, pp. 380-400.

57 For the history of the hunt in early modern

times cf. Ernst-Walter Zeeden, *Deutsche Kul-
tur in der frühen Neuzeit (Handbuch der Kul-
turgeschichte)*, Frankfurt 1968, pp. 41 ff. –
Hannsferdinand Döbler, *Jäger, Hirten, Bauern*,
Munich, undated (1979), pages. 70 ff. –
Zedler, *Universal-Lexikon*, volume 14,
columns 250 ff.

58 Fernand Braudel, *Sozialgeschichte des 15.-18.
Jahrhunderts. Der Alltag*, Munich 1985, p.
198.

59 Aelianus, *De Natura Animalium Libri XVII*,
ed. by R. Hercher, Leipzig 1864, V, 34; Alber-
tus Magnus, *De Animalibus VIII*, 2 and 4.

60 Veit Ludwig von Seckendorff, *Teutscher Für-
sten-Staat*, Jena 1737 (extended version of the
earlier edition, Frankfurt 1656), reprint, Aalen
1972, pp. 437 ff. ("Vom Wild-Bann, Jägerey
etc"). – On Seckendorff, cf. Klaus Garber, 'Zur
Statuskonkurrenz von Adel und gelehrtem
Bürgertum im theoretischen Schrifttum des 17.
Jahrhunderts. Veit Ludwig von Seckendorff's
"Teutscher Fürstenstaat,"' in: August Buck et
al. (eds.), *Europäische Hofkultur im 16. und 17.
Jahrhundert*, Hamburg 1979, pp. 229 ff.; ex-
tended edition in *Daphnis* 11, 1982, H. 1-2, pp.
115 ff.

61 Cf. Peter Eikemeier, 'Der Jagdzyklus des Jan
Weenix aus Schloß Bensberg,' in: *Weltkunst*
XLVIII, 1978, pp. 296 ff.

62 Cf. Jan Lauts, *Stilleben alter Meister I. Nieder-
länder und Deutsche*. Staatliche Kunsthalle
Karlsruhe, Karlsruhe 1969, pp. 34 ff.

63 See Chapter 1. – On the topic of this chapter, cf.
also the essay by Hans Kauffmann, now a clas-
sic: 'Die Fünfsinne in der niederländischen
Malerei des 17. Jahrhunderts,' in: *Kunstge-
schichtliche Studien für Dagobert Frey*, Breslau
1943, pp. 133-157.

64 Nikolaus von Kues, *Compendium. Lateinisch
und deutsch*, ed. by B. Decker and K. Bormann,
Hamburg 1970 (*Philosophische Bibliothek* vol-
ume 267), chapter 8, p. 31.

65 Werner Sombart, *Liebe, Luxus und Kapitalis-
mus*, Munich 1967, pp. 127 ff. ('Der Sieg des
Weibchens').

66 Cf. Klaus Ertz, *Jan Brueghel der Ältere. Die
Gemälde*, Cologne 1979. Unfortunately, how-
ever, Ertz's monograph says too little about
iconographic aspects.

67 Erich Trunz (ed.), *Goethes Werke* (Hamburg
edition), volume 1, Hamburg 1952, p. 367,
also: editor's notes p. 572.

68 Cf. Wilhelm Dilthey, 'Die Funktion der An-
thropologie in der Kultur des 16. und 17. Jahr-
hunderts,' in: ibid., *Gesammelte Schriften*,
volume II, Stuttgart/Göttingen 1969, pp. 416
ff. – Schneider (note 20).

69 Cf. the catalogue *Die Sprache der Bilder* (see
note 49), nos. 10f-j, pp. 70 ff.

70 Christian Klemm, 'Weltdeutung – Allegorien
und Symbole in Stilleben,' in: the *Stilleben*
catalogue (see note 56), p. 140 ff., here: pp. 182
ff.

71 (same as 70) See footnote *71 in book.

72 Cf. Bergström (see note 1), p. 15 (illus. 12).

73 On this topic cf. the recent study by Christiane Wiebel, *Askese und Endlichkeitsdemut in der italienischen Renaissance. Ikonologische Studien zum Bild des Heiligen Hieronymus*, Weinheim 1988.

74 The painting bears the Inv. No. D 1/1953/14.

75 Cf. Bergström (see note 1), p. 15 (illus. 13). - This didactic poem by Lucretius had already been published as an incunabulum in Brescia in 1473. For Lucretius' philosophy cf. P. Boyance, *Lucrèce et l'épicureisme*, Paris 1963.

76 Cf. Hans Rupprich, *Die deutsche Literatur vom späten Mittelalter bis zum Barock*, part one, Munich 1970, pp. 216 ff. (bibliography p. 753). - T.S.R. Boase, 'Sterben, Jüngstes Gericht und Auferstehung,' in: Joan Evans (ed.), *Blüte des Mittelalters*, Munich/Zurich 1966, pp. 203 ff.

77 Cf. Karl Heussi, *Kompendium der Kirchengeschichte*, 12th edition, Tübingen 1960, pp. 236 ff. (65-72).

78 Alberto Tenenti, 'Auf dem Weg zu einer neuen Kultur,' in: R. Romano/A. Tenenti, *Die Grundlegung der modernen Welt*, (Fischer Weltgeschichte, volume 12), Frankfurt 1967, pp. 116 ff.

79 Rudolf Wittkower, 'Gelegenheit, Zeit und Tugend,' in: ibid., *Allegorie und der Wandel der Symbole in Antike und Renaissance*, Cologne 1983, pp. 186-206 (particularly illus. 139 and 140: *Ergriffene und verpaßte Gelegenheit* [Seized and Missed Opportunity] by Theodor Galle, 1605). - Schneider (see note 20).

80 On Pereda cf. *Real Academia de bellas artes de San Fernando. Catalogo de las pinturas por Fernando Labrada*, Madrid 1965, p. 66 (no. 639, 'La vida es sueño'). Cf. also the picture *In Ictu Oculi* by Juan de Valdés Leal, painted for the Hospital de la Caridad in Seville, whose chairman he was. Set against a sombre background, it shows Death with a sickle rising above armours and a globe, extinguishing the light of a candle. The candle is placed on a rostrum consisting of a tiara and worldly crowns. An open book shows an etching with the inscription 'Pompa introitus honori Serenissimi principis Ferdinandi Austriaci . . .' by Johannes Casparus Gevartus (Antwerp 1641). On the same subject cf. Elisabeth du Gué Trapier, *Valdés Leal. Spanish Baroque Painter*, New York 1960, fig. 127.

81 'Eternally he stings, he comes flying quickly and cuts down (everything).'

82 Calderón de la Barca, *Ausgewählte Werke* (Selected Works) in ten volumes, ed. by W. von Wurzbach, Leipzig 1910, volume 2, pp. 83f., translated into German by J.D. Gries.

83 Cf. *Le siècle de Rubens dans les collections publiques françaises* catalogue, Paris 1977/78, No. 8, pp. 43 ff.

84 *Le siècle de Rubens* catalogue (see note 83), p. 43. - Albert Chatelet, *Cent chef-d'œuvres du Musée de Lille*, Lille 1970, p. 98. - On Poussin's self-portrait cf. Matthias Winner, 'Poussins Selbstbildnis im Louvre als kunsttheoretische Allegorie,' in: *Römisches Jahrbuch für Kunstgeschichte* 20, 1983, pp. 417-449.

85 Cf. Klaus Bußmann, *Burgund. Kunst, Geschichte, Landschaft*, Cologne 1977, illus. 161: Claus Sluter and Jean de Marville, *Trauernde Mönche* (Mourning Monks).

86 Cf. Gerhard Langemeyer, 'Das Stilleben als Attribut,' in: *Stilleben* catalogue (see note 56), p. 220 ff., illus. 241.

87 Cf. Noel Deerr, *The History of Sugar*, 2 volumes, London 1949/50. - O. von Lippmann, *Geschichte des Zuckers seit den ältesten Zeiten bis zum Beginn der Rübenzuckerfabrikation. Ein Beitrag zur Kulturgeschichte*, 2nd edition, Berlin 1929. - Zedler, *Universal-Lexikon*, volume 63, columns 1029 ff.

88 Cf. Kurt Wettengl, 'Die Mahlzeitenstilleben von Georg Flegel', thesis, Osnabrück 1983.

89 Numerous Bible passages were suitable for filling the idea of 'sweetness' with spiritual content (cf. Revelation 10:9: 'In your mouth it [the book] will be as sweet as honey,' Psalm 119:103: 'How sweet are your words to my taste, sweeter than honey to my mouth!'). See also Friedrich Ohly, 'Geistige Süße bei Otfried,' in: *Typologia litterarum. Festschrift Max Wehrli*, Zurich 1969, pp. 95-124.

90 Cf. Herbert Cysarz (ed.), *Deutsche Barock-Lyrik*, Stuttgart 1965, pp. 66f and 68.

91 Cf. Bergström, note 24.

92 For the parrot as a symbol (Lat. *psittacus*), cf. Hrabanus Maurus, 'De universo liber' VIII, in: MPL vol. 111, column 246. Parrots, it is claimed, say 'Ave,' which can be read back to front as 'Eva,' as a prefiguration of Mary.

93 The motif of the knife threatening to fall off the table at any moment contains latent reminders of its dangerousness in a society where people still have not learned to control their emotions. Cf. Norbert Elias, *Über den Prozeß der Zivilisation*, Bern 1969, vol. I, pp. 159 ff.

94 On the symbolic character of the pomegranate, cf. the article by C. Dutilh in: LCI, vol. 2, column 198 ff.

95 Cf. *Der Physiologus*, translated and interpreted by Otto Seel, 4th edition, Zurich/Munich 1983, pp. 42 ff. - On van Mieris's *Meal of Oysters* cf. Otto Nauman, *Frans van Mieris (1635-1681) The Elder*, Doornspijk, undated (1981), vol. II, pp. 43 ff.; plate 36.

96 Cf. 'Vnderweisung/ wie man nach Französischer Art ein grosses Panquet anstellen solle' (1679), in: Johannes Anderegg (ed.), *Deutsches Lesebuch*, vol. 1/1, *Das Zeitalter des Barock*, Frankfurt 1970, pp. 44-46.

97 Cf. Bergström (see note 1), pp. 98 ff.

98 R. van Luttervelt, *Schilders van het stilleven*, Naarden 1947, notes 12 and 17. - Bergström (see note 1). - Cf. also Jakob Rosenberg / Seymore Slive / E.H. ter Kuile, *Dutch Art and Architecture 1600 – 1800 (The Pelican History of Art)*, Harmondsworth 1977, pp. 333 ff.

99 Zedler, *Universal-Lexicon*, volume 15, column 49.

100 Joseph Lammers, 'Fasten und Genuß,' in: *Stilleben* catalogue (see note 56), pp. 402 ff., here p. 406.

101 Op. cit., p. 406. - Cf. also Simon Schama, *Überfluß und schöner Schein. Zur Kultur der Niederlande im goldenen Zeitalter*, Munich 1988, pp. 147 ff.

102 Zedler, *Universal-Lexicon*, volume 9, column 297.

103 Cf. Stuart George Hall / Joseph H. Crehan, 'Fasten', in: *Theologische Realenzyklopädie*, volume XI, Berlin/New York 1983, pp. 55f.

104 For the following section cf. Bergström (see note 1), illus. pp. 100 ff.

105 Op.cit., illus. p. 104.

106 Op.cit., illus. p. 106.

107 Probably in association with Numbers 11:5-6 ('Recordamur piscium quos comedebamus in Aegypto gratis, in mentem nobis veniunt cucumeres et pepones porrique et cepae et alia. Anima nostra arida est'. - 'We remember the fish we ate in Egypt at no cost – also the cucumbers, melons, leeks, onions and garlic. But now we have lost our appetite.')

108 Early Christians used the fish as a secret symbol of Christ, as the letters of the Greek word *ichthys* ('fish') were also the initials of the words *Iesous Christós Hyós Theoú Sotér* ('Jesus Christ, Son of God, Saviour']).

109 Negative meaning of insects, according to Psalm 105:34.

110 However, in the second half of the century, there was a period of re-feudalization, with a concomitant revival of ceremonial pomp, though this time by the newly rich.

111 In practice, this artistic aestheticism already anticipates the epistemological elements that were to become characteristic of British Empiricism, e.g., George Berkeley ('An Essay Towards a New Theory of Vision,' 1709), who maintained that 'to be is to be perceived' ('esse est percipi').

112 Cf. illus. cat.no. 117 in: Lucius Grisebach, *Willem Kalf, 1617-1693*, Berlin 1974, a still life which was painted in 1662 and is now part of the Thyssen-Bornemisza Collection, Castagnola-Lugano.

113 Cf. Hibbard (see note 6), pp. 80 ff., illus. 47. Michel Butor, 'Der Korb in Ambrosiana,' in: ibid., *Aufsätze zur Malerei*, Munich 1970, pp. 16-32.

114 On the subject of trompe l'œil cf. Christa Burda, 'Das Trompe l'œil in der holländischen Malerei des 17. Jahrhunderts,' doctoral thesis, Munich 1970. - Milman (see note 10).

115 Cf. Hibbard (see note 6), pp. 17 ff.

116 Cf. Panofsky (see note 23), pp. 131 ff. (on the subject of 'disguised symbolism')

117 Eddy de Jongh, 'Grape Symbolism in Paintings of the 16th and 17th Centuries,' in: *Simiolus* 7, 1974, No. 4, pp. 166-191.

118 Sam Segal points out that peaches often occur in brothel scenes and that apricots – as in Rabelais' *Gargantua and Pantagruel* – may well be a vaginal symbol (cf. *Niederländische Stilleben* catalogue – see note 51 – p. 15). And of course, in connection with the Fall of Man, the Latin word for an apple – *malum* – was equated with the word for evil – also *malum*, even though the two words were not etymologically related. Apples and other fruits were given a positive meaning with reference to Proverbs 25:11 ('A word aptly spoken is like apples of gold in settings of silver').

119 Roemer Visscher, *Sinnepoppen*, Amsterdam 1614, No. 27.

120 Cf. Maria Corti / Giorgio T. Faggin, *L'opera completa di Memling*, Milan 1969, colour panel LXIV, cat.no. 101, p. 110. – On the theme of flower still lifes cf. Norbert Schneider, 'Vom Klostergarten zur Tulpenmanie. Hinweise zur materiellen Vorgeschichte des Blumenstillebens,' in: *Stilleben* catalogue (see note 56), pp. 294 ff. – Paul Pieper, 'Das Blumenbukett,' in: *Stilleben* catalogue (ibid.), pp. 314 ff.

121 Cf. Panofsky (see note 23), p. 333. According to Panofsky, scarlet lilies symbolize the Blood of the Passion, irises on the other hand the sword which pierced the Mater Dolorosa. On the complex symbolism of the honeysuckle, cf. Panofsky, p. 416, note 6, as a reference to p. 146.

122 Cf. Max Wehrli, *Literatur im deutschen Mittelalter*, Stuttgart 1984, pp. 236 ff.

123 Jean Leclercq, *Wissenschaft und Gottverlangen. Zur Mönchstheologie des Mittelalters*, Düsseldorf 1963, p. 152.

124 Cf. Paul Pieper, 'Ludger tom Ring d.J. und die Anfänge des Stillebens,' in: *Münchner Jahrbuch der bildenden Kunst*, 3f., 15, 1964, p. 113f.

125 Alistair C. Crombie, *Von Augustinus bis Galilei. Die Emanzipation der Naturwissenschaft*, Munich 1977, p. 486

126 *Stilleben* catalogue (see note 56), p. 115

127 Crombie (see note 125), p. 495.

128 Cf. Claus Nissen, *Die botanische Buchillustration. Ihre Geschichte und Bibliographie*, volume 1: *Geschichte*, Stuttgart 1951, pages 66 ff.

129 Ernst Kris, 'Georg Hoefnagel und der wissenschaftliche Naturalismus', in: A. Weixlgärtner and L. Planiscig (eds.), *Festschrift für Julius Schlosser zum 60. Geburtstag*, Zurich/Leipzig/Vienna 1927, pp. 243-253.

130 Cf. Nissen (see note 128), p. 67.

131 L.J. Bol, *The Bosschaert Dynasty*, Leigh-on-Sea 1960, no. 37. – P. Mitchell, *European Flower Painters*, London 1973, p. 65 (on *Vase with Flowers* at the Mauritshuis, The Hague).

132 Cf. Fritz Nemitz, 'Jan Brueghel d.Ä., Blumenstrauß,' in: *Kunstwerke der Welt. Alte Pinakothek München*, Munich 1967, pp. 93 ff. – Ertz (see note 66), pp. 260 ff.

133 It is worth noting that Brueghel's Ambrosiana still life, painted earlier (in 1606), did not show a crown imperial at the top. On the occupation of Donauwörth cf. Heussi (see note 77), p. 354 (section 94).

134 Cf. Carmen Bechtold, *Eine Einführung in die Symbolik von Pflanzendarstellungen vom Mittelalter bis zum Barock*, leaflet of the Staatliche Kunsthalle Karlsruhe, 1985.

135 For the following section cf. Schneider (see note 120), pp. 308 ff. Tulips were mentioned quite early by Oliver de Serres, *Le Théâtre d'Agriculture et Mesnage des Champs*, Paris 1600, pp. 577f. ('Tulipan': 'Ceste plante produit des rares fleures de la grandeur & figure comme celle du lys, fort recerchées pour leur excellente couleur d'orangé-rouge').

136 On Daniel Seghers, cf. F. Kieckens, *Daniel Seghers, de la compagnie de Jésus, peintre de fleurs, sa vie et ses œuvres*, Antwerp 1886. – M.-L. Hairs, *Les peintres flamands de fleurs au XVIIe siècle*, Paris/Brussels 1955, 2nd edition, 1964, passim. – Günther Heinz, 'Geistliches Blumenbild und dekoratives Stilleben in der Geschichte der kaiserlichen Gemäldesammlungen,' in: *Jahrbuch der kunsthist. Sammlungen in Wien* 69, 1973, pp. 7-54, here: p. 20.

137 Cf. Jean Delumeau, *Le catholicisme entre Luther et Voltaire*, Paris 1971. – P. Bossy, 'The Counter-Reformation and the People of Catholic Europe,' in *Past and Present* 47, 1970, pp. 51-70. – Hubert Jedin, 'Katholische Reform und Gegenreformation,' in: *Handbuch der Kirchengeschichte*, volume 4, Freiburg i. Br. 1967, p. 449 ff.

138 On pictures within pictures cf. Martin Warnke, 'Das Reiterbild des Balthasar Carlos von Velázquez,' in: *Amici Amico, Festschrift für Werner Gross*, Munich 1968, p. 217-227. – ibid., 'Italienische Bildtabernakel bis zum Frühbarock,' in: *Münchner Jahrbuch der bildenden Kunst*, 3rd edition, 19, 1968, pp. 61-102.

139 There are eleven putti – a number which probably refers to the Apostles minus Judas, the traitor. Cf. *Alte Pinakothek* catalogue, Munich 1983, pp. 443 ff.

140 On Jan Davidsz. de Heem cf. Heinz (see note 136), p. 18. – Klemm (see note 70), pp. 140 ff., especially pp. 182 ff.

141 Cf. Erwin Iserloh, 'Abendmahl III/4,' in: *Theologische Realenzyklopädie*, volume I, Berlin/New York 1977, pp. 126 ff. (with extensive bibliography).

142 Cf. Norbert Schneider, *Jan van Eyck, Der Genter Altar. Vorschläge für eine Reform der Kirche*, Frankfurt 1986, pp. 79 ff.

143 On the tendency towards empirical research, which started in the 17th and 18th centuries, cf. Wolf Lepenies, *Das Ende der Naturgeschichte*, Munich 1976, especially pp. 16 ff. – Michel Foucault, *Die Ordnung der Dinge*, Frankfurt 1971.

144 On *Physiologus* cf. Norbert Schneider, 'Natur und Kunst im Mittelalter,' in: Werner Busch (editor), *Funkkolleg Kunst*, volume II, Munich and Zurich 1987, pp. 619-648, here: p. 636.

145 *Hermolai Barbari Castigationes Plinianae. Item emendatio in Melam Pomponium*, Rome 1492/93.

146 Otto Brunfels, *Contrafayt Kreütterbuch. Nach rechter vollkommener art, vnud [sic] Beschreibung der Alten, besst-berümpten ärzt, vormals in Teütscher sprach, der maszen nye gesehen, noch im Truck auszgangen etc.*, 2 volumes, Strasbourg 1532 (abridged translation of Brunfels' *Herbarum vivae eicones ad naturae imitationem summa cum diligentia et artificio effigiatae*, Argentorati 1530-1536.

147 Marie Boas, *Die Renaissance der Naturwissenschaften 1450-1630. Das Zeitalter des Kopernicus*, Gütersloh 1965, p. 60.

148 Hans Blumenberg, *Die Legitimität der Neuzeit*, Frankfurt 1966 (Part 3: *Der Prozeß der theoretischen Neugierde*), p. 363.

149 Quoted from Boas (see note 147), pp. 57 f.

150 Cf. Zedler, *Universal-Lexicon*, volume XX, column XX.

151 Augustinus, *Confessiones* V, 3, 4; X, 35, 55 ('curiositas' as part of man's reprehensible lust of the eye).

152 Leonardo, *Codex Arundel* (ed. J.P. and I.A. Richter), p. 155. – Josef Gantner, *Leonardos Visionen von der Sintflut und vom Untergang der Welt*, Bern 1958, p. 100 ff. – Quoted from Blumenberg (see note 148), p. 362.

153 Cf. Gisela Luther, 'Stilleben als Bilder der Sammelleidenschaft,' in: *Stilleben* catalogue, pp. 88-128 (fundamental reading, with further literature listed in the notes, pp. 566 ff.). – Julius von Schlosser, *Die Kunst- und Wunderkammern der Spätrenaissance*, 2nd edition, Brunswick 1978.

154 On Frans Francken II cf. *Stilleben* catalogue (see note 56), illus. 80 (p. 124; Historisches Museum, Frankfurt) and 81 (p. 127, Kunsthistorisches Museum, Vienna).

155 Cf. Ulla Krempel, *Jan van Kessel d.Ä., Die vier Erdteile* catalogue, Munich 1973. U. Krempel has pointed out that numerous motifs painted by the artist were borrowed from zoological and botanical works (e.g., Theodor de Brys' 13 volumes on 'oriental' and 'occidental' India, Frankfurt, 1590-1634).

156 Cf. Bergström (see note 1), p. 157.

157 Cf. Rudolf Burckhardt, *Geschichte der Zoologie und ihrer wissenschaftlichen Probleme*, 2nd edition, revised by H. Erhard, volume I: *Bis zur Mitte des 18. Jahrhunderts*, Berlin/Leipzig 1921, pp. 71 ff.

158 At this point of scientific development there was already growing scepticism about the magical properties of the mandrake, though throughout the Middle Ages everyone had been convinced of its excellent therapeutic effect. Cf. H. Rahner, 'Die seelenheilende Blume, II, Mandragore, die ewige Menschenwurzel,' in: *Eranos-Jahrbuch 1945*, pp. 202-239. – Thomas de Perseigne, 'In canticum VI,' in: *MPL*, volume 206, column 759. – On 16th-century views of the mandrake cf. Lynn Thorndike, *A History of Magic and Experimental Science*, Vol. VI, New York 1941, p. 292 (on Hieronymus Bock).

159 According to U. Krempel (see note 155), van Kessel was referring to J. Nieuhoff, *Het Gesamtschap der Neerlantsche Oostindische Compagnie*, Amsterdam 1665.

160 U. Krempel has shown that the main source of this picture of America was Wilhelm Piso, *Historia Naturalis Brasiliae*, Amsterdam 1658. Van Kessel also used J.E. Nieremberg, *Historia Naturae*, Antwerp 1635.

161 On depictions of the enchantment of trees and animals by Orpheus (Ovid, *Metamorphoses X*, pp. 86-105), cf. A. Pigler, *Barockthemen*, Budapest/Berlin 1956, volume II, pp. 186ff.

162 Cf. H.E. Wethey, *The Paintings of Titian*, complete edition, volume III: *The Mythological and Historical Paintings*, no place of publication, 1975, pp. 10ff. and catalogue no. 29 (with literature).

163 On the subject of 'merry society' cf. Chr. Brown, *Holländische Genremalerei im 17. Jahrhundert*, Munich 1984, pp. 177ff. – On the depiction of the subject in graphic cycles (e.g., Element Cycle by Chrispijn de Passe, after Maerten de Vos, *Terra*) cf. *Tot lering* catalogue (see note 26), p. 24, illus. 6. The connection between music and eroticism, e.g., in emblems, has been discussed by Gabriel Rollenhagen, *Nucleus emblematum*, Cologne 1611, p. 70, and Jacob Cats, *Sinne- en minnebeelden*, Amsterdam/Utrecht 1700, 1st edition 1618, p. I. 86 ('Quid non sentit amor'). – Cf. in this context Caravaggio's *Concerto of Young Men* (Metropolitan Museum, New York), and Hibbard (see note 6), pp. 31ff. who refers to Callisto Piazza's *Concerto* (Johnson Collection, Philadelphia Museum) as a prototype from the 1520s (in his book illus. 16, p. 34).

164 E.g. Frans Floris, *Familie van Berchem*, 1561, Lier, Wuyts-van-Campen-Caroly Museum, inv.no. 52. The inscription in the frame apparently points to the *concordia* symbolism. – An emblematic allegory of harmony can be found in Cesare Ripa, *Iconologia overo descrittione di diverse imagini cavate dall' antichità, e di propria inventione*, with an introduction by Erna Mandowsky (reprint of the Rome 1603 edition), Hildesheim/New York 1970, p. 26. – Cf. also A.P. de Mirimonde, 'La musique dans les allégories de l'amour,' I, in: *Gazette des Beaux-Arts* 68, 1966, pp. 265-290; II, in: op. cit. 69, 1967, pp. 319-346. – E. Winternitz: Musical Instruments and their Smybolism in Western Art.

165 Recent literature on Baschenis: Marco Rosci, *Evaristo Baschenis, Bartolommeo e Bonaventura Bettera. Estratto da »I Pittori Bergamaschi, Il Seicento – Volume III«. Raccolta di studi a cura della Banca Popolare*, Bergamo 1985 (text and œuvre catalogue). – Pierre Nicolas Huilliot's painting should be mentioned here as an example of later still lifes of musical instruments (Residenzgalerie, Landessammlungen, Salzburg).

166 An emblem by Sebastián de Covarrubias Oroszco (1539-1613), *Emblemas Morales ...*, Madrid 1610, 2nd book, no. 31 (HS, column 1303), shows a guitar lying on a marble table. The painting bears the motto: 'Sonus est qui vivit in illa' ('It is the sound that lives in it'). This points to the musical potential of the instrument – an aspect which is probably also hinted at by Baschenis. – A 'genre' scene with instruments made by Willem Duyster (Berlin, state palaces and gardens) expresses the context that preceded the stillife situation staged by Baschenis (cf. *Tot lering* catalogue – see note 26 – no. 21, pp. 104ff.)

167 On the numerical theory of Pythagoras cf. Aristotle, *Metaphysics* I, p.5.

168 Further musical tracts of the Middle Ages are listed in Schneider (see note 142), p. 95, note 34.

169 On Johannes de Muris cf the article by H. Besseler in *Musik in Geschichte und Gegenwart*, Kassel et al. 1958, volume 7, columns 105-115 (with literature). – Cf. also the instructive article 'Musik, Musikinstrumente' by Hartmut Braun in: *LCI*, volume 4, columns 597-611.

170 Marco Rosci, 'Metodi di produzione delle botteghe bergamasche e natura morta italiana: asterischi su Bascheni, Bettera e collaterali,' in *Arte Ill.* 1, 1968, pp. 22ff.; cf. Wallraf-Richartz-Museum catalogue, Cologne: Brigitte Klesse, *Italienische, französische und spanische Gemälde bis 1800*, Cologne 1973, pp. 18 f.

171 Cf. Sigrid Braunfels, 'Scorpion', in: *LCI*, volume 4, p. 171.

172 Cf. *Sprache der Bilder* catalogue (see note 49), no. 27, pp. 128 ff.

173 Diego de Saavreda, *Idea de un principe*, 1640, quoted from *Sprache der Bilder* catalogue (see note 49, p. 130)

174 Cf. Giovanni Battista Moroni's *Nobleman* at the National Gallery, London (Inv. no. 1022). Cf. also Cecil Gould, *National Gallery Catalogues. The Sixteenth-Century Italian Schools*, London 1975, p. 167ff.

175 See chapter 6.

176 Guillaume de la Perrière, *Le Théâtre des bons engins etc.*, Paris 1539 (HS, column 1485).

177 *Deutsche Barock-Lyrik*, see note 91, p. 27.

178 Cf. *Alte Pinakothek* catalogue, Munich 1983, pp. 116ff.

179 On Hugo Grotius cf. Will and Ariel Durant, *Europa im Dreißigjährigen Krieg*, (*Kulturgeschichte der Menschheit*) volume 11, Frankfurt, Berlin and Vienna 1982, pp. 435ff.

180 Quoted by Ernst Robert Curtius, *Europäische Literatur und lateinisches Mittelalter*, 7th edition, Berne/Munich 1969, pp. 307.

181 Cf. Denys Hay, 'Fiat lux,' in: John Carter/Percy H. Muir (eds.), *Bücher, die die Welt verändern*, Munich 1968, pp. 11-46. – Eva-Maria Hanebutt-Benz, *Die Kunst des Lesens* catalogue, Museum für Kunsthandwerk, Frankfurt 1985, pp. 55ff. – On still lifes of books cf. Jochen Becker, 'Das Buch im Stilleben – das Stilleben im Buch,' in: *Stilleben* catalogue (see note 56), pp. 448ff.

182 Alanus ab Insulis, in: *MPL*, volume 210, column 579A. – Cf. Curtius (see note 180), p. 32.

183 Rolf Engelsing, *Analphabetentum und Lektüre. Zur Sozialgeschichte des Lesens in Deutschland zwischen feudaler und industrieller Gesellschaft*, Stuttgart 1973, pp. 42ff.

184 Sebastian Brant, *Das Narrenschiff*, text and woodcuts of the first edition of 1494, and amendments to the 1495 and 1499 editions, Frankfurt 1980, p. 42ff. – On Barnabe Rich and Robert Burton, see Will and Ariel Durant, 'Gegenreformation und Elisabethanisches Zeitalter,' in: *Kulturgeschichte der Menschheit* volume 10, Frankfurt, Berlin and Vienna 1982, pp. 376ff. – Cf. Robert Burton, *Anatomy of Melancholy*.

185 Aaron J. Gurjewitsch, *Das Weltbild des mittelalterlichen Menschen*, Dresden 1978, p. 171ff. – Jacques Le Goff, 'Zeit der Kirche und Zeit des Händlers,' in: M. Bloch et al., *Schrift und Materie der Geschichte* (ed. by Claudia Honegger), Frankfurt 1976, pp. 393-417.

186 *Alte Pinakothek* catalogue, Munich 1983, p. 286.

187 Bergström (see note 1), p. 163. – A.P. Mirimonde, 'Musique et symbolisme chez Jan-Davidzoon de Heem, Cornelis-Jandzoon en Jan II Janszoon de Heem,' in: *Jaerboek Koninklijk Museum voor Schone Kunsten*, Antwerp 1970, pp. 251ff.

188 Cf. Th. H. d'Angremond, 'De Spaansche Brabander', in: *Tijdschrift voor taal en letteren*, 24, 1936, pp. 276ff.

189 'C. Suetonii Tranquilli De vita Caesarum libri VIII recensuit L. Prud'homme,' Groningen 1906. (German translation: Sueton, *Werke in einem Band*, Berlin/Weimar 1985 [*Bibliothek der Antike, Römische Reihe*], pp. 336-349).

190 Cf. Carel ter Haar, 'Das goldene Zeitalter der Literatur in den Niederlanden,' in: *Propyläen Geschichte der Literatur*, volume III: *Renaissance und Barock 1400-1700*, 2nd edition, Berlin 1988, p. 388.

191 Ingvar Bergström, 'Marseus, peintre de fleurs, papillons et serpents,' in: *L'Oeil* 233, 1974, pp. 24 and 65. – Ibid. in: *Natura in posa*, Milan 1977, p. 201. – V. C. Habicht, 'Ein vergessener Phantast der holländischen Malerei,' in: *Oud Holland* 41, 1923, pp. 33ff., illus. 1.

192 See note 191

193 On Frederick Ruysch cf. the entry in Thieme-Becker, *Allgemeines Lexikon der bildenden Künstler*, Leipzig 1908ff., volume 29, p. 243.

194 The theory of 'spontaneous generation' continued to be propounded for quite a while, although it had already been refuted by Swammerdam et al. Cf. Ulisse Aldrovandi, *Serpentum et Draconum historiae libiri duo*, Bologna 1640, p. 12. – Ibid., *De reliquis animalibus exanguibus*, Bologna 1606. pp. 299ff. – Ibid., *De animalibus insectis*, Bologna 1602, lib. I, p. 57. – Moufetus (Thomas Moffet), *Insectorum sive minimorum animalium theatrum olim ab Edoardo Wottono, Conrado Gesnero, Thomaque Pennio inchoatum*, London 1634, II, pp. 247-248. – Also Thorndike (see note 158), pp. 700ff. and elsewhere. – Cf. also Henricus Ruysch, *Theatri universalis animalium pars quinta . . . de insectis libri III*, Amsterdam 1718, volume II, p. 98.

195 The combination of a stone plinth and an oak tree in Mignon's Cologne painting probably alludes to Joshua 24:26 ('Then he took a large stone and set it up there under the oak near the holy place of the Lord.').

196 Very little is known about Abraham Mignon. We only know that, together with Marell, he had to leave Frankfurt in 1664, under growing pressure from the counter-reformation. Until then Frankfurt had been a German centre of Calvinist refugees from France. He went to Utrecht where he soon became a member of the Guild of St. Luke (1669). During these years Mignon associated himself very closely with Jan Davidsz de Heem, who spent the years 1669-1672 in Utrecht, his place of birth. In 1672 Mignon was elected deacon of the Walloon Church, the French-speaking Reformed Church in the northern Netherlands. It is particularly interesting that Mignon should have cooperated with de Heem, whose position was decidedly Catholic and whose symbolism followed Jesuit theology. – On Abraham Mignon cf. the monograph by M. Kraemer-Noble (Leigh-on-Sea 1973), p. 9.

197 In Baroque poetry the pumpkin was sometimes used as a metaphor of life. 'Life is a pumpkin,' wrote Daniel Casper von Lohenstein, 'the skin is flesh and bones / the seeds are the spirit / and the wormholes are death . . .' Cf. Christian Wagenknecht (ed.), *Gedichte 1600-1700 (Epochen der deutschen Lyrik)*, ed. by Walther Killy, volume 4, Munich 1969, p. 303f.

198 Because of the old age which the oak tree is able to attain, it was considered to be a symbol of eternal life.

199 'Muscae immundos spiritus vel peccatores squalores vitiorum sectantes significant, qui sordibus scelerum oleum misericordiae atque charitatis corrumpunt. Unde in Ecclesiaste scriptum est: »Muscae morientes exterminant suavitatem unguenti« (Ecclesiastes 10:1), quia malus mistus bonis contaminat plurimos, quomodo muscae si moriantur in unguento, perdunt odorem et saporem illius . . .' (Hrabanus Maurus, 'De universo lib. IX', in: *MPL* 111, column 258).

200 Cf. Thorndike (see note 158), p. 284.

201 'Lacerta est via iniqui,' 'stellio est pravus' (Hrabanus Maurus, 'Allegoriae,' in: *MPL* 111, columns 979 and 1052; cf. also L. Wehrhahn-Stauch, in: *LCI*, volume 1, columns 589f.).

202 Cf. above on Georg Flegel, chapter 7.

203 Konrad von Megenberg, *Das Buch der Natur. Die erste Naturgeschichte in deutscher Sprache* (ed. by Franz Pfeiffer), Hildesheim/New York 1971 (reprint of the Stuttgart 1961 edition), pp. 183f. – Cf. also Albertus Magnus, 'De Animalibus,' in: Albert Fries (ed. and transl.), *Albertus Magnus, Ausgewählte Texte*, Darmstadt 1981, pp. 65f. (on the squirrel and goldfinch). – Hildegard von Bingen, 'Phisica lib. VI de avibus, cap. LII: »De Distelwincke« (fringilla carduelis),' in: *MPL* 197, column 1306.

204 Ruprich (see note 76), p. 349.

205 Cf. Leibniz's 'Essais de Théodicée sur la bonté de Dieu, la liberté de l'homme et l'origine du mal' of 1710. ('We hold firm to the indisputable doctrine that the number of those damned for ever is incomparably greater than that of the saved, that evil, compared with good, seems like nothing if one is concerned with the true greatness of God's Kingdom . . .,' *Theodizee*, German edition, Leipzig, undated, pp. 110f.).

Artists' Biographies

Willem van Aelst
Born Delft 1627, died Amsterdam c. 1683.
Pupil of his uncle, Evert van Aelst, Delft, and the still life painter Otto Marseus van Schrieck, with whom he studied in Florence. Travelled to France and Italy 1645-56. Specialized particularly in still lifes of fruit, flowers and game.
Lit.: L.J. Bol, *Holländische Maler des 17. Jahrhunderts*, Brunswick 1969 – J. Lauts, *Stilleben alter Meister I. Niederländer und Deutsche*, Karlsruhe 1969, pp. 34ff.

Pieter Aertsen
Born Amsterdam 1508, died Amsterdam 1575.
Pupil of Allaert Claesz in Amsterdam. Joined the Antwerp Guild of St. Luke in 1535. Returned to Amsterdam in 1556. Uncle and teacher Joachim Beuckelaers. Painted in particular market and kitchen still lifes with biblical scenes, which were usually in the background.
Lit.: J. Sievers, *Pieter Aertsen*, Leipzig 1908 – K.P. F. Moxey, *Pieter Aertsen, Joachim Beuckelaer and the Rise of Secular Painting in the Context of the Reformation*, New York/London 1977 (doctoral thesis: Chicago 1974) – M.B. Buchan, *The Paintings of Pieter Aertsen*, Ph.D. thesis, New York 1975

Giuseppe Arcimboldo
Born Milan c. 1527/30, died Milan 1593.
Famous for his allegorical *teste composte* (Lomazzo 1584), heads composed of flowers, fruit, animals, books, weapons or other objects. First trained with his father Biagio Arcimboldo (designed stained glass windows at Milan Cathedral). Court painter of the Emperor Ferdinand I in Prague from 1592, and later for the Emperors Maximilian II and Rudolf II, who made him honorary Count Palatine.
Lit.: R. Barthes, *Arcimboldi*, Parma 1978 – F. Porzio, *L'Universo illusorio di Arcimboldi*, Milan 1979 – W. Kriegeskorte, *Arcimboldo*, Cologne 1988 – *The Arcimboldo Effect*, exhibition catalogue of the Palazzo Grassi in Venice, Milan 1987.

Balthasar van der Ast
Born Middelburg 1593/94, died Delf 1657.
Studied with his brother-in-law Ambrosius Boss-chaert. Worked in Utrecht, where he joined the Guild of St. Luke in 1619, and in Delft (from 1632).
Lit.: L.J. Bol, *The Bosschaert Dynasty*, Leigh-on-Sea 1960

David Bailly
Born Leiden 1584, died Leiden 1657.
Pupil of his father, Pieter Bailly from Antwerp and the copper engraver Jacques de Gheyn. Studied portraiture with Cornelis van der Voort in Amsterdam. Numerous trips abroad. Worked for many princes, including the Duke of Brunswick. Apart from portraits, he painted still lifes such as the famous *vanitas* painting of 1651. Bailly taught his nephews Harmen and Pieter Steenwyck.
Lit.: Still. cat., pp. 239ff – N. Popper-Voskuil, 'Self-portraiture and Vanitas Still Life Paintings in 17th-Century Holland in Reference to D. Bailly's Vanitas Oeuvre', in: *Pantheon* 31, 1973, pp. 58-74.

Hendrick van Balen II
Born Antwerp 1575 (?), died Antwerp 1632.
Visited Italy 1600, where he may have met Rottenhammer in Venice. Travelled to Holland with Peter Paul Rubens and Jan Brueghel the Elder in 1611-12 and 1616. Worked together with other artists, including Joos de Momper, Jan Brueghel the Elder and Frans Snyders.
Lit.: See Jan Brueghel the Elder.

Jacopo de'Barbari
Born Venice c. 1440, died in the Netherlands before 1515.
Venetian painter, copper engraver and wood carver. Met Dürer in Venice in 1494/96. Became court painter for the Emperor Maximilian in Nuremberg and – from 1503/4 – the Elector Frederick III (the Wise) of Saxony. Later, from 1510, also court painter of the Governor of the Netherlands, Margarethe of Austria. His *Still Life with Partridge, Iron Gloves and Bolt of a Crossbow* (Munich) from 1504 is considered to be one of the earliest paintings of this genre.
Lit.: *Alte Pinakothek* catalogue, no. V, *Italienische Malerei*, revised by R. Kultzen, Munich 1975, pp. 14ff.

Evaristo Baschenis
Born Bergamo 1617, died Bergamo 1677.
Italian painter, originally priest. Specialized in the depiction of musical instruments, described as 'unsurpassed' by his contemporaries. Also painted portraits and imaginary battles in the style of Jacques Courtois, known as Bourgignon.
Lit.: *Wallraf-Richartz-Museum* catalogue: B. Klesse, *Italienische, französische und spanische Gemälde bis 1800*, Cologne 1973, pp. 18f – *Un incontro bergamasco*. Ceresa, *Baschenis nelle collezioni private bergamasche*, A cura di Marco Valsecchi, Galleria Lorenzelli, Bergamo catalogue, Bergamo 1972.

Lubin Baugin
Born Pithiviers (Loiret) c. 1610, died Paris 1663.
Was called 'le petit guide' by his contemporaries, due to his stylistic closeness with Guido Reni. The motif of his famous still life (*Five Senses*) seems to be an exception to his œuvre.
Lit.: M. Faré, 'Baugin, peintre de natures mortes', in: *Bulletin de la Société de l'Histoire de l'Art Français*, 1955, pp. 15-26 – Ch. Wright, *The French Painters of the Seventeenth Century*, Boston 1985, pp. 135f.

Osias Beert
Born Antwerp c. 1580, died Antwerp 1624.
Joined the Guild of St. Luke, Antwerp, as a privileged master in 1602. Married Margareta Yckens in 1606. Beert, who died at an early age, worked in Antwerp nearly all his life. As a still life painter, he specialized in flowers and fruit.
Lit.: *Le siècle de Rubens* catalogue, Paris 1977/78, pp. 41ff. (and further literature).

Joachim Beuckelaer
Born Antwerp c. 1530, died Antwerp 1573.
Flemish painter of kitchens and market scenes with first still life elements. Nephew of Pieter Aertsen, in whose studio he learnt to paint. Painted many pictures on the basis of daily payments (1½ guilders a day). Joined the Guild of St. Luke in Antwerp in 1560.
Lit.: K.P.F. Moxey, 'The "Humanist" Market

Scenes of Joachim Beuckelaer: Moralizing Example or "Slices of Life"?', in: *Jaerboek van het Koninklijk Museum voor Schone Kunsten*, Antwerp 16, 1976, pp. 109-187 – *Joachim Beuckelaer. Het markt en keukenstuk in de Nederlanden 1550-1650* exhibition catalogue, Ghent 1986/1987.

Abraham van Beijeren
Born The Hague 1620/21, died Overschie 1690.
Probably pupil of Pieter de Putters. Worked in The Hague, Delft, Amsterdam, Alkmaar and Overschie. Famous for his 'festive still lifes', a sub-genre of the *ontbijtje* (breakfast still lifes).
Lit.: I. Bergström, *Dutch Still Life Painting in the Seventeenth Century*, London 1956, pp. 198 and 239f.

Pieter Boel
Born Antwerp 1622, died Paris 1674.
Boel probably went to Italy in 1650/51 and then became a master of the Guild of St. Luke in Antwerp. In 1668 he worked for Charles le Bruns at his Parisian tapestry workshop, as well as being a court painter (*peintre ordinaire du roi*). Among other things, he painted animals in the style of Fyt, as well as *vanitas* still lifes like the one at the Musée des Beaux-Arts, Lille.
Lit.: *Le siècle de Rubens* catalogue, Paris 1977/78, pp. 43ff. (and further literature).

Ambrosius Bosschaert
Born Antwerp 1573, died The Hague 1621.
Worked in Middelburg, Utrecht and Breda. Famous for his radially composed still lifes of flowers. Also worked as art dealer. His three sons painted flower still lifes as well.
Lit.: L.J. Bol, *The Bosschaert Dynasty*, Leigh-on-Sea 1960 – P. Mitchell, *European Flower Painters*, London 1973, esp. p. 65.

Jan Brueghel the Elder
Born Brussels 1568, died Antwerp 1625.
Son of Pieter Brueghel the Elder and pupil of Pieter Goetkint the Elder in Antwerp. Worked in Italy (Naples 1590, Rome 1592-94, then Milan), returned to Antwerp in 1596 where he joined the Guild of St. Luke. Travelled to Prague in 1604. Travelled to Holland together with Rubens and Hendrick van Balen around 1613. Became court painter of the Archduke Albrecht of Austria, Spanish Governor of the Netherlands, in 1610. Specialized in small-format panoramic landscapes as well as still lifes of flowers. Many paintings together with other artists (Rubens, van Balen, F. Francken II et al.).
Lit.: K. Ertz, *Jan Brueghel der Ältere. Die Gemälde*, Cologne 1979.

Bartholomäus (Barthel) Bruyn the Elder
born Wesel (?) 1493, died Cologne 1555.
Worked in Cologne from 1515. Influenced by Jan Joost van Calcar and Joos van Cleve
Lit.: H. Westhoff-Krummacher, *Barthel Bruyn der Ältere*, Munich/Berlin 1965.

Vincenzo Campi
Born Cremona 1536, died Cremona 1591.
Painted mainly saints and portraits as well as genre-like still lifes, like the two fruit and fishmongers'

paintings at the Brera, Milan. Both show that he was influenced by Pieter Aertsen.
Lit.: Th./B. vol. V, p. 472 – Still. cat., pp. 276ff. (illus. 147).

Michelangelo Merisi da Caravaggio
Born Caravaggio near Bergamo 1571, died Porto Ercole (Tuscany) 1610.
Studied with Simone Peterzano in Milan for four years, from 1584. Lived in Rome from c. 1592/93, where he worked at Cardinal del Monte's house from 1594/95 onwards. Del Monte became his patron. 1599ff. paintings for the Contarelli Chapel in S. Luigi dei Francesi. 1600/01 side painting for the Cerasi Chapel in S. Maria del Popolo. Repeated conflicts with the law. Had to flee from Rome because of manslaughter in 1606 and went first to Naples, then to Malta (1608), where he joined the Maltese Order. Had to flee again. Died on the way back to Rome upon disembarkation at Porto Ercole in 1610.
Lit.: W. Friedlaender, *Caravaggio Studies*, Princeton 1955 – M. Marini, *Michelangelo da Caravaggio*, Rome 1974 – H. Hibbard, *Caravaggio*, London 1983 – *The Age of Caravaggio* catalogue, The Metropolitan Museum, New York 1985.

Annibale Carracci
Born Bologna 1560, died Rome 1609.
Ran a studio with his brothers Agostino and Ludovico, which later developed into the *Accademia degli Incamminati*. Genre paintings at first, in the style of Bologna mannerism (Passarotti, Fontana). Later, particularly when he moved to Rome, tendency towards Classicist severity (frescoes of the large gallery at the Palazzo Farnese).
Lit.: D. Posner, *Annibale Carracci*, London 1971.

Jean Baptiste Siméon Chardin
Born Paris 1699, died Paris 1779.
Pupil of N.N. Coypel, P.J. Cazes and J.B. van Loo. Master of the Guild of St. Luke in 1724. In 1728 joined the Academy as a painter of animals and fruit, where he advanced to the position of *conseiller* (1743) and eventually also became treasurer and organizer of the Academy's exhibitions. Lived at the Louvre from 1757, and was given a royal pension from 1768. Apart from still lifes, Chardin also painted portraits and genre scenes. Was valued by Diderot (cf. Diderot's Salon reviews).
Lit.: P. Rosenberg, *Chardin* exhibition catalogue, Paris/Cleveland/Boston 1979 – P. Rosenberg, *Tout l'œuvre peint de Chardin*, Paris 1983 – Ph. Consibee, *Chardin*, Oxford 1986 – M. Breitmoser, *Tradition als Problem der Stillebenmalerei J. B. S. Chardins*, Munich 1987 – N. Bryson, 'Chardin and the Text of Still Life', in: *Critical Inquiry* 15, winter 1989, H.2 (cf. *Frankfurter Allgemeine Zeitung* of May 17, 1989, no. 112, p. 4N).

Pieter Claesz
Born Burgsteinfurt (Westphalia) 1597, died Haarlem 1660.
Probably never left Haarlem after his marriage in 1617. His dated works of 1621-60 are nearly all breakfast still lifes. In addition, he also painted simple *vanitas* still lifes. Claesz is regarded as a typical painter of 'monochrome *banketjes*'.
Lit.: N.R.A. Vroom, *De schilders van het monochrome banketje*, Amsterdam 1945 – P.J.J. van

Thiel, 'Een stilleven door Pieter Claesz', in: *Bulletin van het Rijksmuseum* 23, 1975, pp. 119-121.

Adriaen Coorte
Dates not known.
Very little is known about this still life painter who was born in Middelburg. He was fined in 1695 for trying to sell paintings without permission. Coorte specialized in simple still lifes of fruit and flowers.
Lit.: Th./B., volume VII, p. 367 (E.W. Moes).

Jacob Gerritsz. Cuyp
Born Dordrecht 1594, died Dordrecht 1651/52.
Son of stained glass artist Gerrit Gerritsz. Cuyp, probably pupil of Abraham Bloemarts in Utrecht.
Lit.: Still. cat., pp. 294, 304 and 310f.

Cornelius Jacobsz. Delff
Born Delft 1571, died Delft 1643.
Not much is known about his life. He was a pupil of his father, the portrait artist Jacob Willemsz. Delff I.
Lit.: *Alte Pinakothek* catalogue, Munich 1983, pp. 161f.

Albrecht Dürer
Born Nuremberg 1471, died Nuremberg 1528.
Studied with Michael Wolgemut. Journeyed in 1490 (Upper Rhine, Basle, Strasbourg). Returned to Nuremberg in 1494. First journey to Italy in the same year; second one in 1505/07. Numerous paintings for Maximilian I between 1512 and 1518. Travelled to Netherlands in 1520/21.
Lit.: *Albrecht Dürer* exhibition catalogue, Nuremberg 1971 – F. Anzelewsky, *Albrecht Dürer. Das malerische Werk*, Berlin 1971 – E. Panofsky, *The Life and Art of Albrecht Dürer*, Princeton 1948ff.

Floris van Dyck
Born Haarlem 1575, died Haarlem 1651.
Specialized particularly in kitchen and fruit still lifes. Affinity between his motifs and those of Nicolas Gillis and Floris van Schooten.
Lit.: Still. cat., p. 410 (illus p. 411).

Carel Fabritius
Born Midden-Beemster 1622, died Delft 1654.
The artist, who died in an explosion at the Delft gunpower factory in 1654 at the age of 32, was probably a pupil of Rembrandt from 1641 to 1643. From 1652 he lived in Delft, where he became an important forerunner of Vermeer.
Lit.: *Mauritshuis – Illustrated General Catalogue*, The Hague 1977, p. 86 – Ch. Brown, *Carel Fabritius*, London 1981 (esp. pp. 126f., no. 7 on the 'gold-finch').

Louis Finson
Born Bruges 1578, died Amsterdam 1617.
The artist stayed in Provence from 1613 to 1615. His art combines elements of 16th-century mannerism and a Caravaggist style.
Lit.: Ch. Wright, *The French Painters of the Seventeenth Century*, Boston 1985, pp. 183f. – D. Bodart, *Louis Finson*, Paris 1970.

Georg Flegel
Born Olmütz 1566, died Frankfurt am Main 1638.
Flegel acquired citizen's rights in Frankfurt in 1597 and stayed there until he died. He worked a lot

together with the Fleming Lucas van Valckenborch. Flegel is considered to be the most important representative of early modern German still lifes. He specialized in so-called show meals, banquet, breakfast and flower still lifes.
Lit.: W.J. Müller, 'Der Maler Georg Flegel und die Anfänge des Stillebens', in: *Schriften des Historischen Museums VIII*, Frankfurt 1956 – K. Wettengl, 'Die Mahlzeitenstilleben von Georg Flegel', doctoral thesis, Osnabrück 1983.

Frans Francken II
Born Antwerp 1581, died Antwerp 1642
Flemish artist. History paintings, allegories, picture galleries (such as the *Banquet at the House of Mayor Rockox*, Alte Pinakothek, Munich), art and wonder chambers, and genre paintings.
Lit.: S. Speth-Holterhoff, *Les peintres flamands de cabinets d'amateurs au XVIIe siècle*, Brussels 1957.

Jan Fyt
Born Antwerp 1611, died Antwerp 1661. Pupil of Frans Snyders, in whose studio he worked until 1631. Stayed in Paris 1633-34, and travelled to Italy. Was particularly valued by his contemporaries as a painter of game still lifes.
Lit.: H. Gerson/E.H. ter Kuile, *Art and Architecture in Belgium*, Harmondsworth 1960, p. 160 – E. Greindl, *Les peintres flamands de nature morte au 17e siècle*, Brussels 1956, p. 75 – Th./B. volume XVII, pp. 612ff.

Taddeo Gaddi
Born Florence c. 1300, died Florence 1366.
Pupil at Giotto's studio. Joined the *Medici e Speziali* guild in Florence in 1327. Painted Baroncelli Chapel in S. Croce, Florence in 1332.
Lit.: R. Oertel, *Die Frühzeit der italienischen Malerei*, Stuttgart 1966 – M. Milman, *Trompe l'œil Painting. The Illusions of Reality*, Geneva 1982, pp. 20f.

Giotto di Bondone
Born Colle di Vespignano near Vicchio 1266(?), died Florence 1337.
Pupil of Cimabues 1288-90. Painted upper portion of the church of S. Francesco in Assisi after 1290. Frescoes in the Arena chapel in Padua c. 1302-06, and in the chapels of Bardi and Peruzzi in S. Croce, Florence, 1320-25. Appointed master architect of the cathedral building project in Florence 1334.
Lit.: G. Vigorelli/E. Bacceschi, *L'opera completa di Giotto*, Milan 1974 (with literature on p. 82).

Cornelius Norbertus Gijsbrechts
Proved activities between 1659 and 1675.
Joined the Guild of St. Luke, Antwerp, 1659/60. Court painter in Copenhagen c. 1670-72. Specialized in trompe l'œil paintings.
Lit.: Th./B., volume XV, pp. 377f. – G. Marlier, 'G.N. Gijsbrechts, l'illusioniste', in: *Connaissance des Arts* 145, 1964, pp. 96-105.

Hugo van der Goes
Born Ghent c. 1440/45, died Roode Klooster near Brussels 1482.
Early Dutch painter. Dean of the Painters' Guild in Ghent several times in succession. Joined the Roode Klooster ('Red Monastery') near Brussels as a *frater*

conversus. This was a collegiate church associated with the Windesheim Congregation..
Lit.: F. Winkler, *Das Werk des Hugo van der Goes*, Berlin 1964 – E. Panofsky, *Early Netherlandish Painting*, Cambridge/Mass. 1953, vol. I, pp. 330-345.

Jan Gossaert, called Mabuse
Born Maubeuge/Hennegau 1470/80, died Breda 1532.
Free master of the Painters' Guild in Antwerp 1503. Took part in Philip of Burgundy's diplomatic journey to Rome in 1508. Worked for Philip at his residence in Wijk near Duurstede from 1517 to 1524.
Lit.: M.J. Friedländer, *Die altniederländische Malerei*, Berlin/Leiden 1924ff., volume VIII – *J. Gossaert genaamd Mabuse* exhibition catalogue, Bruges 1965.

Willem Claesz. Heda
Born Haarlem 1594, died Haarlem 1680/82.
Probably influenced by Floris van Dijck. Main representative of 'monochrome *banketjes*' in Holland in the 2nd quarter of the 17th century.
Lit.: N.R.A. Vroom, *De schilders van het monochrome banketje*, Amsterdam 1945 – I. Bergström, *Dutch Still-Life Painting*, London 1956.

Jan Davidsz de Heem
Born Utrecht 1606, died Antwerp 1654.
Pupil of his father David de Heem the Elder. Worked in Leiden from 1626 to 1636, where he was influenced by the Steenwyck brothers and Pieter Potter. Later he worked in Antwerp under the influence of Daniel Seghers, Utrecht 1669-72, then returned to Antwerp.
Lit.: E. Greindl, *Les peintres flamands de nature morte au XVII siècle*, Brussels 1956.

Maerten van Heemskerck
Born Heemskerck 1498, died Haarlem 1574.
Pupil of Jan van Scorel. Travelled to Italy 1527-29. Then worked in Haarlem.
Lit.: M.J. Friedländer, *Early Netherlandish Painting*, Leiden 1967ff., volume XIII.

Georg (Joris) Hoefnagel
Born Antwerp 1542, died Vienna 1600.
Son of a wealthy diamond merchant. Mainly scientific miniature paintings in the style of early modern curios. Many of his works bear the motto 'natura sola magistra' (Nature is the only teacher). Hoefnagel travelled together with his friend, the geographer Abraham Ortelius. Spent some time as a painter at the court of Duke Albrecht V of Bavaria. Was appointed to the Imperial Court jn Vienna and Prague by Rudolf II in 1590. His son, Jacob Hoefnagel (1575-1630) – Rudolf II's court painter from 1602 on – published the *Archetypa Studiaque Patris G. Hoefnagelii* in four volumes in 1592, with copper engravings after drawings of plants and animals by his father.
Lit.: E. Kris, 'Georg Hoefnagel und der wissenschaftliche Naturalismus', in: *Festschrift für Julius Schlosser*, Leipzig/Vienna/Zurich 1927, pp. 243ff. – U. Lee Hendrix, 'Joris Hoefnagel and Four Elements. A Study in Sixteenth Century Nature Painting', doctoral thesis, Princeton University, Prince-

ton 1983 – *Prag um 1600. Kunst und Kultur am Hofe Rudolfs II.* exhibition catalogue, Essen 1988, pp. 301ff. (T. Gerszi).

Hans Holbein the Younger
Born Augsburg 1497/98, died 1543 London.
Son of Hans Holbein the Elder (c. 1465-1524). Basle 1515-26, London 1526-28, Basle 1528-32, London 1532 until death. Court painter of Henry VIII from 1536 on.
Lit.: R. Salvini/H.W. Grohn, *Holbein il Giovane*, Milan 1971.

Samuel van Hoogstraten
Born Dordrecht 1627, died Dordrecht 1678
Dutch painter who specialized in genre and history paintings, as well as landscapes and still lifes (esp. *betriegertjes* in quodlibet form).
Wrote *Inleyding tot de hooge schoole der schilderkonst* (Introduction to the Art of Painting), Rotterdam 1678.
Lit.: A.P. de Mirimonde, 'Les peintres flamands de trompe l'œil et de natures mortes au XVIIe siècle et les sujets de musique', in: *Jaerboek Koninklijk Museum voor Schone Kunsten* 1971, pp. 223-272 (and further literature).

Pierre-Nicolas Huillot
Born Paris 1674, died 1751.
This artist was born of a renowned painters' family. He entered the Academy in 1721. Numerous paintings for the royal family.
Lit.: Th./B. volume XVIII, pp. 103f. – Faré I, p. 354 – Faré II, pp. 20-35.

Jan van Huysum
Born Amsterdam 1682, died Amsterdam 1749.
Van Huysum broke with the previous tradition of brightly coloured fruit and vegetable still lifes. He was valued by rich private collectors and princes, including those outside the Netherlands, and was paid large amounts of money for his art. His paintings achieved up to 1,450 guilders at auctions.
Lit.: Th./B. volume XVIII, pp. 207f. (C. Hofstede de Groot) - M.H. Grant, *Jan van Huysum*, Leigh-on-Sea 1954 – C. White, *The Flower Drawings of Jan van Huysum*, Leigh-on-Sea 1964.

Jacob Jordaens
Born Antwerp 1593, died Antwerp 1678 Flemish painter and contemporary of Rubens, whose oil sketches he used for large canvas paintings of the hunting lodge *Torre de la Parada* near Madrid in 1637/38. Together with Rubens and van Dyck, he was one of the major 17th-century southern Dutch painters. Famous for his large-format genre paintings (e.g., *Feast of Beans*)
Lit.: *Jordaens* exhibition catalogue, Ottawa 1968/69 – R.A. d'Hulst, *Jacob Jordaens*, Stuttgart 1982.

Willem Kalf
Born Rotterdam 1619, died Amsterdam 1693.
Was definitely in Paris in 1642, though he may already have been there before, in 1639/40. Returned to Rotterdam in 1646. Lived in Amsterdam from 1653 until he died. Under the influence of P. van den Bosch and F. Ryckhals, his early work includes small-format interiors of farmhouses and poor peasants' kitchens. Abandoning this line complete-

ly, he then painted ornamental still lifes at first with a superficial emphasis on wealth, though he later concentrated on more refined methods of depiction, selecting his objects according to aspects of composition and colour.
Lit.: L. Grisebach, *Willem Kalf*, Berlin 1974.

Jan van Kessel
Born Antwerp 1626, died Antwerp 1679
Son of the portrait artist Hieronymus van Kessel and his wife Paschasie, a daughter of Jan Brueghel the Elder. Studied with the genre painter Simon de Vos. Became master of the Guild of St. Luke in Antwerp in 1644/45. Painted mainly animals and flowers, with a special interest in varieties of insects.
Lit.: U. Krempel. *Jan van Kessel d.Ä.* exhibition catalogue, *Die vier Erdteile*, Munich 1973.

Leonardo da Vinci
Born Villa Anchina near Vinci and Empoli, 1452, died Château Cloux near Amboise 1519.
Florentine painter, architect, sculptor, fortress architect and engineer. At the court of Milan in 1498. Worked on preparatory drawings for the fresco of the Anghiari Battle at the Palazzo Vecchio in Florence from 1503 onwards. Milan 1506-13. Following an invitation by King Francis I of France, he went to live at Cloux in 1517.
Lit.: H. Heydenreich, *Leonardo da Vinci*, Basle/London/New York 1954, 2 volumes – K. Clark, *Leonardo da Vinci*, London 1956.

Jacques Linard
Born Paris c. 1600, died Paris 1645.
Main representative of 17th-century French flower still lifes, under the influence of Flemish artists living in Paris.
Lit.: Ch. Wright, *The French Painters of the Seventeenth Century*, Boston 1985, pp. 222ff. – R. Guilly in *Kindlers Malerei Lexikon im dtv*, Munich 1976, volume 8, pp. 196-198 – Faré I, p. 174.

Quentin (Quinten) Massys (Metsys)
Born Louvain 1465/66, died Antwerp 1530
Free master of the Guild of St. Luke, Antwerp, in 1491. A friend of humanists such as Erasmus of Rotterdam, he concentrated mainly on religious paintings (cf. his St. Anne's altar, now in Brussels), portraits and genre scenes. He was very influential with 16th century Flemish painters.
Lit.: M.J. Friedländer, *Early Netherlandish Painting*, Leiden/Brussels 1967ff., volume VII.

Master of the Annunciation of Aix
French (Provençale) who lived in the 2nd quarter of the 15th century, named after the triptych (c. 1445) at the Eglise Ste. Madeleine in Aix. (The altarpiece is still there today, and the two panels are now in Brussels and Amsterdam).
Lit.: J. Boyer, 'Personnages représentés sur les volets du triptyque de l'Annonciation d'Aix', in: *Gazette des Beaux-Arts* 102, LVI, 1960, pp. 137ff.

Otto Marseus van Schrieck
Born Nijmegen 1619, died Amsterdam 1678.
The artist travelled to England, France and Italy (Rome 1652) and worked in Amsterdam after his return. Willem van Aelst was one of his pupils. Van Schrieck bred exotic snakes and reptiles which also frequently occur (together with insects) in his paintings of forest undergrowth.
Lit.: I. Bergström, 'Marseus, peintre de fleurs, papillons et serpents', in: *L'Oeil* 233, 1974, pp. 24ff. – I. Bergström et al., *Natura in posa*, Milan 1977, p. 210.

Francesco di Giorgio Martini
Born Siena 1439, died Siena 1502.
Important Italian architect, sculptor, painter and art historian. Wrote a *Trattato dell'architettura* (ed. by Saluzzo, 1841).
Lit.: M. Milman, *Trompe l'œil. The Illussions of Reality*, Geneva 1983, pp. 50ff. (on the intarsias).

Hans Memling
Born Seligenstadt near Aschaffenburg c. 1430/40, died Bruges 1494.
Probably a pupil of Rogier van der Weydens. Definitely in Bruges after 1466. Painted numerous altarpieces.
Lit.: M.J. Friedländer, *Early Netherlandish Painting*, Leiden/Brussels 1967ff., volume VI.

Abraham Mignon
Born Frankfurt am Main 1640, died Wetzlar (?) 1679.
Spent some time working in Jan Davidsz. de Heem's studio in Utrecht. Returned to Frankfurt in 1676 where Maria Sibylle Merian became one of his pupils.
Lit.: M. Kraemer-Noble, *Abraham Mignon*, Leighon-Sea 1973.

Louise Moillon
Born Paris 1615/16, died Paris 1674 or later.
Most significant 17th-century French painter of still lifes (Ch. Wright). Preferred to paint fruit and flower still lifes.
Lit.: Ch. Wright, *The French Painters of the Seventeenth Century*, Boston 1985, pp. 232ff. – Faré I, pp. 48ff.

Adriaen van Nieulandt
Born Antwerp 1587, died Amsterdam 1658.
Flemish-Dutch painter who specialized in landscapes and interiors with secular and biblical incidental characters.
Lit.: *Die holländischen Gemälde. Kritisches Verzeichnis* catalogue, ed. by R. Klessmann, Herzog Anton Ulrich Museum, Brunswick 1983, pp. 152f.

Barolommeo Passarotti
Born Bologna 1529, died Bologna 1592.
Passarotti's studio was a central meeting point for Bologna's artists. Passarotti advocated the separation of painters from the Guild of Saddlers and Armorors. He can be seen as the first Italian genre and still life painter.
Lit.: C. Hoeper, *Bartolommeo Passarotti (1529-1592)*, Worms 1987.

Clara Peeters
Born Antwerp 1594, place and date of death not known.
Flemish painter who specialized in banquet and breakfast still lifes.
Lit.: *Alte Pinakothek* catalogue, Munich 1983, pp. 383f.

Antonio de Pereda
Born Valladolid 1608/1611, died Madrid 1678.
Spanish artist. History paintings and religious motifs, as well as *vanitas* still lifes, such as *The Knight's Dream* and the *Allegory of Transience* in Vienna.
Lit.: F. Klauner, *Die Gemäldegalerie des Kunsthistorischen Museums in Wien*, Salzburg/Vienna 1978 (2nd edition 1981), pp. 421f.

Willem de Poorter
Born 1608, died after 1648.
Probably a pupil of Rembrandt. History paintings (especially biblical subjects). In his late phase also allegorical paintings and still lifes.
Lit.: *Die Sprache der Bilder* catalogue, Brunswick 1978, no. 27.

Henrick Pot
Born Haarlem 1585, died Amsterdam 1657.
Studied under Karel van Mander, probably together with Frans Hals. Was made Dean of the Haarlem Guild of St. Luke in 1648. Portraits (especially marksmen's guild pieces) and genre paintings.
Lit.: Th./B. volume XXVII, pp. 301f.

Rembrandt Harmensz. van Rijn
Born Leiden 1606, died Amsterdam 1669.
Pupil of Jacob van Swanenburch (in Leiden) and Pieter Lastman (in Amsterdam, 1623). Worked in Leiden until 1631, where he worked together with Lievens and Dou, then in Amsterdam. Rembrandt had numerous pupils in Amsterdam. Also worked as an art dealer.
Lit.: G. Schwartz, *Rembrandt*, Stuttgart/Zurich 1987, pp. 255 and 370 (on the *Slaughtered Ox*) – K.M. Craig, 'Rembrandt and the "Slaughtered Ox"', in: *Journal of the Warburg and Courtauld Institutes* 46, 1983, pp. 235-239.

Pieter de Ring
Born Leiden c. 1615, died Leiden 1660.
Still-life painter whose style was close to Jan Davidsz. de Heem. He specialised in fruit and flowers still lifes. Co-founder of the Leiden Guild of Painters (1648/49).
Lit.: Th./B. volume XXVIII, pp. 366f. (H. Gerson).

Ludger tom Ring the Younger
Born Münster 1522, died Brunswick 1583.
Studied with his father Ludger tom Ring the Elder, then travelled to the Netherlands, and to England in 1550. Mainly portraits, but also still lifes that were influenced by Dutch artists.
Lit.: P. Pieper, 'Ludger tom Ring d.J. und die Anfänge des Stillebens', in: *Münchner Jahrbuch der bildenden Kunst*, 3rd edition, XV, 1964, pp. 113-122.

Peter Paul Rubens
Born Siegen 1577, died Antwerp 1640.
Pupil of Tobias Verhaecht, Adam van Noort and Otto van Veen. Travelled to Italy and Spain between 1600 and 1608. Then worked in Antwerp. Court painter of the Archduke Albert. Frequently worked for Maria de' Medici in Paris. Sent on diplomatic missions by the Archduchess Isabella in 1628 and 1630 to Spain and England.
Lit.: E. Kieser, 'Rubens' Madonna im Blumen-

kranz', in: *Münchner Jahrbuch der bildenden Kunst*, 3rd edition, I, 1950, pp. 215ff.

Pieter Cornelisz. van Ryck
Born Delft 1568, died 1628(?).
Pupil of Jacob Willemsz. I Delff and Huybrecht Jacobsz. Spent 15 years in Italy. Lived in Haarlem from 1604. Specialized in large kitchen interiors.
Lit.: Th./B. volume XXIX, p. 251.

Rachel Ruysch
Born Amsterdam 1664, died Amsterdam 1750.
Daughter of the anatomist and entomologist Prof. Frederick Ruysch (1638-1731), who also enjoyed painting in his spare time. She was a pupil of Willem van Aelst. In 1693 she married the painter Juriaen Pool II, and had ten children. From 1708 to 1716 she worked for Johann Wilhelm von der Pfalz as a court painter. Her still lifes – usually paintings of forest undergrowth with reptiles and insects – were much valued by her contemporaries.
Lit.: Th./B. volume XXIX, p. 243 (W. Stechow) – M.H. Grant, *Rachel Ruysch*, Leigh-on-Sea 1956 – J. Sip, 'Notities bij het stilleven van Rachel Ruysch', in: *Nederlands Kunsthistorisch Jaerboek* 19, 1968, pp. 157-170.

Jan Saenredam
Born Saerdam 1565, died Assendelf 1607.
Copper engraver, father of the architectural painter Pieter Jansz. Saenredam.
Lit.: *Die Sprache der Bilder* catalogue, Brunswick 1978, pp. 70ff. (on the series of copper engravings of the Five Senses after Hendrik Goltzius) – Th./B. volume XXIX, pp. 305f. (W. Stechow).

Fray Juan de Sánchez-Cotán
Born near Toledo 1561, died Granada 1627.
Studied with Blas del Prado in Toledo. Joined the Carthusian monastery El Paular in Segovia as a lay brother in 1603. Worked in Granada from 1612.
Lit.: J. Held, 'Verzicht und Zeremoniell. Zu den Stilleben von Sánchez-Cotán und van der Hamen', in: Still. cat. p. 380ff.

Daniel Seghers
Born Antwerp 1590, died Antwerp 1661.
Pupil of Jan Brueghel the Elder in Antwerp. Became free master of the Antwerp Guild of Painters in 1614, while at the same time joining the Jesuit Order as a lay brother. Numerous trips, including Rome. Painted for Prince Frederick Hendrick of Nassau and the Elector of Brandenburg.
Lit.: M.-L. Hairs, *Les peintres flamands de fleurs au XVIIe siècle*, Brussels 1965, passim.

Frans Snyders
Born Antwerp 1579, died Antwerp 1657.
Pupil of Pieter Brueghel the Younger and Hendrick van Balen. Visited Italy and then stayed in Antwerp until he died. Worked a lot with Rubens, van Dyck and Jan Wildens.
Lit.: H. Robels, 'Frans Snyders' Entwicklung als Stillebenmaler', in: *Wallraf-Richartz-Jahrbuch* 31, 1969, pp. 61ff.

Adriaen van der Spelt
Born Leiden c. 1630, died Gouda 1673.
Joined the Guild of St. Luke in Leiden in 1658. Later, he became court painter to the Great Elector in Berlin. Then returned to his native town of Gouda. Specialized in flower still lifes.
Lit.: *Tentoonstelling van bloemenstukken van oude meesters in de konsth. P. de Boer* catalogue, Amsterdam 1935 – Th./B. volume XXXI, p. 313.

Sebastian Stosskopf
Born Strasbourg 1597, died Idstein 1657.
Son of a mounted soldier. Studied with Daniel Soreau in Hanau, whose studio he took over later. Numerous trips abroad, including the Netherlands, Paris and Venice. Settled in Strasbourg in 1641. Stosskopf specialized in still lifes of drinking vessels, bowls of strawberries, glasses, etc.
Lit.: Still. cat. – Faré I, pp. 115-133 and 372f.

David Teniers the Younger
Born Antwerp 1610, died Brussels 1690.
Pupil of his father David Teniers the Elder. Considerably influenced by Adriaen Brouwer. Worked in Antwerp until 1651, then court painter in Brussels. In charge of the art collection of the Archduke Leopold Willem and founder of the Antwerp Academy.
Lit.: P.J.J. van Thile, in: *Openbaar Kunstbezit* XIV, 1970, No. 40 (on the *Kitchen Interior* at The Hague) – J.P. Davidson, *David Teniers the Younger*, London 1980.

Theodor van Thulden
Born Herzogenbosch 1606, died Herzogenbosch 1669.
Dutch painter who specialized in allegorical, mythological and religious paintings. Strongly influenced by Rubens.
Lit.: *Portretten van echt en trouw. Huwelijk en gezin in de Nederlandse kunst van de zeventiende eeuw*, Haarlem 1986, No. 70 (illus. p. 287).

Jan Vermeer van Delft
Born Delft 1632, died Delft 1675.
Together with Rembrandt and Frans Hals probably the most important Dutch painter of the 17th century. Influenced by Utrecht Caravaggism at first (Ter Brugghen) as well as Carel Fabritius, who moved to Delft in 1652. Vermeer was also an art dealer.
Lit.: L. Gowing, *Johannes Vermeer, painter of Delft*, Utrecht 1950 – A. Blankert, *Johannes Vermeer*, Utrecht/Antwerp 1975 – G. Allaud/A. Blankert/J.M. Montias, *Vermeer*, Paris 1986.

Diego de Silva y Velázquez
Born Seville 1599, died Madrid 1660.
Major 17th-century Spanish painter. Pupil of F. Pacheco. Moved to Madrid in 1623, where he became court painter and preferred portrait artist of the royal house. Two trips to Italy (1629-31 and 1649-51). Religious paintings and bodegones at first, influenced by Caravaggist chiaroscuro painting.
Lit.: J. Brown, *Velázquez. Painter and Courtier*, London 1986.

Jan Weenix
Born Amsterdam 1640, died Amsterdam 1719.
Dutch painter who specialized in painting animals. Son of Jan Baptist Weenix. Worked in Utrecht and was court painter of the Elector von der Pfalz at Schloss Bensberg near Düsseldorf (1702-12).
Lit.: P. Eikemeier, 'Der Jagdzyklus des Jan Weenix aus Schloß Bensberg', in: *Weltkunst* XLVIII, 1978, pp. 296ff.

Jan Baptist Weenix
Born Amsterdam 1621, died Deutecum c. 1663.
Dutch painter and father of Jan Weenix. Pupil of Abraham Bloemart in Utrecht. Spent four years in Italy, where he painted the Campagna with ruins and Arcadian motifs. Also still lifes and animals (for example, chicken runs).
Lit.: W. Stechow, 'Jan Baptist Weenix', in: *The Art Quarterly* XI, 1948, pp. 181-198.

Joachim Antonisz. Wtewael (Wttewael, Uytewael, Utenwaell)
Born Utrecht c. 1566, died Utrecht 1638.
At the age of 20, the son of a stained glass artist accompanied the Bishop of St. Malo on a trip to Padua for two years. Then two years in France. Lived in Utrecht until he died. Worked as a flax and linen trader. Wtewael is considered to be one of the most important representatives of late Utrecht mannerism.
Lit.: Th./B. volume XXXVI, pp. 285ff. – C.M.A.A. Lindeman, *J.A. Wtewael*, Utrecht 1929.

Francisco Zurbarán
Born Fuente de Cantos (Estremadura) 1598, died Madrid 1664.
Major 17th-century Spanish painter. Court painter of Philip IV in 1638. Above all religious paintings, but also still lifes.
Lit.: *Zurbarán* exhibition catalogue, ed. by J. Baticle, texts by J. Brown, Y. Bottineau et al., Paris 1987 – P. Guinard, *Zurbarán et les peintres espagnoles de la vie monastique*, no place of publication, 1988.

Literature

Abbreviations
HS Arthur Henkel/Albrecht Schöne, *Emblemata. Handbuch zur Sinnbildkunst des XVI. und XVII. Jahrhunderts*, Stuttgart 1967.
LCI *Lexikon der christlichen Ikonographie*, Freiburg 1968ff., 4 volumes.
MPL J.-P. Migne (ed.), *Patrologiae cursus completus*, Series Latina, Paris 1844ff., 217 volumes, 4 volumes of register.
Zedler *Grosses vollständiges Universal-Lexicon Aller Wissenschaften und Künste etc.*, Halle/Leipzig 1732-50, 64 volumes, 4 supplements.

General works
Ingvar Bergström, *Dutch Still-Life Painting in the Seventeenth Century*, London/New York 1956.
Michel Faré, *La nature morte en France, son histoire, son évolution, du XVIIe au XXe siècles*, Geneva 1962.
Michel Faré, *Le grand siècle de la nature morte en France. Le XVIIe siècle*, Fribourg/Paris 1976.
Edith Greindl, *Les peintres flamands de nature morte au XVIIe siècle*, Brussels 1956, extended edition, Brussels 1983.
Claus Grimm, *Stilleben. Die niederländischen und deutschen Meister*, Stuttgart/Zurich 1988.
M.-L. Hairs, *Les peintres flamands de fleurs au XVIIe siècle*, 2nd edition, Paris/Brussels 1964.
Jan Lauts, *Stilleben alter Meister I: Niederländer und Deutsche*, Staatliche Kunsthalle Karlsruhe, Karlsruhe, 1969.
Jan Lauts, *Stilleben alter Meister II: Franzosen*, Staatliche Kunsthalle Karlsruhe, Karlsruhe 1970
Natura in posa. La grande stazione della natura morta europea, Milan 1977, with articles by Ingvar Bergström, Claus Grimm, M. Rosci, M. and F. Faré and J.A. Gaya Nuno.
Charles Sterling, *Still Life Painting. From Antiquity to the Twentieth Century*, 2nd revised edition, New York etc. 1981 (with extensive bibliography pp. 305-315).

Important exhibition catalogues
Ijdelheid der ijdelheden, Leiden 1970.
Tot lering en vermaak. Betekenissen van Hollandse genrevoorstellingen uit de zeventiende eeuw, Amsterdam 1976.
La nature morte de Brueghel à Soutine, Bordeaux 1978.
Die Sprache der Bilder. Realität und Bedeutung in der niederländischen Malerei des 17. Jahrhunderts, Braunschweig 1978.
Stilleben in Europea, Münster/Baden-Baden 1979/80.
Still Life in the Age of Rembrandt, Auckland 1982.
Sam Segal, *Niederländische Stilleben von Brueghel bis van Gogh*, Amsterdam/Brunswick 1983.
Das Stilleben und sein Gegenstand, Dresden 1983.
Spanish Still Life and the Golden Age 1600-1650, Fort Worth/Toledo, Ohio 1985.
Sam Segal, *A Prosperous Past. The Sumptuous Still Life in the Netherlands 1600-1700* (William B. Jordan, ed.), The Hague 1988 (Kimbell Art Museum, Fort Worth; Fogg Art Museum; Stedelijk Museum, Delft).

The publishers wish to express their gratitude to the museums, archives and photographers for their kind permission to reproduce material, and for their help in the production of this book. In addition to the individuals and organizations quoted in this book, we would like to thank the *Artothek – Kunstdiaarchiv J. Hinrichs* in Planegg, the *Bildarchiv Alexander Koch* in Munich, the *Archiv für Kunst und Geschichte* in Berlin, and the *Scala* in Florence.